WATERFOWL

THE ARTIST'S GUIDE TO ANATOMY, ATTITUDE, AND COLOR

Richard LeMaster

Contemporary Books, Inc.
Chicago

Library of Congress Cataloging in Publication Data

LeMaster, Richard, 1928–
 Waterfowl : the artist's guide to anatomy, attitude,
and color.

 Includes index.
 1. Waterfowl in art. 2. Art—Technique.
3. Waterfowl—Anatomy. 4. Birds—Anatomy. 5. Color
of birds. I. Title.
N7665.L33 1983 745.593 83-14409
ISBN 0-8092-5472-7

Copyright © 1983 by Richard LeMaster
All rights reserved
Published by Contemporary Books, Inc.
180 North Michigan Avenue, Chicago, Illinois 60601
Manufactured in the United States of America
Library of Congress Catalog Card Number: 83-14409
International Standard Book Number: 0-8092-5472-7

Published simultaneously in Canada by Beaverbooks, Ltd.
195 Allstate Parkway, Valleywood Business Park
Markham, Ontario L3R 4T8 Canada

CONTENTS

*This book is dedicated to
the collectors of waterfowl art.
Their acclamation is our inspiration.*

AUTHOR'S NOTE

This book was undertaken solely for the purpose of teaching the understanding of waterfowl art. In this book, various terms will be found that do not coincide with those given by ornithologists or biologists. I have retermed some areas of waterfowl anatomy so the layman may associate the area through known positions relative to other animals or objects. My own terms and definitions are used to simplify the meaning for artists. I do not pretend to be trained as either an ornithologist or a biologist.

Although I have tried to show infinite details of waterfowl throughout this book, I am convinced that the artist will use it only for a better understanding of the subject. The more you know of the anatomy, the easier it will be to simplify your art and give it personal interpretation.

Many of the photographs in this book were taken under controlled conditions in my workshop. Most of the ducks were trapped, then released after the pictures were taken. The pictures that I did not take are credited to some of my friends, who graciously let me use their pictures.

Although I am convinced of my personal observations pertaining to ducks as of this writing, I try to remain open to change as each bit of new information builds my knowledge—hoping that it will never be complete nor complacent.

INTRODUCTION

Waterfowl painting has existed for thousands of years. From the beginning, the stylized figures of prehistoric cave dwellers, hunting scenes in Egyptian tombs and ancient Oriental tapestries, to the present-day art, the colors and shapes of waterfowl have intrigued mankind.

There seems to be a universal appeal to any art that depicts waterfowl. Worldwide distribution naturally plays a part in the popularity, but what is so intriguing about waterfowl?

In the past several decades, waterfowl art has grown very rapidly through not only hunters' interest, but people of all types who love the combination of art and nature's subjects. One of the aspects that has helped tremendously in the growth of waterfowl art has been the availability of prints of the original art. This has enabled many people to collect and admire what only a few could do before. It has created a lot of appreciation of waterfowl art for the masses who simply could not afford the original artwork.

Another dimension of waterfowl art has also gained in popularity—decoys. Decorative decoys have evolved from the art of the super-simple hunting decoys of yesteryear; and in recent years, the evolution has turned to super-realistic sculptures of wood. Viewers of these realistic sculptures are in awe of the lifelike creations.

Today, waterfowl art encompasses wood and bronze sculptures as well as paintings. With all the interest in this form of art and the multitude of

1

artists joining the ranks, how do you tell good art from the mediocre? If you are a collector the answer is in personal likes only, for beauty is in the eye of the beholder.

I do not think that I understood what collecting was all about until a collector passed me by at a show and purchased a sculpture from a friend at the next table. This particular collector had already purchased several sculptures from me, so I knew that he respected my work, and yet he bought from another artist. He even paid more money for it than he would for one of mine. I thought for awhile and finally realized that a true collector has to have variety. Without an assemblage of various works, there is nothing to compare one work to another and enjoy them as art.

There are as many styles within waterfowl art as there are painters and sculptors. The good artists and their individual styles eventually stand out like sore thumbs, to coin a phrase. The good will be standouts in any field, and from these, a select few will rise above and be more than just good; they will be great—the masters. What makes or establishes these special artists as master artists? It certainly is not that they are better painters or carvers by any means, for there are many who are just as dexterous with brush and tools.

The masters rise above the rest through total dedication, their artistic styles, and knowledge of their subject matter. The dedication of learning their subject before they capture it in art form is the first big step in the separation from the crowd and their rise in stature. The style they become known for usually evolves over the years of a laborious apprenticeship. Yes, *apprenticeship*. Everyone has to go through the learning and dedication before his or her own true style emerges.

Today, there are many fantastic artists emerging in the field of waterfowl art—extremely talented people with brush, canvas, and tools. And yet only a few will achieve any sort of real success. Some of these newcomers to this particular field have already made a niche in another area of art, so why aren't they recognized immediately in this new field of endeavor? The quality of their work is certainly just as good as it ever was. Some of these new artists will achieve recognition in the manner they wish and yet there will be others that may gain recognition in a way that they may not understand.

At this thought, several artists come to mind whose artistic talents are superb; however, they are now being recognized as the best of the painters of dead birds. Oh, the subjects are depicted as being alive alright, but with any knowledge of waterfowl the viewer can tell the model used was a stuffed or mounted specimen. It is quite apparent these artists have not taken time to study the live bird.

There is no substitute for studying the live subject and it eventually shows in an artist's work. The number of waterfowl artists that rely on the taxidermist's knowledge is staggering. There are certain things that a taxidermist can do and some that are impossible to do, the most important of which is he can never give life back to the duck. ONCE A BIRD IS DEAD, IT'S DEAD! It can never be brought back to life so the next best thing is to try to get the appearance as close as possible to lifelike.

There are many fine taxidermists, but what happens if one of them mounts a specimen and he really does not know the anatomy of the duck? If he makes a mistake, the artist will certainly repeat the error. It is the lack of errors that a connoisseur can detect immediately, which is not a conscious scrutinization necessarily, but a recognition of the details that make the piece of art distinctive. The lack of errors can only come about through the knowledge of the live subject.

Style will emerge on its own unless there is an attempt to copy others. Style should be a personal interpretation as individual as the artist that completes the art. If we all strived for the same style, all art might look alike. Therefore if it is to remain art, it must show individuality. In simple terms: do your own thing.

KNOWLEDGE—
THE MASTER KEY

There is no substitute for knowledge. If you are unsure or have to guess while carving or painting, you are surely in trouble. If an artist's knowledge of the subject is limited, it will be reflected in his work. The foundation of things we accomplish is usually 90 percent knowledge and 10 percent ability. With this in mind, it is really important that you should make every effort possible to learn the details and facts of the subject matter before you start. If something is to be more complex, there will have to be more knowledge of it and this should be done before you start the project.

Homework is the answer, as it always has been and always will be. Those who excel are the ones willing to dedicate their time, first to learning and then to accomplishing.

I have heard many people make a statement like "they inherited their talent." Usually they are talking about little Johnny or Suzy and referring to someone in the family tree who could draw or paint. I really have a hard time believing anything of the sort and have proven over and over that anyone can carve or paint. They just have to have the desire to do it first. The desire to do something can overcome the biggest obstacle. The simple statement, "I want to do this," can open all the doors to knowledge. Certainly, the knowledge cannot all be attained at one time but will build by little bits and pieces until understanding takes over. In our quest for learning there will be no detail too small or trivial to study.

Painting is a factor of knowledge just as everything else is. Knowing what color something is, what colors might be mixed to create that color, where to buy the paint, how to mix it and on which type surface—all of this is knowledge. What brush to use, how to effectively load it with paint, and where to apply it, is still in the knowledge field. After accomplishing these feats over and over, you develop the ability to do it. When the whole process can be accomplished with ease, perhaps then and only then, talent becomes involved.

It is far more important to know the anatomy of a duck, its attitude, behavior, and the pertinent information about waterfowl, than it is to have the actual ability to carve or paint. The ability will come through repetitious doing, but you can't do it if you do not know what to do. The sets of feathers, the directions of the feathers, and what feathers do in one action or another—how they splay, create shape or form—are the major focus points for our knowledge of waterfowl art. The structure and the color pattern of the feathers and their actual texture also have to be studied. All of these factors have a bearing on waterfowl painting because of the rounded surface of the waterfowl and the play of light and shadow which enfolds the live duck.

Many artists simply do not understand waterfowl when they first start. Not understanding the subject usually leads to seeking works by other artists for study purposes. When uncertainty creeps in, it is only natural to turn toward others that have already been accepted for their knowledge and ability. This can be good, but it can also be a source for concern, for it depends solely upon the reference the original artist had to work with. Trying to find reference to follow that does not pass on the mistakes of the original artist may lead to a lot of frustration.

The problem of reference, good reference, has always been one of the stumbling blocks in our knowledge process. One of the first considerations of a reliable reference source might be a trip to the museums. Their displays of waterfowl have to be perfect or they would not be on exhibit—right? Not necessarily; this depends again upon the knowledge of anatomy as interpreted in a particular pose or action by the individual who mounted the specimen. I have seen very few museum specimens, though, that bear resemblance to the actual living bird. The ones that did look lifelike certainly reflected the dedication and study of the people who mounted the specimens.

Many museums have a collection of study skins that you may examine if you obtain permission. These study skins are just what the name implies, skins for you to study. They do not look like the live bird but will provide some basic colors for you to study. The wings are normally folded on these study skins; then the entire skin is placed upside down for storage. Since they have been folded for some time, the wings usually

have taken a set and can only be reopened by experts in a painstaking process.

It may seem that I have a very negative attitude toward mounts and study skins, but this is not so. They all fill a need. I am only trying to make you aware of some of the problems before you get yourself in too deep. I have tried to put this book together in a manner that will simplify the learning process. Study each step, one at a time, and try to get a firm understanding of each facet before you go on to the next. It is very simple if you avoid getting ahead of yourself and trying to skip areas that you feel insignificant. The smallest of details cannot be overlooked if your knowledge is to be complete.

DIVER DUCK— PUDDLE DUCK?

Sooner or later the name *diver duck* or *puddle duck* will be mentioned when the conversation turns to ducks. The distinction is a matter of categorizing by behavior rather than by species. To break this down and simplify it for you, let's start with *species*. Species is a name given to a particular type of duck. A Mallard is a species, a Pintail is a species, a Wood Duck is a species, etc.

The word *diver* is used to designate all the species that dive underwater and forage for their food on the bottom—hence, the word diver. For the sake of simplicity and art I am including bay and sea ducks, Mergansers, and Ruddy Ducks in the diver category. *Paddle* ducks, on the other hand, frequent shallow ponds or bodies of water and forage for their food by tipping in the water and reaching to feel on the shallow bottom. They also skim the surface with their bills at times and dabble the edibles on top or on the shorelines (hence, puddle ducks are also called dabblers or dabbling ducks). Thus, the basic breakdown is according to feeding habits—at least as far as their designation as either a diver duck or puddle duck. There are more behavioral differences for furthering the separation though.

A diver normally has to run across the water to gain speed and take off from the water. Their wings are narrower and shorter than the puddle ducks in ratio to body size and weight. Therefore, they require a running takeoff. With the wings having less lift for the amount of

weight to be carried, the divers must have a faster wingbeat to remain airborne.

There are other waterfowl that have to utilize a running start across the water but are not necessarily divers. These species include loons, grebes, cormorants, geese, and swans. The first three of these species do dive underwater to feed but the various species of geese and swans feed from the surface by tipping (the same as puddle ducks). The large size of the geese and swans requires running across the water to become airborne.

Divers have much larger feet than puddle ducks because of the need to propel themselves down into the water for feeding. The hind toe of the diver has a flap of skin on it called the lobe, which is not present on the the hind toe of the puddle duck. To increase the thrust of the leg motion for underwater diving, nature has placed the legs farther to the rear on the body of the diver. Having this attribute then forces them to walk in a more upright position on land.

Tails of the divers are much smaller than those of the puddle duck species, although the species of Goldeneye, Bufflehead, and Hooded Mergansers do have longer tails than most diver ducks. All three of these ducks nest in trees which would account for the need of long tails for better maneuverability.

The wings of a puddle duck have a great capacity for lift and thrust enabling them to rise right out of the water without a running start. Puddle ducks can launch straight up from the water when danger threatens. The wings of the puddle ducks also are known for their metallic-colored speculum.

Divers will be found more frequently about large, open masses of water while puddle ducks are usually found in ponds, small streams, or near the shallow edges of any body of water. They may also be found feeding in fields; divers seen in fields would be a rarity.

All of the species listed in the chart on page 11 are regular migrants found throughout the various flyways of the United States and Canada. Many people do not realize that there are so many species of ducks on this continent. If you were to ask someone with little knowledge of waterfowl about species, what would be your guess as to their answer? A neophyte might ask, "What's the difference? A duck is a duck, right?"

Webbed feet are the first thought whenever a question on the anatomy of a duck is asked. What other traits do ducks have? They all have bills, can fly, are covered with feathers, and spend lots of time on the water. Add the webbed feet to this list along with the sound of "quack," and the popular knowledge of ducks is complete. I might add here, though, that only the females of a couple of species emit a quacking sound; the rest purr, whir, peep, whistle, and honk!

DIFFERENCES BETWEEN DIVER DUCKS AND PUDDLE DUCKS

DIVERS:
- dive for their food
- run across the water to take off
- have larger feet with lobe on the hind toe
- have narrower wings with little or no coloring on speculum
- have faster wingbeat
- frequent large bodies of open water

The diver duck species include:
Canvasback, Redhead, Lesser and Greater Scaup, Ring-necked, Bufflehead, Goldeneye, Ruddy, Mergansers, Scoters, and Eiders.

PUDDLE DUCKS:
- tip or dabble on the surface for their food
- spring from the water when alarmed
- have no fleshy lobe on the hind toe
- have broader wings with colored speculum
- have slower wingbeat
- frequent small ponds or streams and also feed in fields

The puddle duck species include:
Mallard, Black Duck, Wigeon, Gadwall, Pintail, Shoveler, Wood Duck, Blue-winged Teal, Green-winged Teal, and the Cinnamon Teal.

This breakdown can help you as an artist, for it forces you to think of actions or reactions, locations, habitat, and some physical characteristics that start putting the bits all together.

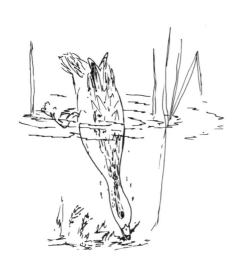

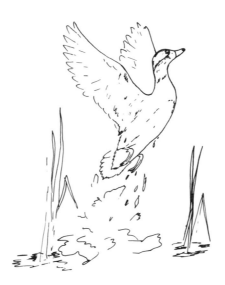

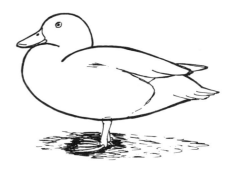

Puddle ducks tip from the surface to forage on the shallow bottoms.

Puddle ducks launch into the air without running.

Puddle ducks have a level stance with the feet in the center between breast and tail.

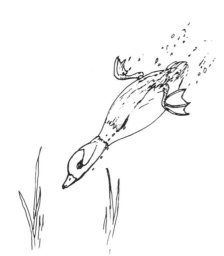

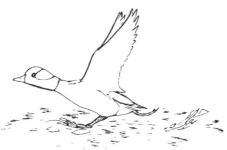

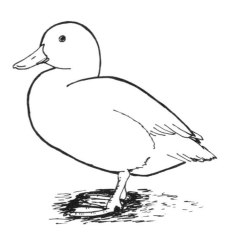

Divers dive to forage on the bottom.

Divers run across the water to take off.

Divers have a more upright stance due to the legs being further back on the body.

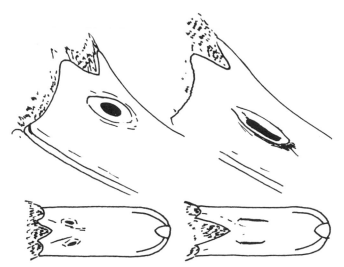

The nostrils of puddle ducks (on left) are more oval shaped than the longer nostril openings of the divers (on right). Puddle duck nostrils angle inward.

The hind toe. Divers have a large flap of skin hanging from the toe (top). The nail of the toe extends beyond the rest of the toe on the puddle ducks.

FURTHER DISTINCTIONS

Duck identification is a must if you are a hunter, and until recently the main keys to identification were flocks at a distance, color markings in the air when they got closer, and wing coloration when the duck was in hand. I was fortunate to recognize that ducks have a habit of flying at specific heights depending upon species. The height of flight, along with the flock characteristics, now help to identify ducks at a distance. Once they get closer, the color markings still are the major factor until the duck is in hand. The size, shape, and color of the bill have become a very positive means of identification of species also. I put these identifying features in a book entitled *The LeMaster Method—Waterfowl Identification* (Scotch Game Call Co., Elba, N.Y.).

I mentioned color markings in the previous paragraph. The colors of ducks and their markings are the most noticeable differences among the variances of species. Next is the overall shape and size—some ducks are large, some are small—but unless there is something to compare with, size does not mean much.

Drakes, or males, are easily identified by their colors especially in the nuptial plumage but the females look very much alike at first glance. (The nuptial plumage is the bright-colored plumage the males attain for the spring courtship and breeding season.) The basic shapes of ducks are very similar except for the divers, who appear shorter and chunkier. There are very definite characteristics that separate one species from another; look for these small details as you progress in the book. I'll try to point them out for you as we go along.

ANATOMY OF A DUCK

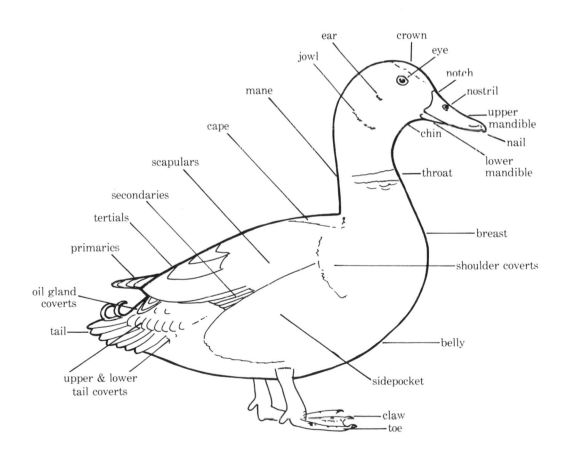

ear crown

jowl eye

mane notch

 nostril

cape upper mandible

scapulars chin

secondaries nail

tertials lower mandible

primaries throat

oil gland coverts breast

tail shoulder coverts

upper & lower tail coverts belly

sidepocket

claw
toe

15

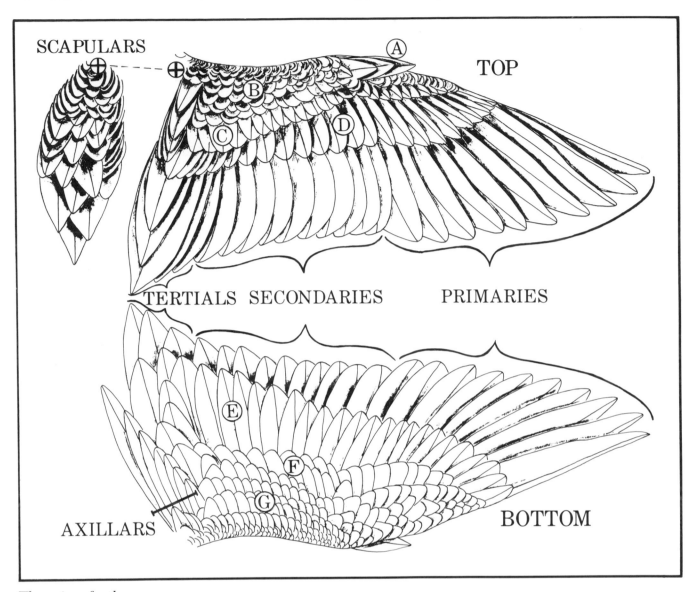

The wing feathers.

A—alula
B—lesser coverts
C—middle coverts
(overlap is reversed)
D—greater coverts

E—greater underlining coverts
F—middle underlining coverts
(overlap is reversed)
G—lesser underlining coverts
(overlap is reversed)

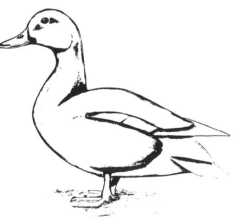

The basic shape of a duck on the water and standing.

LOOKING
BEYOND COLOR

Let's face it—humans are influenced by colors. Bright colors are recognized as beautiful. Earth colors are overlooked perhaps as being dull and lifeless; gray colors are frequently labeled as depressing. Pink for girls, blue for boys, colors handed down for generations. The list goes on and on, always connecting color with human emotion in some way. When we see a brightly colored male duck it is only natural then to label it as being beautiful. The female with its drab earthy colors should, by human standards, be called unbeautiful—right?

It would take a calculator to figure the number of times that I have been asked, "What duck do you consider the prettiest?" The same would be true of hearing the statement, "I don't like the female ducks; they're so plain." Most people expect me to answer that I consider the Wood Duck drake to be the prettiest of all waterfowl because of its vivid multicolors. They are surprised when I tell them that I consider the Wood Duck hen to be one of my choices.

Actually, my personal preference would be equally divided between the Wood Duck hen and the Pintail hen. They are my estimation of nature's answer to beauty. People that usually consider the "Woody" drake as the most beautiful are influenced by bright colors, colors that catch the eye. I am not putting these people down for their choices, for we all have personal preferences and they are as right as I am.

When I started building models for industry many years ago, one of

17

the first things that I had to learn was to look past or beyond the color. The shape had to be exact and color was secondary because it was only a covering of the surface to make it look good. My early training was to overlook the "gingerbread," and let structure and shape take over, then go for color. This is very difficult to do when you are first learning because you usually do not know what to look for.

When I give lectures or seminars, I begin with a picture of the so-called beautiful Wood Duck drake. The colors are very vivid in that first picture on the screen. After all the oohs and aahs, I start showing my method of observation priorities. My first thought is to put everything into a level or horizontal situation. This is no problem if the duck is swimming, for you have nature's built-in level for you, the water. Once you have a known factor, everything is gauged from that—the level or angles of the back from that known factor, the angle of the tail, the bill, the head, the sets of feathers, etc. I try to visually break the picture down into minute sections, using this one reference. From that point, I visualize lines running straight up and down (vertically). This would make them right angles since the water is a level horizon.

With these imaginary lines in mind, I start with the front and see how much of the bill extends in front of or behind the breast. Then I might do the same with the location of the eye in relation to the head, then the whole body. The visual dissecting goes on and on, and all the while we are overlooking the colors. Within a few short minutes, you begin to look at what you should be looking at to gain the most information.

Several years ago, I judged a national taxidermy show and gave a lecture that evening. In the audience were some of the finest taxidermists in the nation. After I had finished the lecture and was putting my slides away, a couple of men from the audience came up to talk to me. One had been a taxidermist for over 30 years, and had also been a game breeder for the same duration. (A game breeder is one who raises birds in captivity.) The other gentleman with him had similar experiences but for only 20 years. They were both bubbling over with excitement because I had been able to show them what to look for. As one of them exclaimed, "All this time it's been there for us to see, but we just did not know what to look for!" My idea of success is in being able to help someone; that night I was doubly successful!

The key in being able to observe the details that you need to know is centered around the amount of information you have previously learned. If this sounds complicated, break it down, so all details are separated into simple pieces to be reassembled or built. If you have not taken the time to learn details of an area of anatomy, you will not know what you are looking at or for. If you have completed your homework first, each area will be very apparent and you will know exactly what to look for.

There is a pattern that needs to be established as you go. Art is no different than any other field that builds or puts things together.

The first step is the outline, perimeter, exterior, or whatever you wish to label it—*the shape*. Once the outline is completed, areas are established within the confines. In these areas there will be smaller details that need to be added. All the time we are getting smaller and more precise with the details. The outline or shape of the duck should be completed first—all details will come from within that shape. Next, the sets of feathers need to be established. Each set of feathers is then broken down into individual feathers until, finally, each feather is detailed. The *shape* must be established first—color is just the covering to make the shape look good.

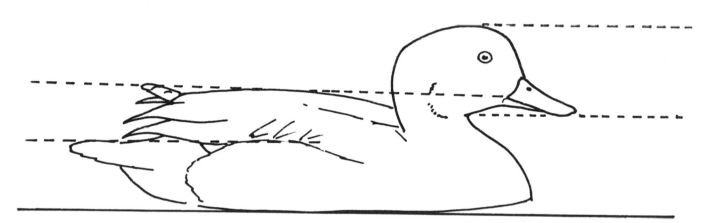

This method of study can be done with pictures or any other reference you can get. If it seems confusing with pictures, trace them and continue with just the outlines. This study can be done with any attitude or action. The first step in analyzing the picture is to establish a horizontal line to be used as a base line. From this base, try to pick out and establish lines that would be parallel to it. They can be wherever you wish to note an elevation or distance from the original line. In this drawing of the Gadwall drake, I started with a line under the bill and found it the same height as the throat. Another line at the top of the head shows me that the bill line was approximately midway between the two. The line across the tail goes forward to show it being the same height as the sidepocket. The top of the back is even with the corner of the mouth. Try it but make sure that you keep it simple.

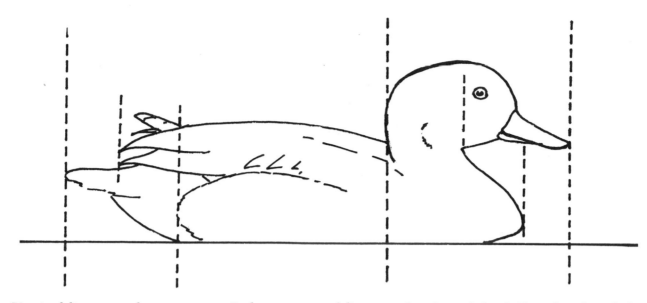

Vertical lines are the next step. I always extend lines at the tips of the bill and tail and then behind the head and sidepocket. This breaks it down into large or small visually detected segments. A line in front of the breast shows the portion of the bill in front and behind that area. The line going up from the throat gives the eye proximity and relation. The primaries emerge on the same line as the rear sidepocket. The tertial extension is shown in relation to the tail.

The next step would be to do the same thing with angles—establish a base line at any angle and parallel lines from it.

ATTITUDE AND ACTION—*SHAPE*

Most lessons in art, whether for sculpture or painting, usually start with the knowledge of the underlying structure—the basics of a skeleton, its movement and dimensions, then the buildup of muscle or mass that defines the total shape. Birds are an exception to these studies. The skeleton defines the limits of movement and size, but the muscles do not form or cause any external shape that is visually detected. The feathers covering the muscles form the entire shape except for the bill and the feet. However, it is important to understand the body without the feathers so you will understand some of the actions and their limitations. But to study the muscles of a bird for the sake of art is of less consequence than studying the sets and structures of the feathers themselves.

There are basics that apply to most species. Once these basics are mastered, you can adapt them to any species by incorporating the species characteristics that separate it from the others. It is all knowledge, as I've mentioned many times.

The shape of a duck changes drastically with its actions or attitude. If you have observed the behavior of waterfowl to any extent, you can tell the nervousness of a duck by its shape. If it is comfortable and feels safe with its surroundings, the feathers are relaxed, giving a puffy, full appearance. The head will be lower also. The first sign of any alertness is the raising of the head. This may be accompanied by some other form of head movement. If standing, there may be a slight stiffening of the legs and possibly some shifting of the feet.

As the bird feels less secure, the head is raised higher and the feathers are pulled in tighter to the body. The artist might try to keep in mind that the more nervous or scared a duck is, the slimmer it looks. The more at ease it is with the surroundings, the fatter it looks. This applies to standing or swimming only though, for if a bird is sleeping it is relaxed. The puffy, full look will also vary. When they are in the air, taking off or landing, all feathers are pulled in tightly giving a thinner, skinny appearance in comparison.

If there is sufficient cause for alarm, a standing duck will crouch, then spring into the air with a flurry that happens so fast that only a camera can record the action. If the duck is on the water when it becomes alarmed, the wings are cocked and bent at the wrists. To propel itself from the water, the wings are slammed down into the water causing the duck to shoot upwards. Puddle ducks are known for this trait; divers usually run across the water as mentioned before. However, I have witnessed divers launching into the air from the water and puddle ducks running across the water to take off. It all depends on the duck's uneasiness with the surroundings and the immediate danger.

TAKING OFF

All ducks will usually take off into the wind. This action increases lifting power and speeds them from danger. The first few power strokes are not in the fashion that most people would think. If a bird, any bird, were to fully extend its wings and lift them to rise into the air, it would go down, not up. Some soaring birds are capable of executing a lift-off in a breeze in this manner. But ducks or any other birds that cannot soar must use other methods of raising themselves into the air.

To overcome opposing forces of wind and gravity, the wings are quickly folded at the elbows with the primaries being folded in a down direction. The elbows are elevated above and behind the back with the primaries still folded until the wrists are at full extension above the body. This reduces the raising of the wing to a minimum of drag. Once full extension is reached, the primaries are brought outward and twisted with the leading edges up. The placement of the quills on the primaries allows them to vane open and let air through with minimum drag. The outer primaries, with their specially placed quills, are the only wing feathers capable of twisting enough to let the air pass through them freely. As the primaries are raised the elbows are being extended at the upper regions of the arc.

Once the primaries are brought to full extension up and back, the wing is then brought down with force. The overlapping of the feathers stops air from passing through any part of the wings. On the forward

stroke, the wings are brought almost together in front and below the rising bird. The same action is quickly repeated over and over within a few seconds. The power strokes start diminishing in a matter of feet, the body angle lessens, and smoother flight strokes become apparent.

The feet pump up and down with the wing action during the takeoff. As the wings go up, the feet go down and vice versa. When the basic lifting is completed, the feet are folded back under the tail to decrease their resistance in flight.

WIGEON DRAKE
The launch.

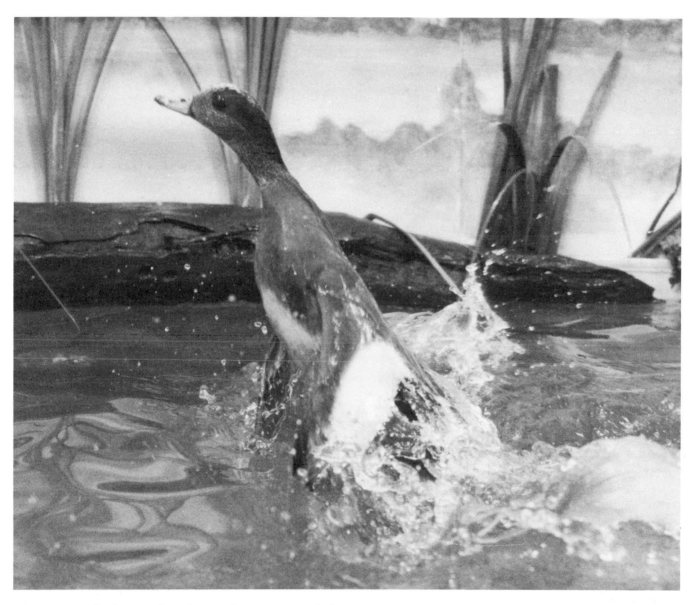

A wigeon drake pushes from the water with his wings. The force splashes the water back as well as outward, indicating the first thrusting motion was created with partially bent wings.

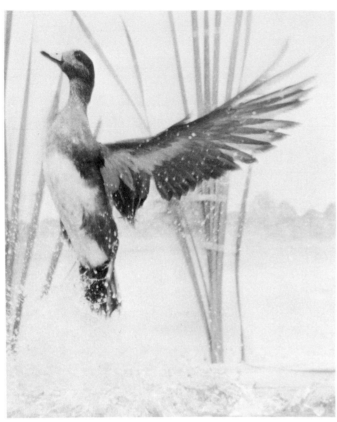

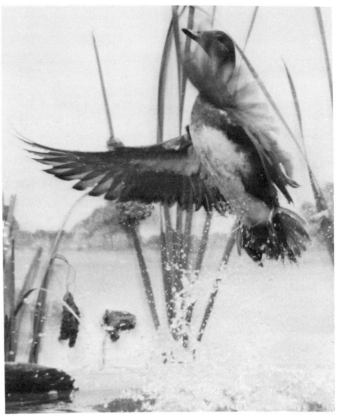

The drake has completed flapping its wings for the first time and they are now being brought down and forward. The outer primaries are the attitude indicators.

The outer primaries are bent as the wing goes forward in front of the body.

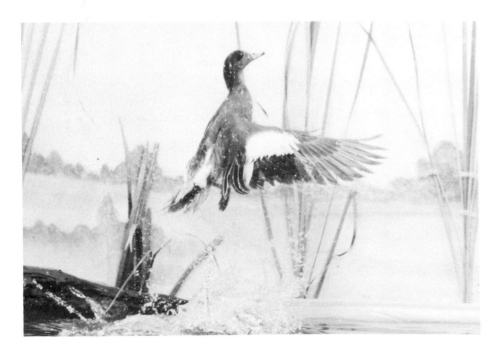

The wings are at full extension on the forward downstroke.

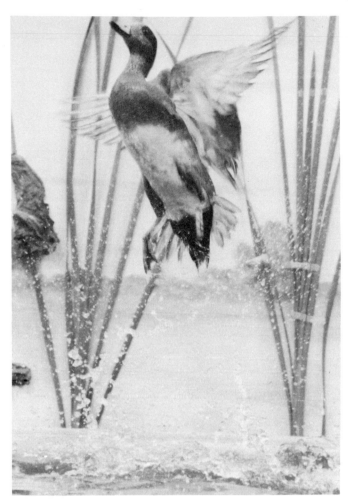

To minimize the drag of the wing on the upstroke, the elbows are raised behind the back with the primaries still bent downward from the wrists. As the primaries are raised, they vane open to let the air pass through. The primaries are almost raised in this picture. Notice how the primaries as a group are angled up to minimize the amount of drag and air that has to pass through.

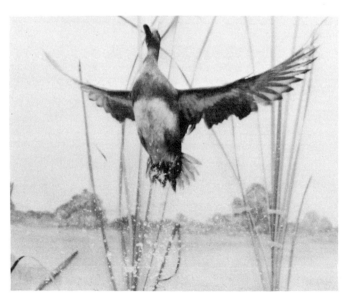

After lifting the primaries and completing the vaning, the wing is extended.

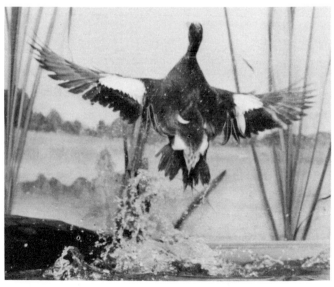

Wings are extended for the powerful downstroke.

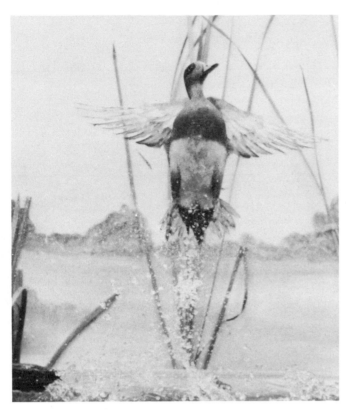

The backstroke from different angles, check these with the same attitude taken from above.

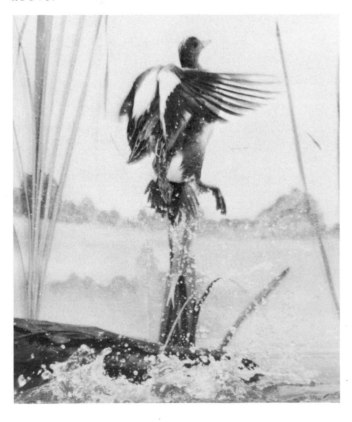

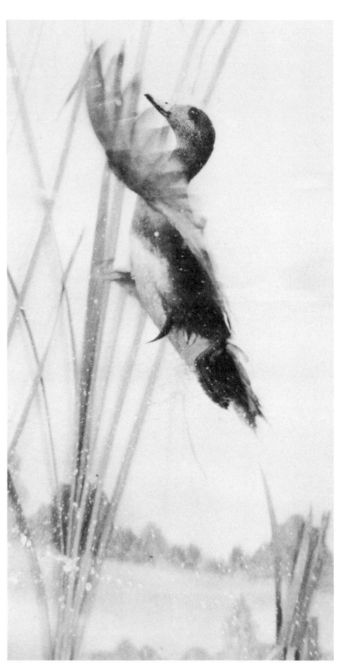

The power and speed of the downstroke bends the tips of the primaries and twists the wing.

The launch from above.

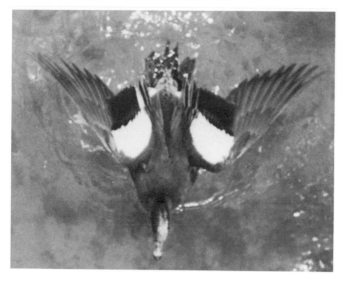

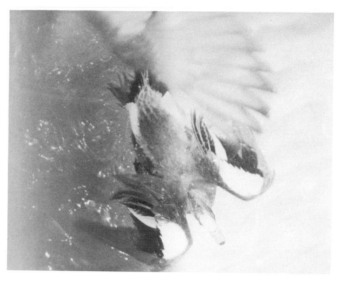

The wings are brought out of the sidepockets at the first signs of danger.

The wings are still folded at the wrists and the duck is reaching forward to grab the water.

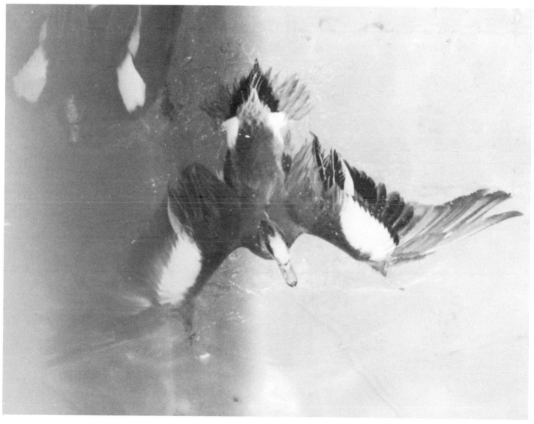

The primaries and the thumbs (alula) are extended. The bent area of the wing is being inserted down into the water.

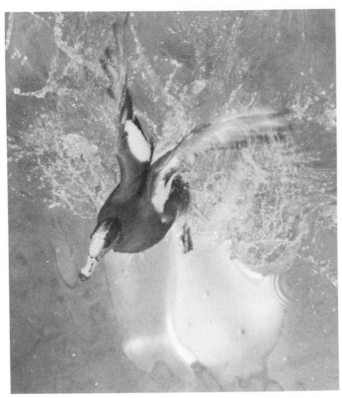

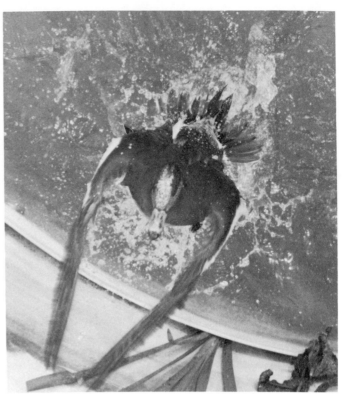

The power thrust leaves the water splashing in the direction of the force with the indentation created by the wings still apparent. This first thrust ends with the wings behind the back and ready for the first stroke which will be a forward-reaching downstroke.

The wings at full extension forward, compare this to the previous side view of the same action. The water is being pulled up with the action. It is common to have water splashing up to four or five feet above the surface.

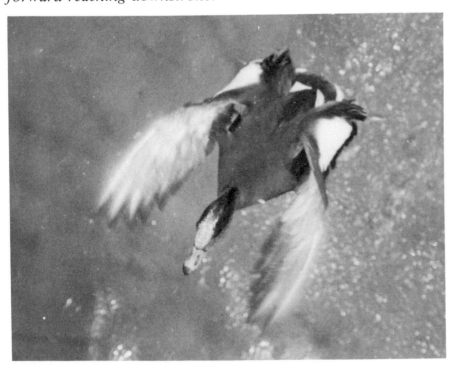

The elbows are nearing the completion of the backstroke with the wrists being brought back. The primaries are starting to vane open. The leading edge of the primaries are normally up in this action.

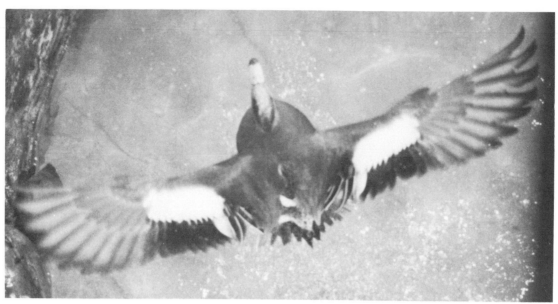

The full extension of the wing can accurately be measured by using the known width of the bill.

PINTAIL HEN

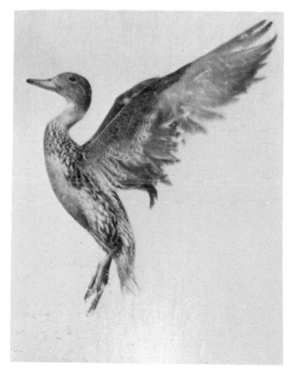

Pintail hen in a classic attitude with raised wings as she takes off.

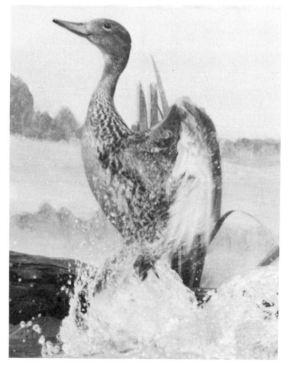

The first stroke is made by raising the wrists above the body with the wing still folded. The wing is starting to vane or open the primaries to reduce the opposing force of the upward movement.

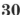

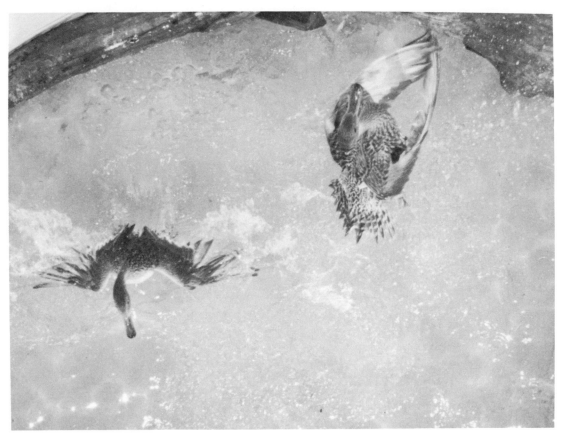

Two Pintail hens launch into the air. These pictures were taken at the same time using two cameras.

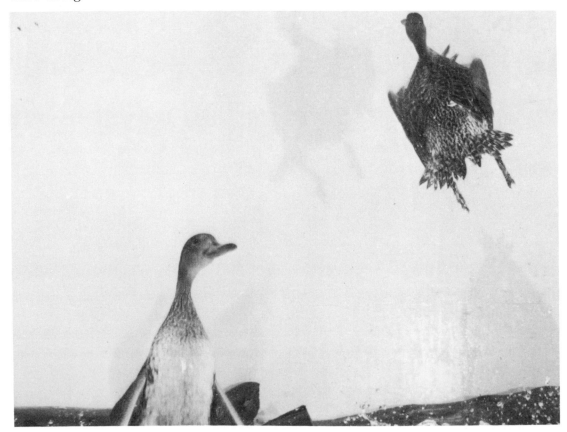

From above.

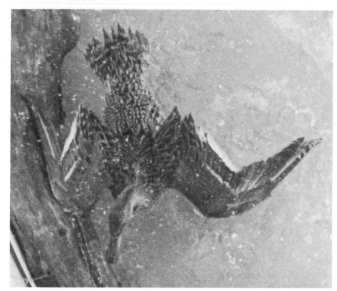

Pintail hen extends her semifolded wings and thrust them into the water. The log was in the way, but is used to push from just the same as the water. The angle of the wings is almost identical to that of the Wigeon drake in the same action (see bottom of page 27).

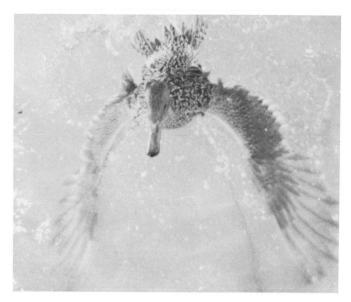

The forward downstroke.

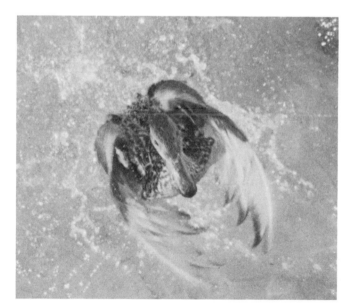

The primaries are just starting to bend as they vane open on the backstroke.

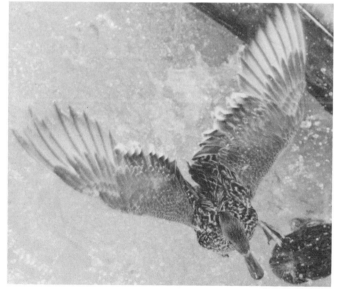

The wings are being extended after the primaries have completed the movement to the back. The dark feathers in the center are the scapulars (angling back and out), and the tertials (angling inward at the rear).

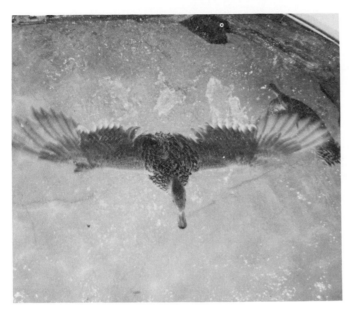

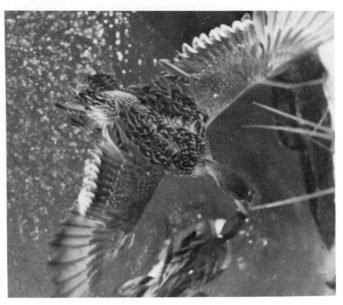

Extension is completed and the wings start their down and forward movement.

The violence of the strokes diminish, and the angle of the body starts to flatten as liftoff is completed.

IN THE AIR

Once in level flight, the head is usually lower than the shoulders. Most diving ducks exhibit this characteristic—especially so with the Canvasbacks, which have a rakish jet-fighter appearance in their attitude. It was a Canvasback female that gave me one of my most thrilling moments during my study of ducks.

I have permits allowing me to take pictures of ducks that are trapped by the Illinois Department of Conservation. The IDOC stipulated that I could hold the birds for only a short time and then had to release them to the wild. After I had taken pictures of several Canvasbacks, I loaded them in a carrying box and took them down to the river to release them. The last one to be released was a beautiful female Canvasback. She was one of the prettiest ducks that I had ever worked with. As soon as I set her free, she started out over the river and as I watched she made a big circle about a half mile in diameter. She flew in this big arc and then came right back at me at full speed. When she was within 15 or 20 feet of me, she peeled off and up, just like a jet in the movies. It was as if she were saying good-bye. I know better than to believe that, but it was nice to think that she had saluted me in some way. It sent shivers down my spine and was as exciting as anything I had ever witnessed. In all probability, she was only getting her bearings but it sure thrilled me.

IN FLIGHT

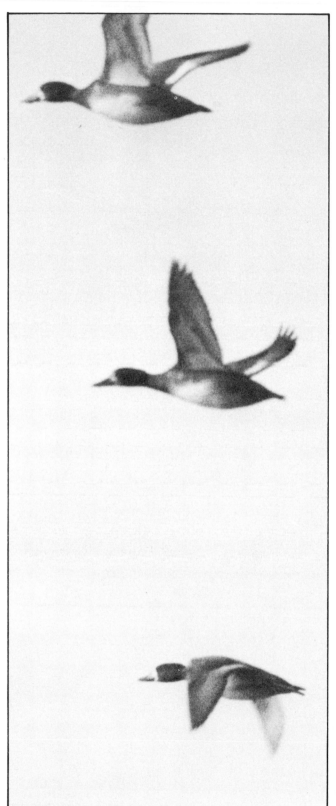

Lesser Scaup hens (Bluebills).

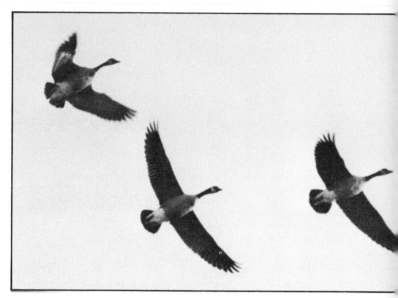

A trio of honkers—Canada geese.

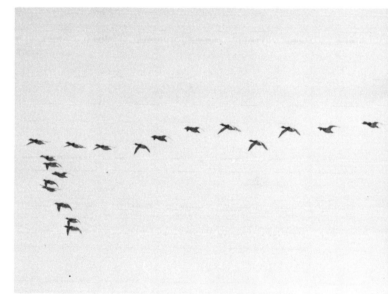

Canvasbacks have a distinctive flock formation.

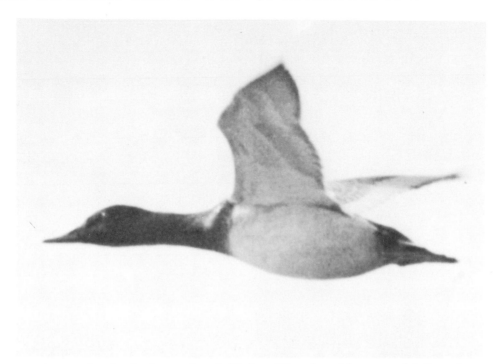

A Canvasback drake in level flight. The shoulders are higher than the head. The bulbous belly toward the rear is a diver distinction, as are the large feet seen trailing beyond the tail in this picture.

COMING DOWN

Most species of ducks will circle an area several times until they decide it is safe to land. As they pass over a particular area they crane their necks back and forth looking for possible danger. If there are feeding ducks on the water, the decision to land is much quicker, for the safety has been checked by the first to land. These traits are the reasons for the original use of the decoys by the Indians. Some species are naturally very nervous and will circle for some time before landing. Once the decision is made to land, the wings are set and the duck starts in a sailing attitude. During the sailing, the wings are held very rigid and the primaries are angled back slightly and in this position they are a very rigid structure. The tips of the primaries in this position rarely twist or bend due to the stacking of the more rigid feathers. The body remains at an angle to retain some of the lifting force and braking as the wings control the descent. During the landing descent, the wings swing in a back-and-forth manner creating less lift than the wing action during takeoff. This action is almost parallel with the landing surface and helps control the forward motion along with the lowering movement.

The feet are used as ballast for balance as well as creating drag to slow down the motion. This is especially true of the divers. I cannot

remember seeing a puddle duck landing or sailing in to land, where the body was angling down unless it had lost balance. This can happen momentarily, but attitude is quickly regained or a crash landing is in store for them. Divers land at a faster forward speed and they may assume a slight down posture for a second or two but the body will angle upward as the duck approaches the water. A very similar angle is assumed by *all* birds as they land. I am still checking on the angles of takeoff and landing but have found closeness in all—especially landing. Takeoff depends on the surrounding area or the elevation of the lift-off.

Once the decision is made to descend, the duck stares at the area chosen and keeps its eyes on that spot until it lands. If the duck is spooked during this time of landing, its natural reaction, to flare from danger, takes over and yet it may continue staring at the landing area. This is one of the times that you may see the bill still angling down and yet the duck has assumed a lifting attitude.

The head attitude of ducks is usually in an upright position, regardless of the other movements of the duck. It would be similar to a gyroscope. If you have ever witnessed a Wood Duck twisting through the trees and dropping into the water, you will know what I mean about the head being held upright. As the Wood Duck goes through these wild gyrations, the head remains virtually straight up and down. All species of waterfowl keep their heads in an upright position throughout any aerial maneuver. It is rare for the head to be tilted when flying except for observation during a pass over a potential landing area or some movement it might detect from the air. If you can find some local ducks at a pond, watch them as they take off or land. Watch for the details of how they do it—not to see how pretty they are.

WATERFOWL COMING DOWN

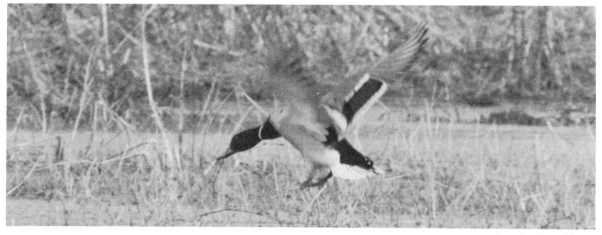

Mallard drake stares at the landing spot until the splashdown.

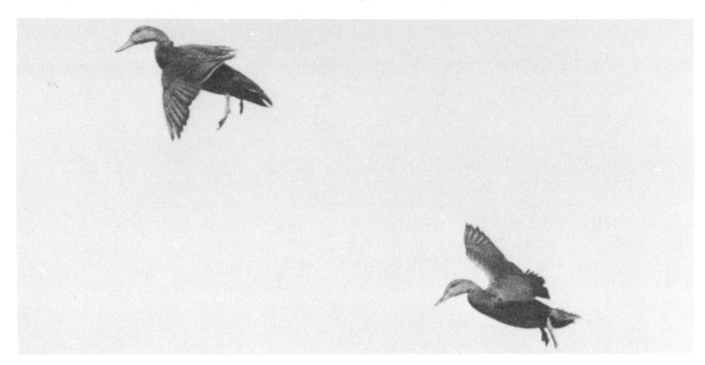

A pair of Black Ducks sailing in after picking out a landing spot. Note the feet spread for balance and braking. The male is on the left. The female has dark saddle on the ridge of the bill.

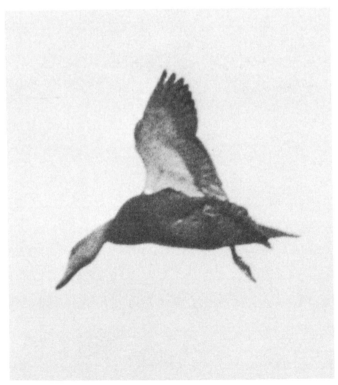

Black Duck drake getting ready for the descending strokes.

WING ATTITUDE

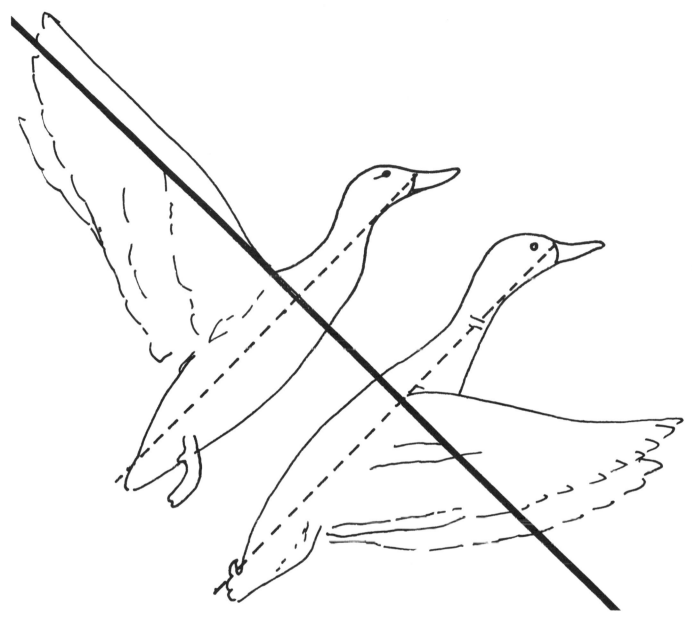

To rise from the water, a duck needs the lifting force resulting in a downward movement of the air. This is accomplished with the actions of the backstroke staying on an axis at right angles to the body centerline (approximate). The downstroke reaches forward from this line.

ON THE WATER

A duck's shape on the water is also determined by attitude or action. It can even change with weather conditions. Under normal conditions though, ducks spend most of their time on the surface of the water. If they are relaxed, they are fluffy and buoyant; they will ride high in the water. This fluffiness accounts for its greater buoyancy, which is controlled by the air trapped in the many layers of feathers. If a duck is nervous or faced with extreme weather conditions, its feathers will be pulled in tightly creating less buoyancy. Thus, it will ride very low in the water.

I have observed a Canada Goose submerged except for part of its head and bill. In this sunken attitude, he swam over 75 yards without the body going up or down in the water. He also zigzagged the bill as it went through the water, giving the impression of a snake's movement. How it was able to control this partially submerged attitude is one of those mysteries I probably will never be able to understand, but I saw it happen.

The wings are protected at all times while on the water. By being able to fold the long extremities, and place them in a down-lined pocket, covered with large feathers on the side and top, only the tips of the wings are visible. The tips (primaries) of the wings are stacked and are of such a tight-knit construction that they are impervious to weather. Therefore, even in the most severe weather conditions, the wings are always safe and dry, ready for flight at any time.

There are certain axioms that I have devised for understanding some of the duck's shape. These axioms might help you:

- In a rest attitude, half of the bill usually extends beyond the breast.
- The breast arches from the throat down to the waterline; it rarely bulges.
- The throat will be behind the eye (vertically).
- The hindmost part of the head will be behind the throat.
- The shoulders will start in the center of the neck area.
- The highest part of the body, except for the primaries, will center between the breast and tail.
- The speculum rarely shows on a swimming duck. If it does, it will start approximately in the center.
- The tail angles up on most puddle ducks with the undertail area extending farther to the rear than above.
- The primaries will point toward the widest area of the body. This is normally the area created by the sidepocket feathers pushed out by the folded wing.
- From the front, the body starts angling in above the waterline and will round to the center of the back. The indentation of the top of the side pocket and the shoulders will come within those confines.

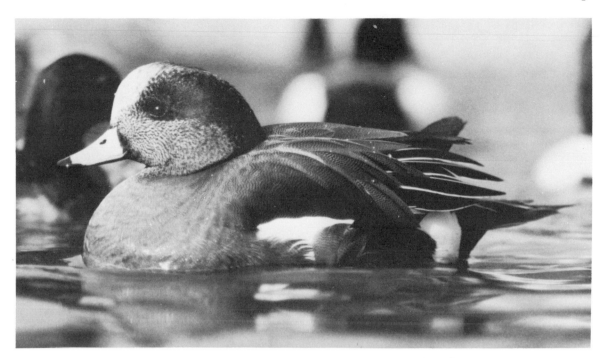

Wigeon drake. The pocket is wet and being pushed down by the wing.

Wigeon hen. The lighter area above the pocket is part of the wing. This area shows frequently on both the drake and hen Wigeon on the water.

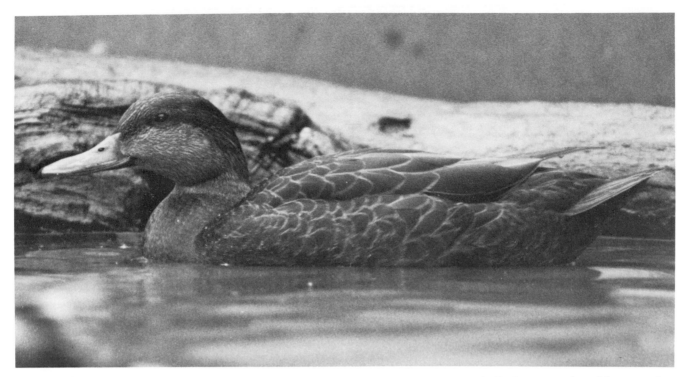

Black Duck drake. Check the angles of the feathers as well as the bill, breast, shoulder, and tail.

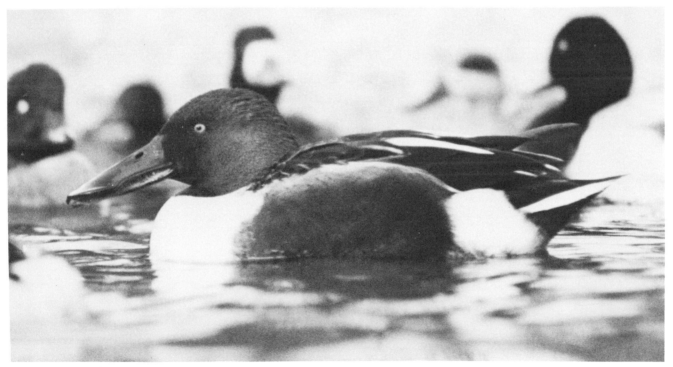

Shoveler drake. Floating high, the sidepocket area is much higher on Shoveler and Blue-winged Teal drakes than the other puddle ducks.

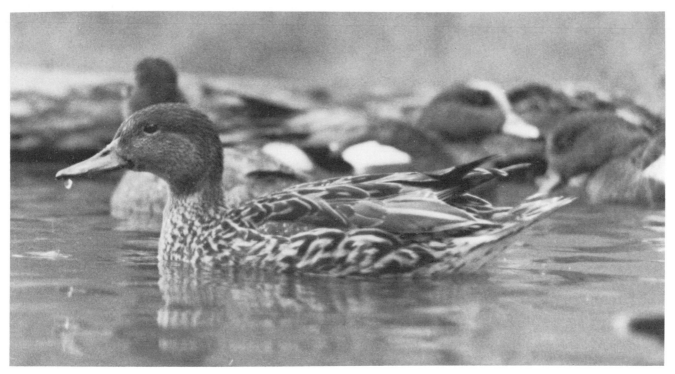

Pintail hen. Check the side against the Shoveler.

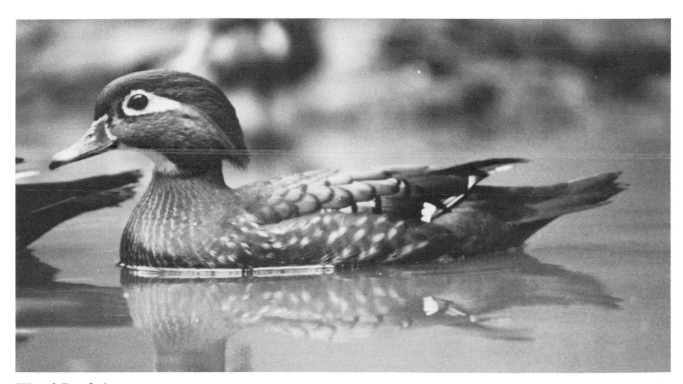

Wood Duck hen.

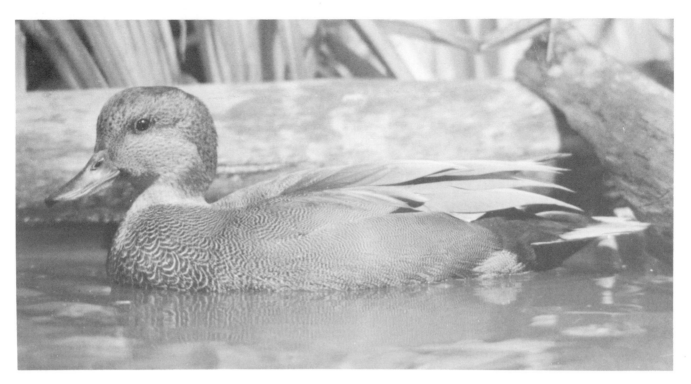

Gadwall drake. Nicknamed the gray duck, it blends with the surroundings even at close range.

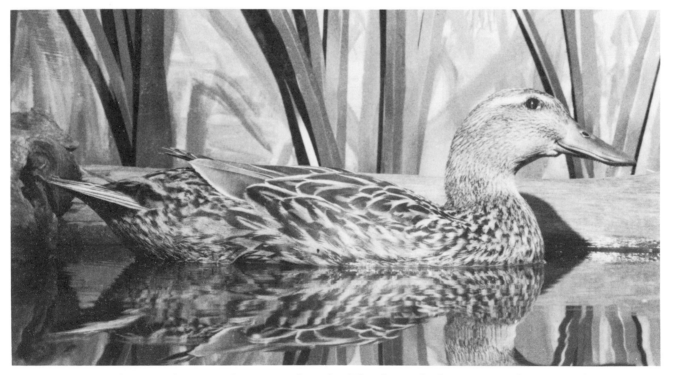

Mallard hen. This is a barnyard variety female. The long deck or space between the end of the tertials and the tail is the attitude indicator. Check the angles of the feathers on the body.

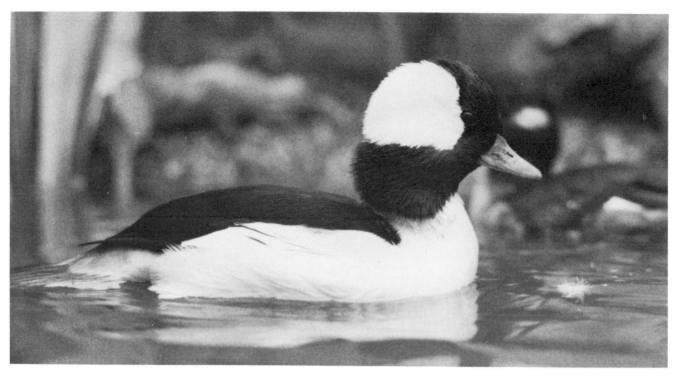

Bufflehead drake. The tail lies flat on the water and is used as a rudder except when at ease.

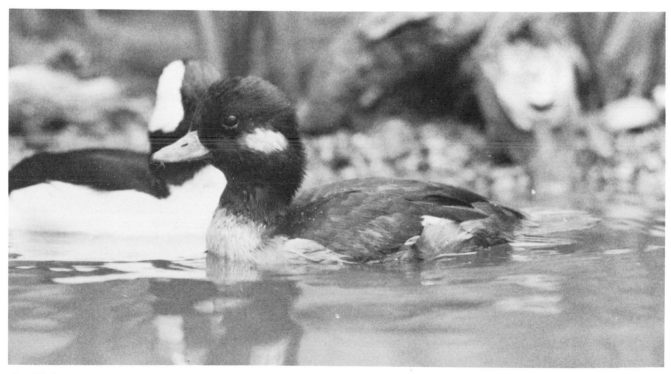

Bufflehead hen. Having finished with her bath she is more concerned with the photographer than the sidepocket being out of place.

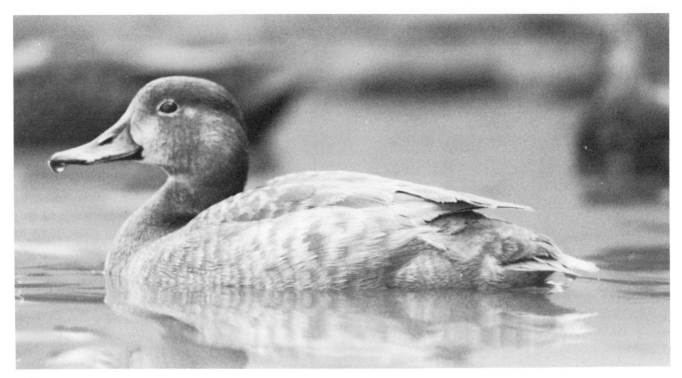

Redhead hen.

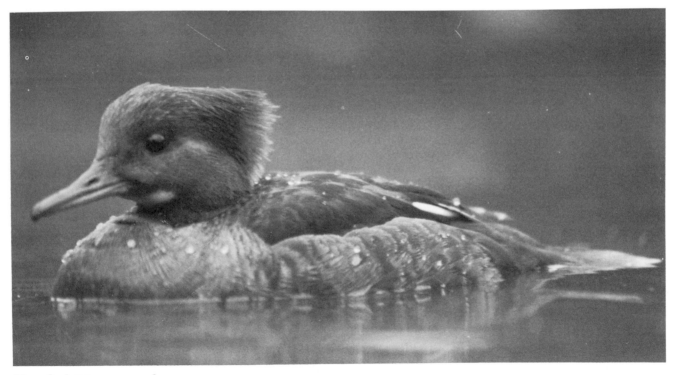

Hooded Merganser hen.

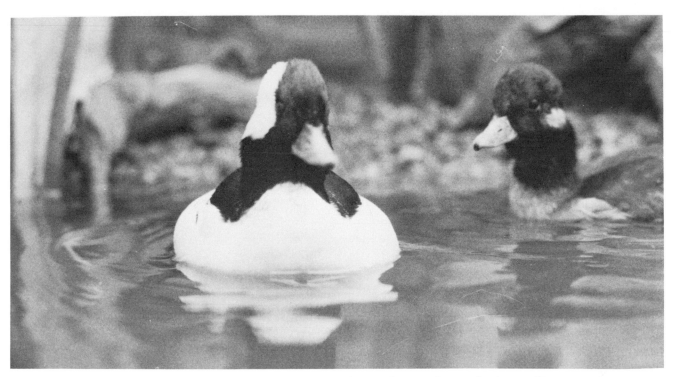

Bufflehead drake. This front view shows the body angles in from the waterline.

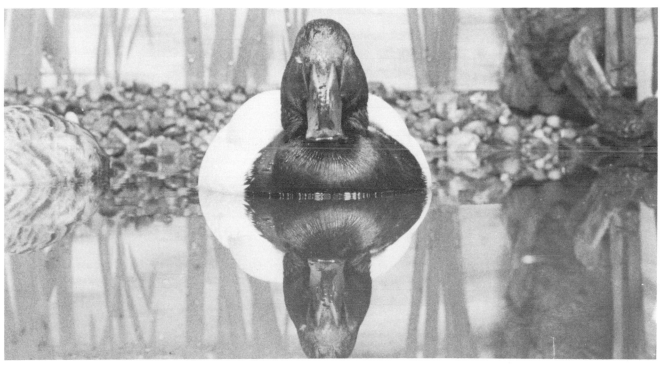

Canvasback drake. Resting with his eyes closed, he is twice as wide as he is high at the back (from waterline).

ON LAND

Although ducks spend most of their time on water, they enjoy preening and resting on land whenever safety permits. This would apply more to the puddle ducks than the divers, but both types thrown into the same situation seem to be similar in their actions. The shape is determined by attitude and nervousness regardless of what the duck is doing. The pictures in this attitude are self-explanatory.

Blue-winged Teal at ease with the surroundings being safe, he is comfortable and relaxed.

Blue-winged Teal drake in a nervous or excited attitude. Same size as the duck in the previous picture, but the feathers are pulled in. The wing is emerging from the sidepocket. The angle of the head indicates that he is just about ready to jump. The bill is elevated as an indicator to this attitude.

Wood Duck drakes. Alert but not scared, the white line of feathers from the bill up over the eye, show entirely on the bird at left. The duck on the right is nervous, the head is raised, bill lifted, and crown lowered some over the same line of feathers. The lower line of white feathers is starting to curl at the back of neck. When the duck is frightened, the crown and crest are compressed.

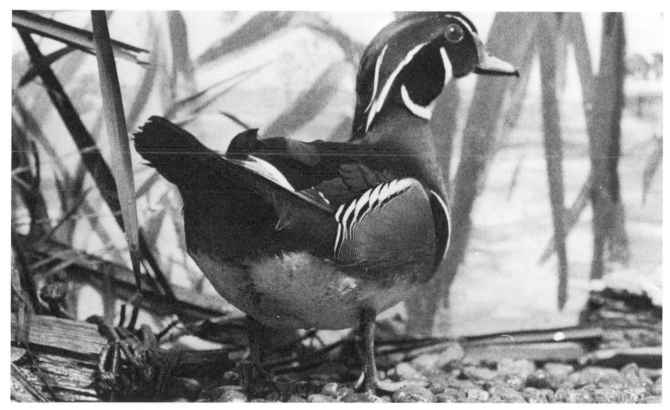

"Woody" drake from the back.

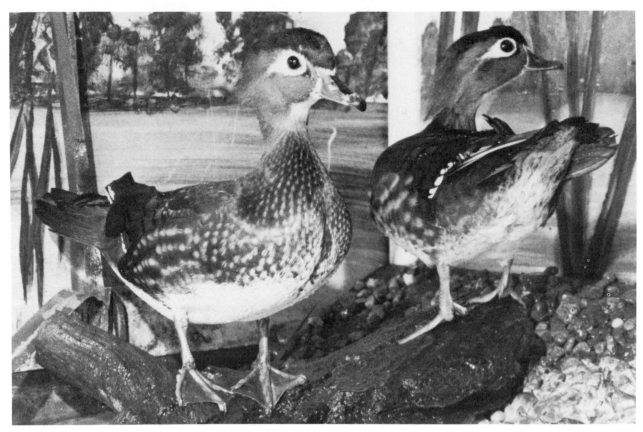

Wood Duck hens. Naturally nervous and alert most of the time, the hen on the right is more excited than the one on the left. The bill is up and the crest down. The breast feathers are wet on the hen on left and they have separated into the left and right sets. Notice the different angles to the sets of feathers.

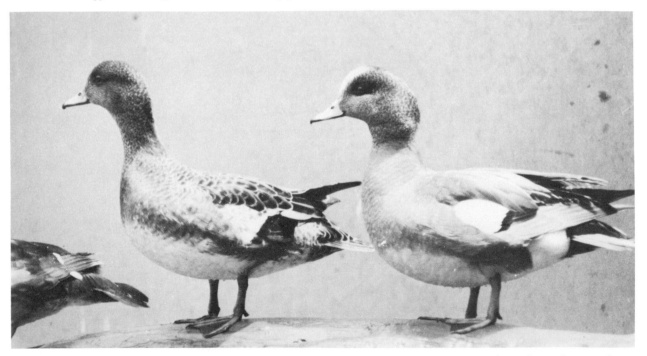

A Wigeon pair. The drake has lowered the primaries of his wings and pushes the pocket down and out. His feathers on the breast and neck show up as rowlike. The hen has not lowered the primaries, but has pushed the lower edge of the folded wing outward.

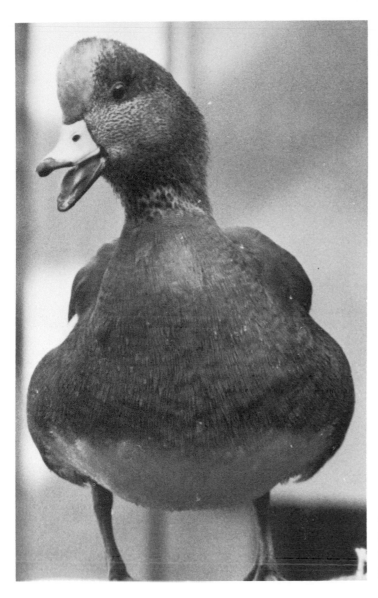

An excited Wigeon drake (the forehead is the indicator). The body shape of a Wigeon usually has more extreme bulges except at rest or flight.

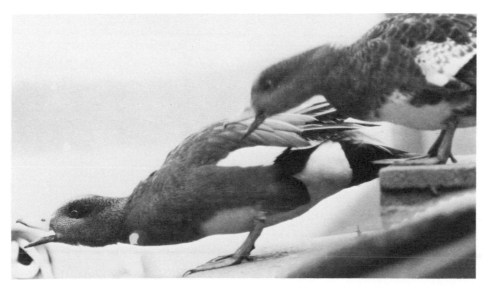

Wigeon pair. Wigeons are more aggressive than other ducks and he is warning others to stay away. She joins in to make sure the others get the message.

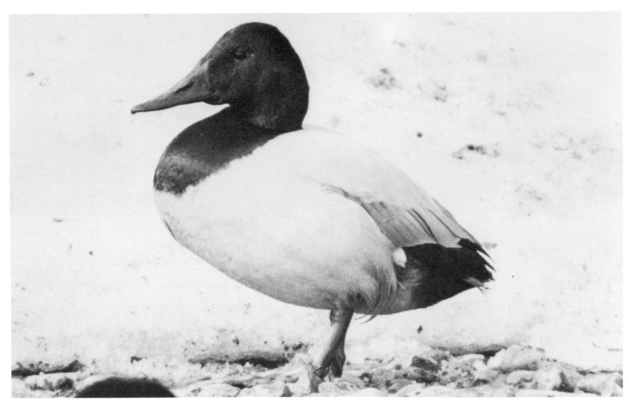

Canvasback drake. This is a normal diver stance once the bird has reaquainted itself with walking. When first out of the water, it will walk more erect until it gets its land legs. Notice the angles and position of legs and extension of the bill in front of the breast. The back of the head is near the center and above foot pad.

Canvasback drake. Having been recently caught and newly released into a pen, the stance is very upright for the first few hours. The pocket feathers of the side show as rowlike on divers.

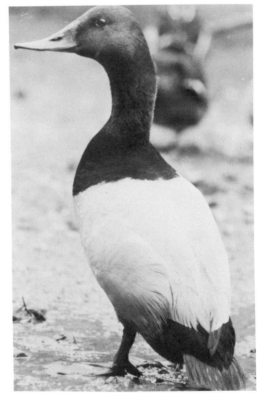

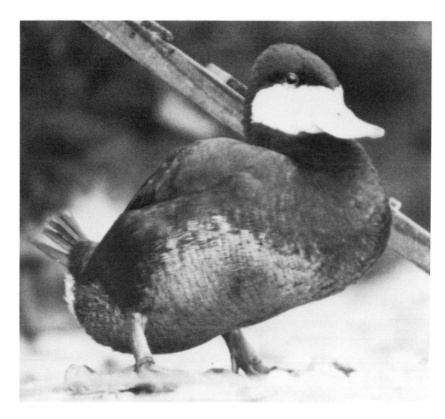

Ruddy Duck drake. Ruddys are the most awkward ducks on land. With their huge feet and their legs positioned far to the rear, they spend little time on land because balance is hard to maintain. This particular drake was a tame bird and able to walk but not without some degree of difficulty.

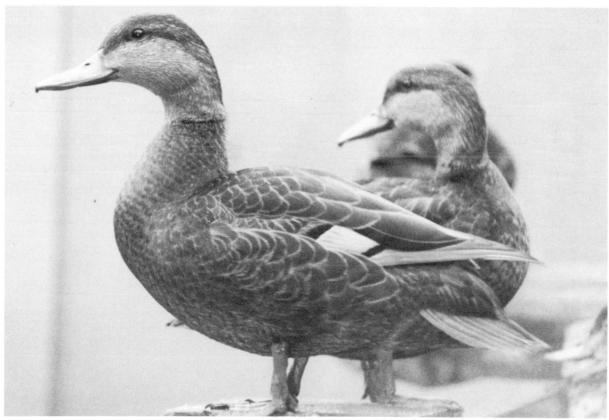

Black Duck drake. A classic pose, the pocket is lower on a standing duck, permitting the speculum and part of the wing to show. When swimming, the pressure forces the pocket up and normally covers the speculum.

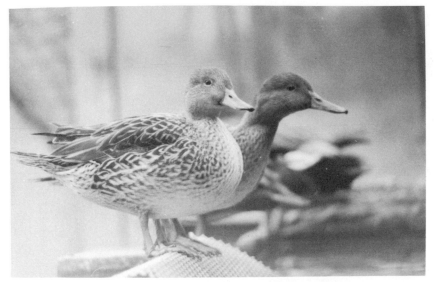

A pair of Pintail hens. At ease in this picture, they are the same hens that are in the sequence pictures of taking off. A real difference in shape when compared with this photo. They are standing on a mesh that was installed to aid the ducks as they climb from the water. Penned birds will continually butt the edges of the water tank and eventually soak and drown unless they can climb out of the water. They do not think of flying and going to another area unless spooked.

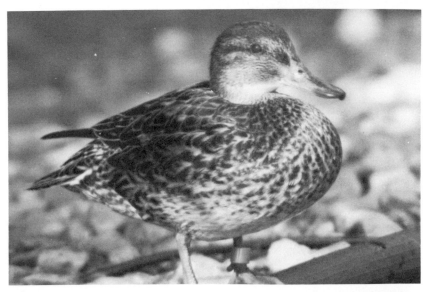

Green-winged Teal hen.

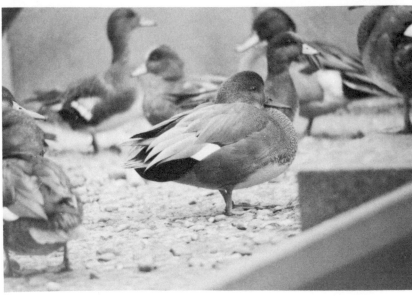

Gadwall drake.

BALANCE—THE KEY TO THE ONE LEGGED STANCE

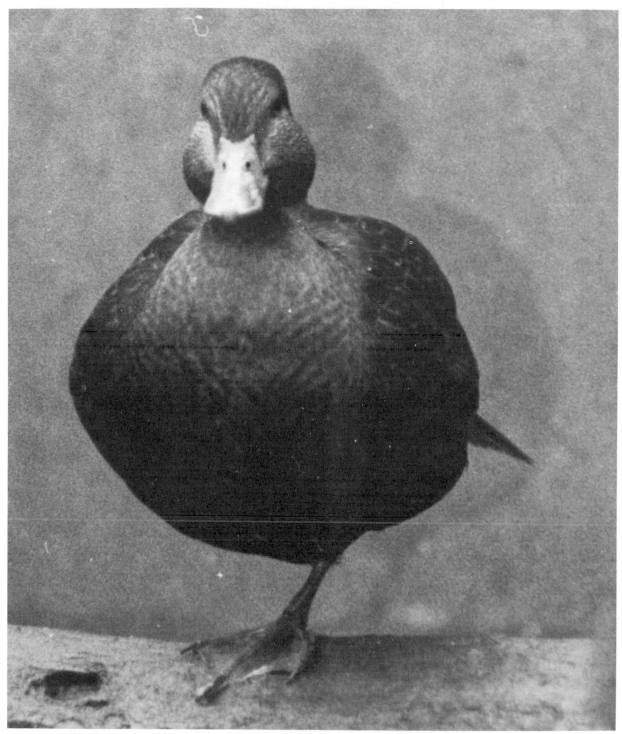

Black Duck drake. The pad of the foot will be at the center of gravity and the toes used to help the balance. Compare the rounded shape here to the front view of the Wigeon drake on page 49 (top).

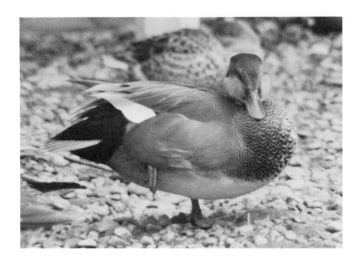
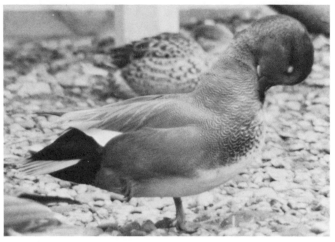

Gadwall drake. Standing on one foot with the other resting partially in the pocket with the wing, balance is maintained easily as he goes through the preening motions.

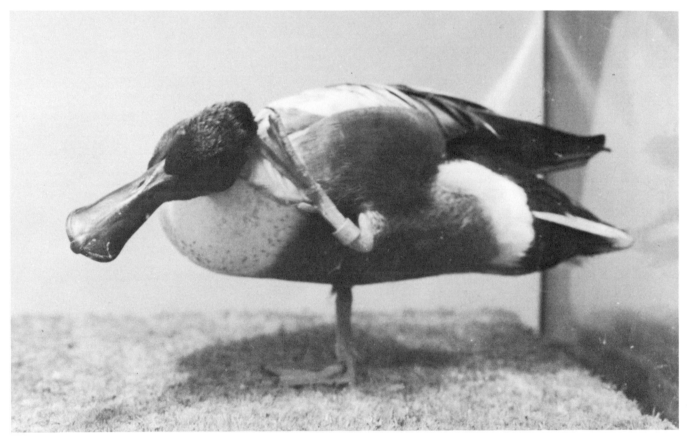

Shoveler drake. It itches, so he scratches. Ducks scratch their heads frequently. The pocket feathers are being pushed out by the leg at the bottom. This is close to the extreme forward opening of the bottom rear edge of the pocket. It is this lower region that shows as an indentation when landing or taking off.

SLEEPING

Most birds turn their heads around to the rear and stick their beaks under feathers when they sleep. This is normal when they really intend to roost for the night. Ducks like to rest in this attitude regardless of duration, but it will only happen when they are sure of safety. They would have a difficult time putting their head or bill under the wing as the popular assumption leads us to believe. The bill is inserted under the scapular feathers of the back.

As a duck twists its neck, creating an S shape, the feathers of the breast bunch together and bulge, creating an indentation in the center of the breast. The largest bulge does not house the neck at all in this attitude. The larger protuberance of the breast will be on the same side that the bill angles toward. There are four axioms for the sleeping position; the first was mentioned above (which side has the largest bulge). The second axiom: the eye will be level with the highest point of the back feathers (except in extreme cases). Number three: the bill will point toward the rear of the sidepocket on the side it is inserted on. The fourth: the rear of the head, actually the forward part, will start behind the breast (vertical line).

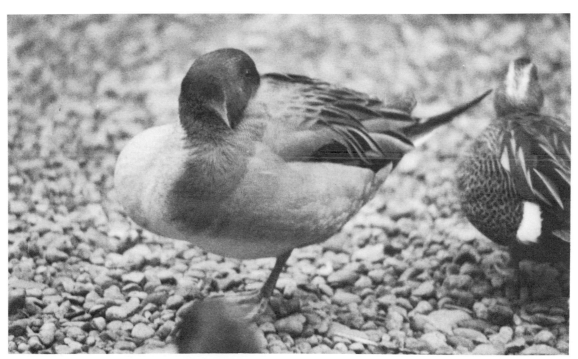

Pintail drake. Balancing on one foot, the neck is twisted around and the bill is inserted under the scapulars. The twist of the neck is apparent in this picture and resembles an S shape. The large bulge on the opposite side of the breast is caused by the bunching of the longer breast feathers being displaced by the shape of the neck in this contortion. The eye is level with the top of the back in a sleeping position.

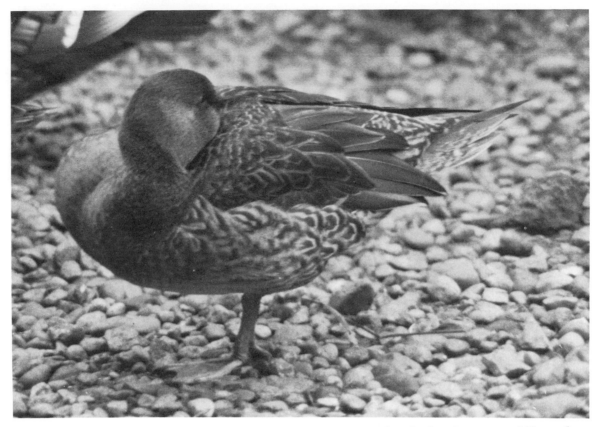

Pintail hen. Check this picture against the one with the drake (on page 55) and compare similarities. This particular hen was a pinioned bird. Without the primaries of the left wing, the tertials fall in an odd attitude.

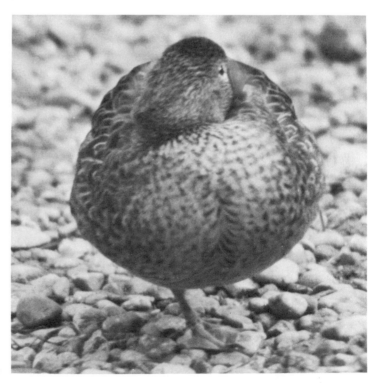

Blue-winged Teal hen. The overall body shape remains round even in this position.

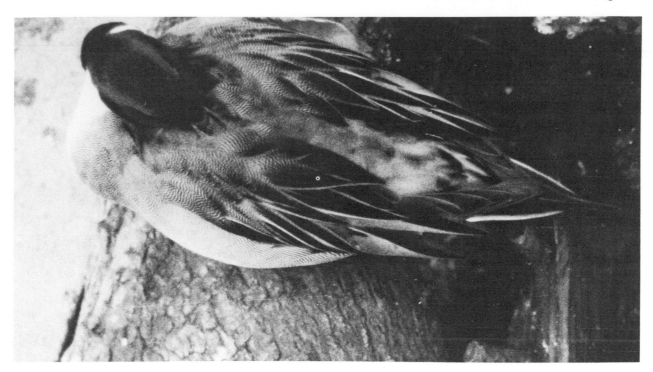

Pintail drake. The bill angles toward the rear of the opposite side pocket. The largest bulge on the front of the breast will be on the same side the bill is pointed toward. The wings are lowered in this picture allowing the tertials to slip to the sides more than usual.

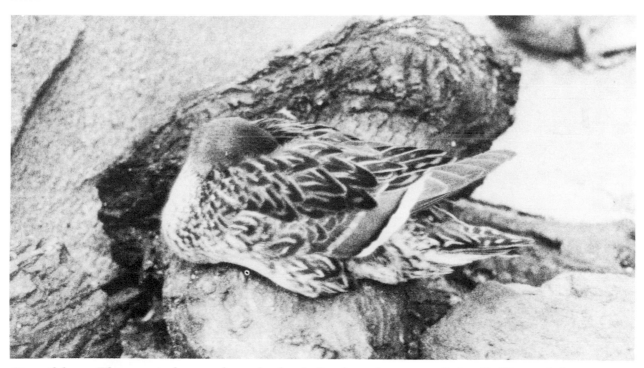

Pintail hen. The eye is lower than the back feathers because of the fluffing of the feathers. The body feathers contour to the log that she is resting on.

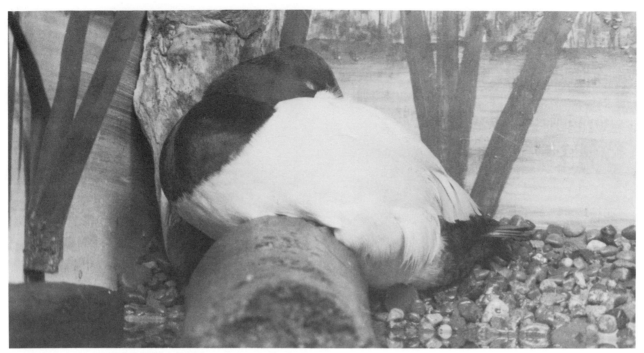

Canvasback drake. The feathers are so long on the lower body regions that it allows complete hiding of the huge feet. The body under the feathers has a keel bone that cannot give, but the feathers wrapping around the log give the impression of it doing so. The head angles back from the breast in this centerline view.

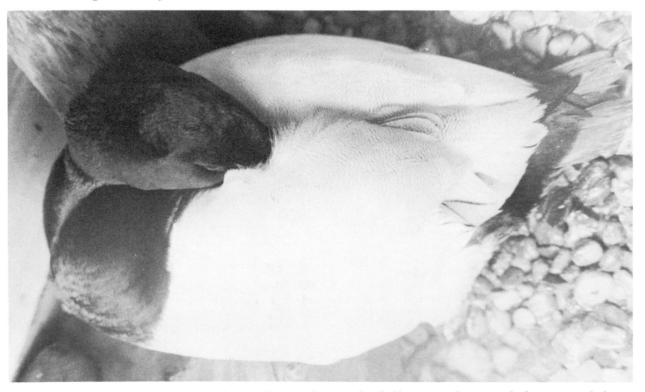

Canvasback drake. This view from above shows the bill pointed toward the rear of the opposite side pocket, the same as puddle ducks.

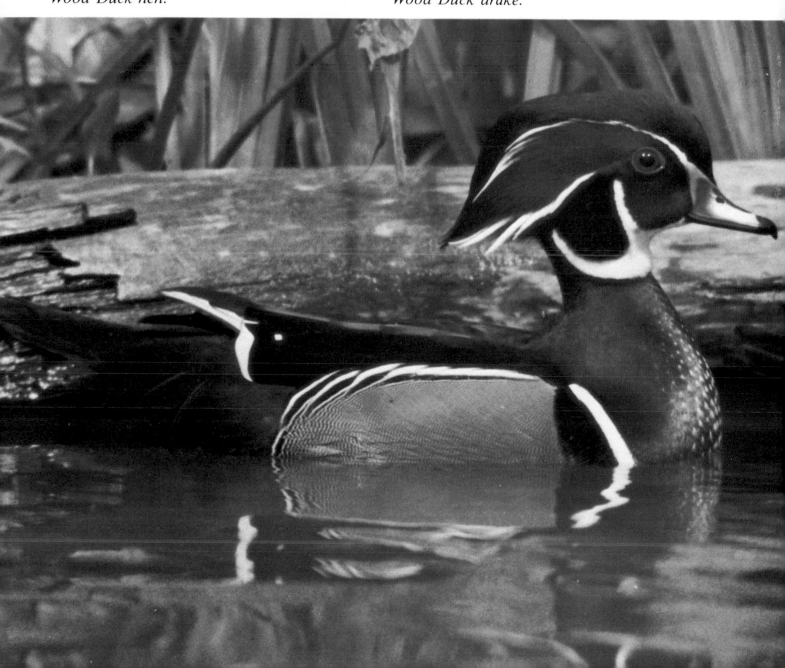

Wood Duck hen. Wood Duck drake.

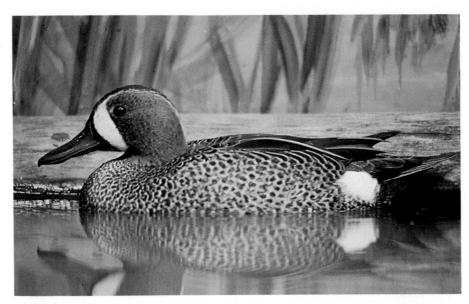

Blue-winged Teal drake.

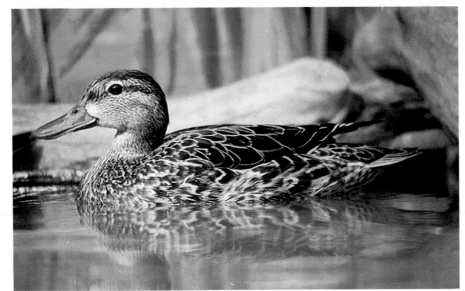

Blue-winged Teal hen.

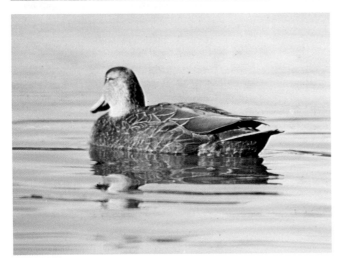

Black Duck.

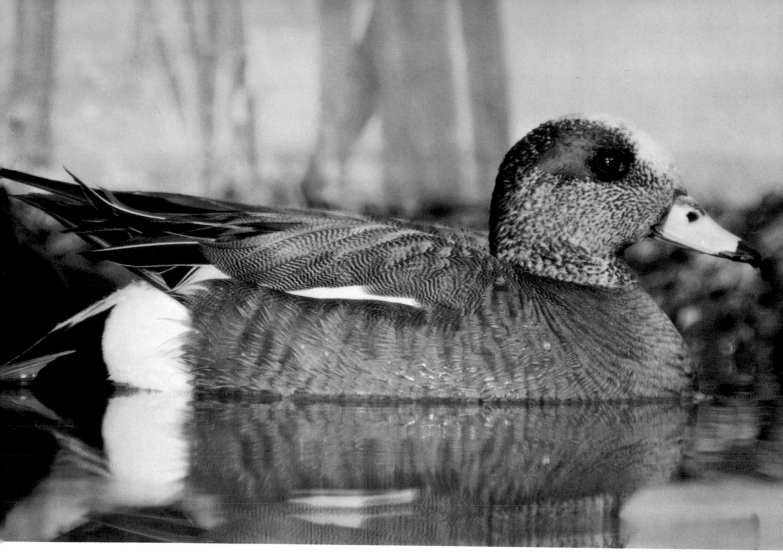

Wigeon drake.

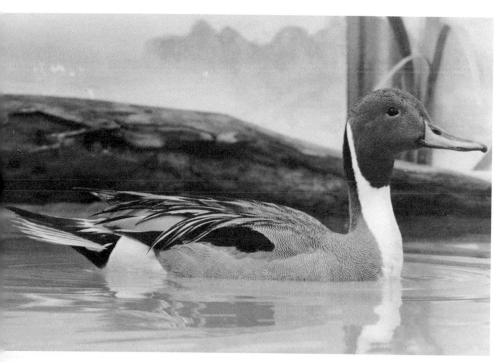

Pintail drake.

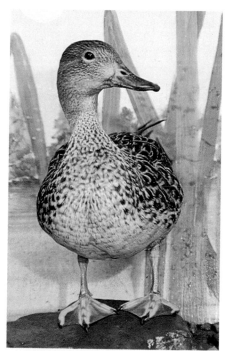

Pintail hen.

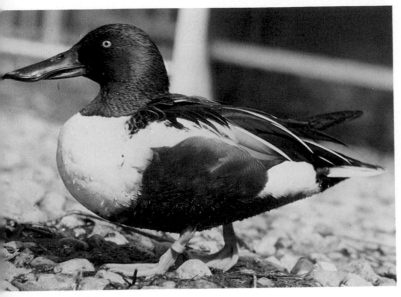

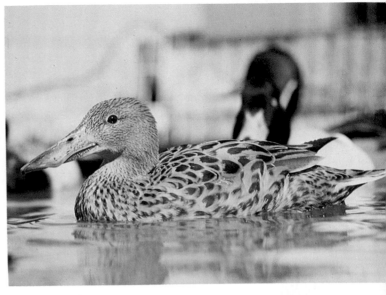

Shoveler drake.

Shoveler hen.

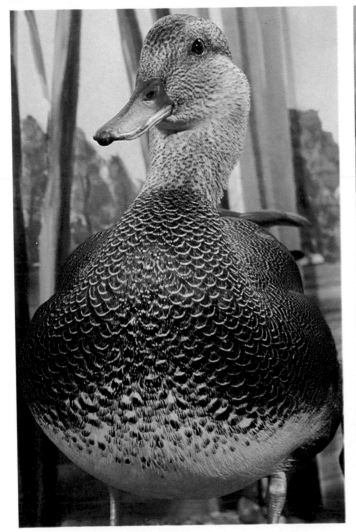

Gadwall drake. (Photo by Dick Etter.)

Gadwall hen.

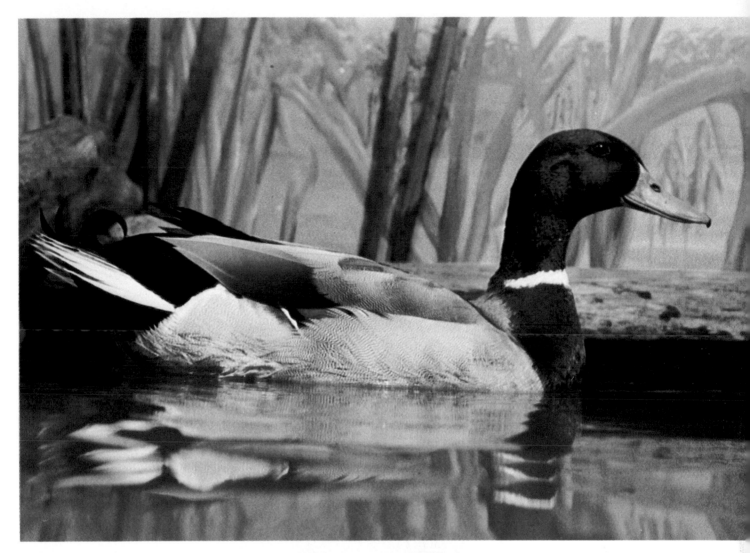

Mallard drake.

Mallard hen.

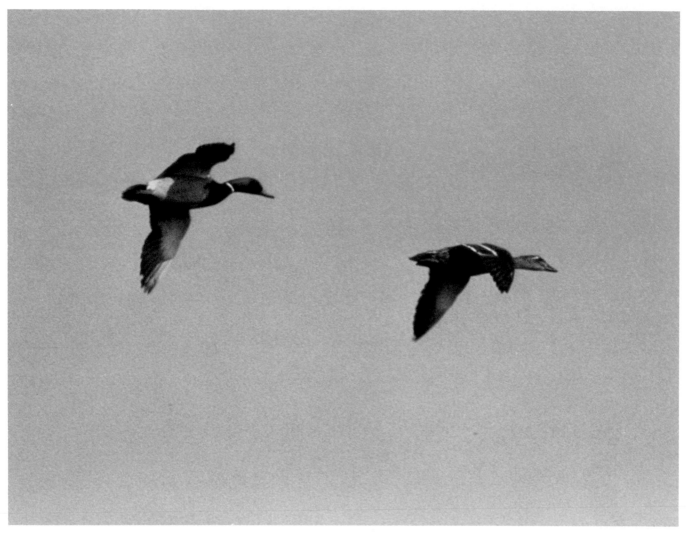

Mallard pair.

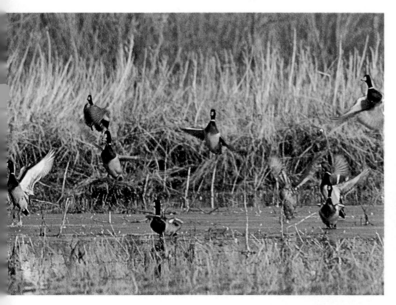

Mallards spooked by the camera clicking.

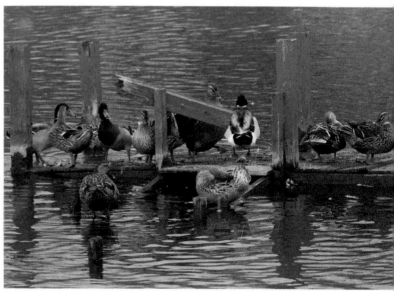

Semi-tame Mallards in a typical dock gathering.

Cinnamon Teal drake.

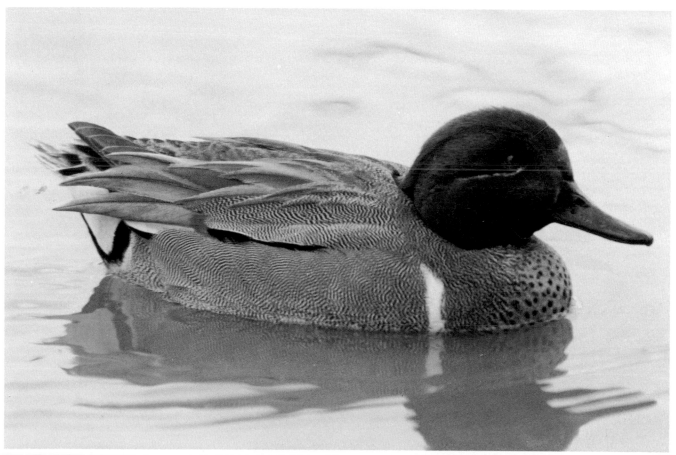

Green-winged Teal drake. (Photo by Bobby Castlebury.)

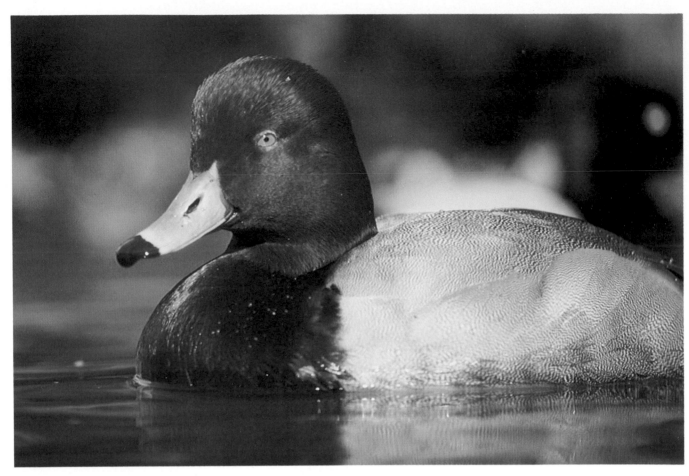

Redhead drake.

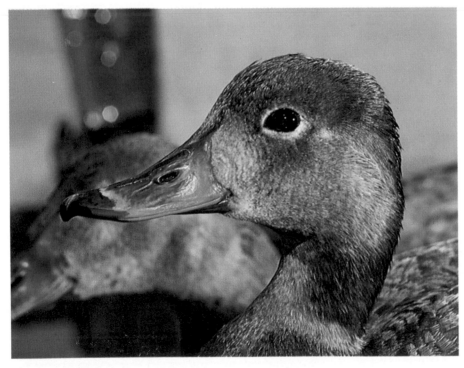

Redhead hen.

DIVER DUCKS

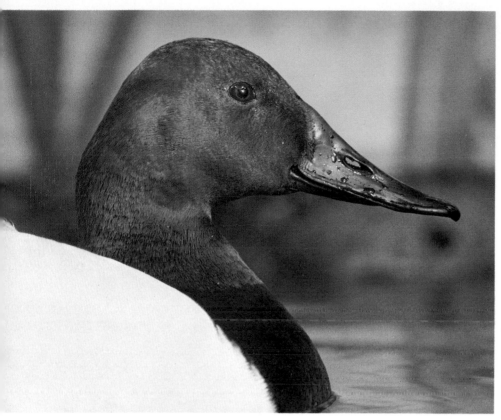

Canvasback drake.

Canvasback hen.

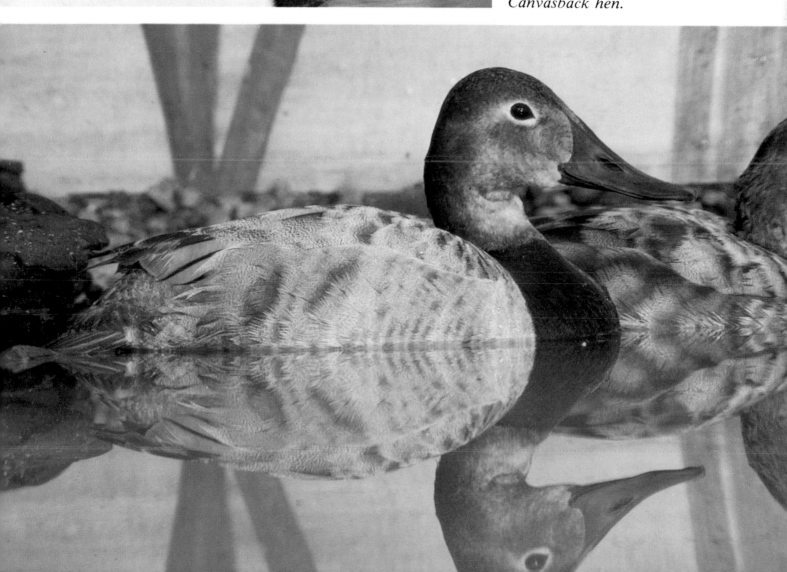

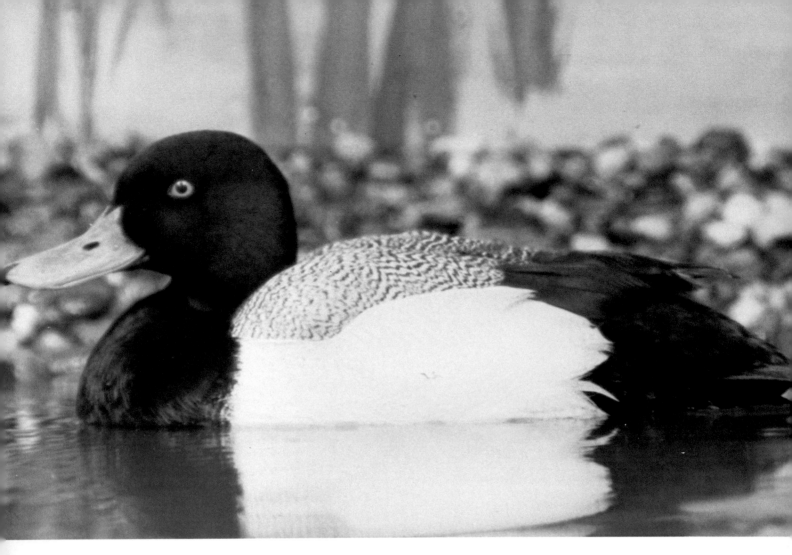

Lesser Scaup drake.

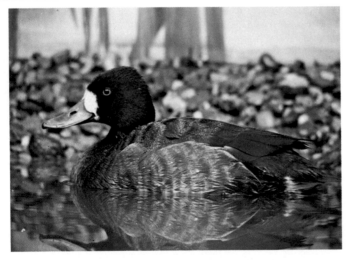

Lesser Scaup hen.

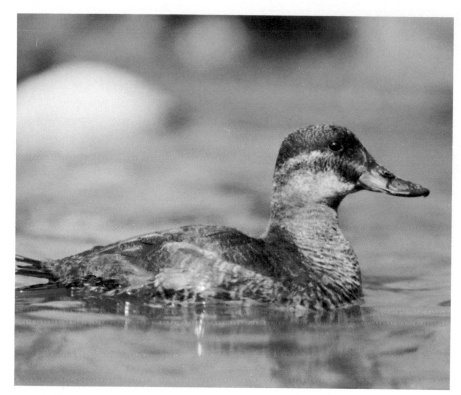

Ruddy Duck hen.

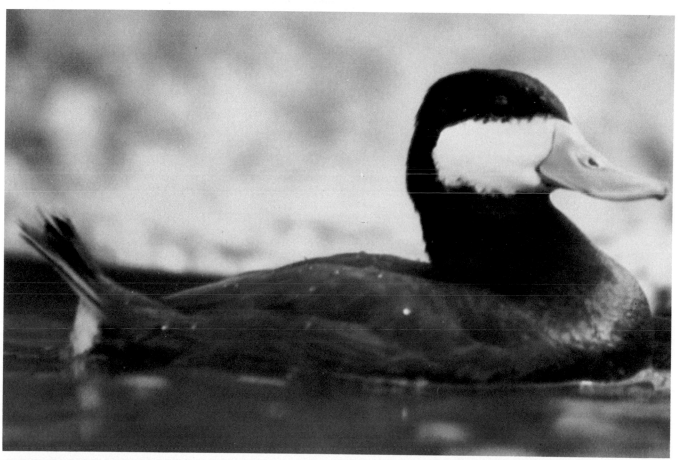

Ruddy Duck drake.

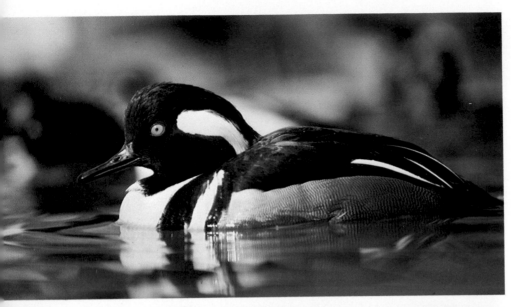

Hooded Merganser drake.

Hooded Merganser hen.

Goldeneye drake.

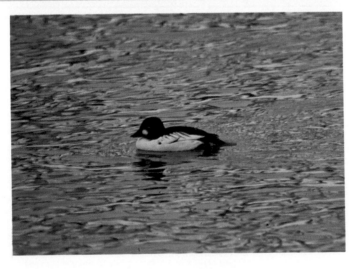

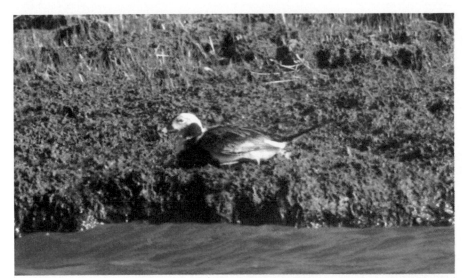

Oldsquaw drake.

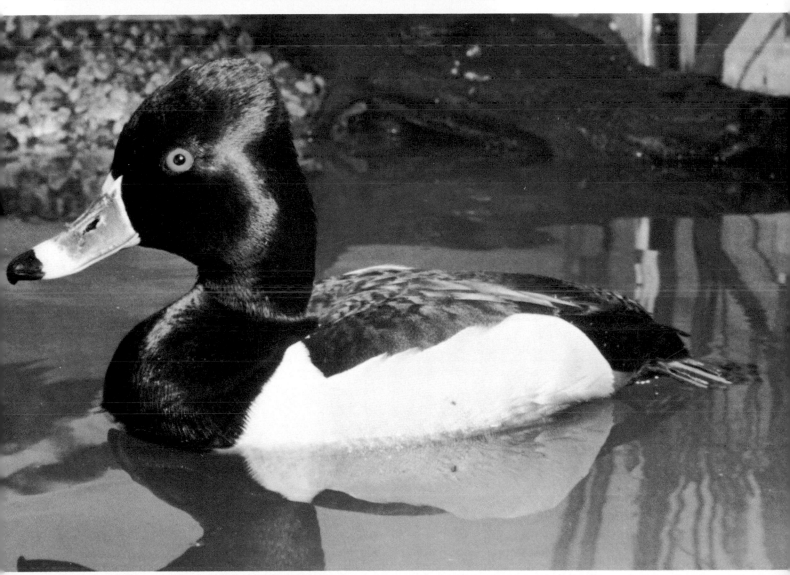

Ring-necked drake.

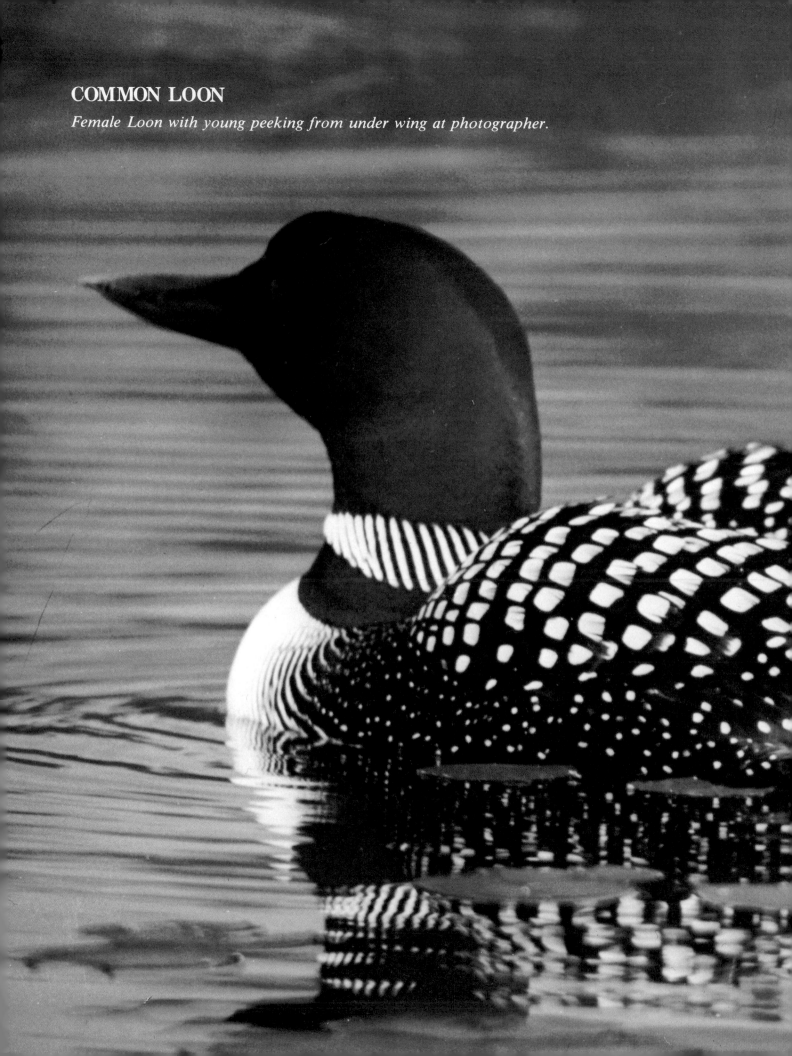

COMMON LOON
Female Loon with young peeking from under wing at photographer.

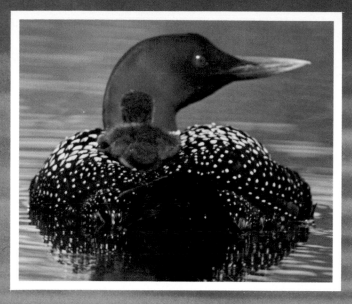

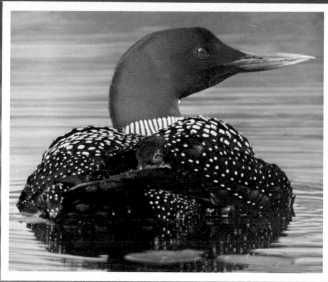

Hitch-hiker. (All loon photos by Woody Hagge.)

Safe under Mother's folded wing.

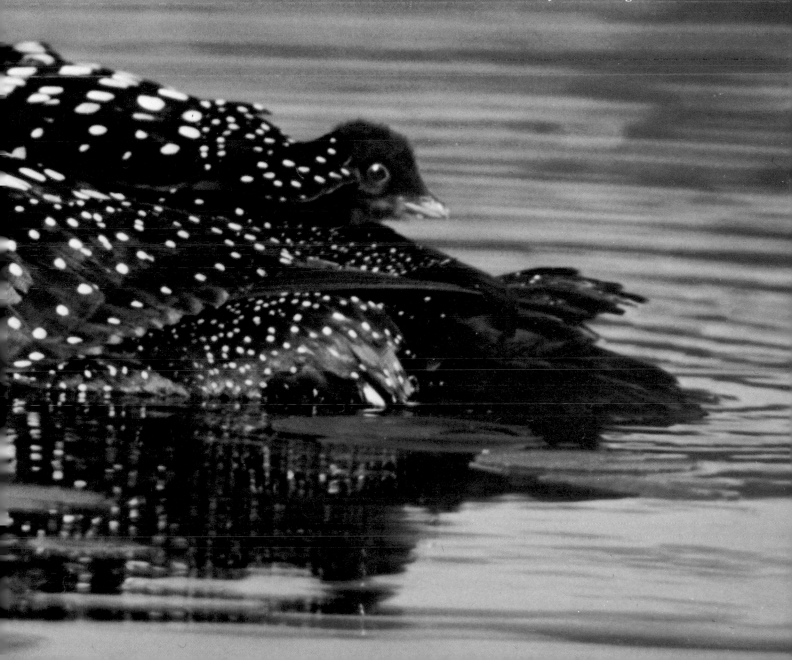

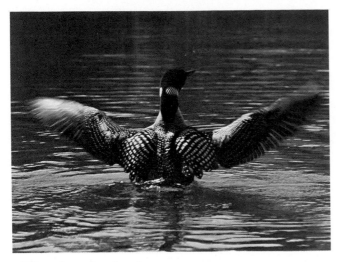

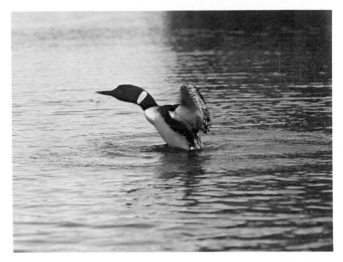

Flapping, back view.

Flapping, side view. (All loon photos by Woody Hagge.)

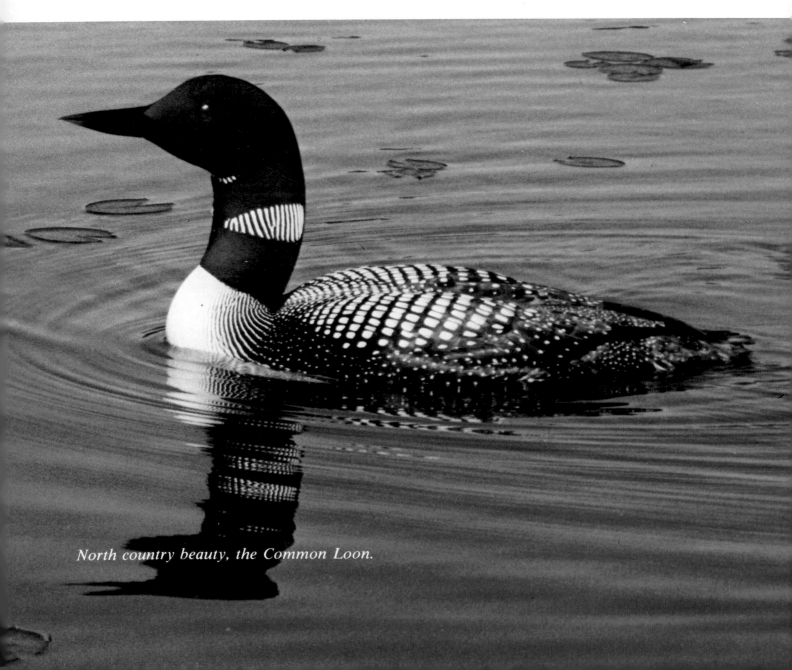

North country beauty, the Common Loon.

Ring-necked drake. Lights out—the eyelid has raised to cover the eye and its sleeping time.

FEATHER FACTS

Birds are covered with feathers. What a naive statement that is! We grow up knowing this fact without being told over and over. The entire surface of a duck certainly appears to be covered with feathers. Many of the feathers cover areas other than where they originate in the skin. Feathers grow in tracts and regions. Their purpose is to protect the body from the elements as well as to make it aerodynamically efficient. There are areas of the body that do not have larger feathers growing from it, but are covered with underlying downy feathers. The larger feathers overlap these areas. What does this mean to the artist? At first, it more than likely will only serve to make you aware that feathers come in many sizes and go in many directions. But as you progress you will find that it does have purpose.

Feathers that cover waterfowl are grouped in sets. Each of these sets fills a role or function although some merely form the contours of the body. Without them, the airflow in flight, or the buoyancy in water would not be efficient. With this in mind, each feather can be labeled as purposeful although it may take many numbers of them in a region to accomplish the function.

Waterfowl have the capability of opening sets of feathers and not necessarily individual feather movement. As each set is opened, the smaller feathers around each area will be raised with them. The longer, stronger feathers extend underneath the smaller feathers. There are

61

certain regions or sets of feathers on waterfowl that I term as *transitional* feathers. These areas act like a hinging or folding area. The direction of the transitional sets of feathers hinges with the actions of the bird when it is in flight or at rest. The feathers, starting at the front of the bird and going back, progressively get larger until they reach the area at the rear of the sidepocket, where the tertials cover the wing feathers on the top. The feathers of the belly are exceptions as they remain similar sized.

The overlapping of each feather is from rear to front and top to bottom except the tertials and the tail. This explanation means that starting at the tail, each feather that is on the bird will partially cover the one behind it. This continues all the way forward to the bill. Not only will it cover part of the feather behind it but some of the feather above it also.

This design is contrary to the normal shingling of a roof for the purpose of water runoff. The waterfowl has to be protected from the water it will be splashing belly first into, not the rainy weather that might occur. And since there will mostly be forward movement in the water, it will also have to be protected from that force. All of this knowledge will help you establish the feathers properly, for there is purpose of design in nature.

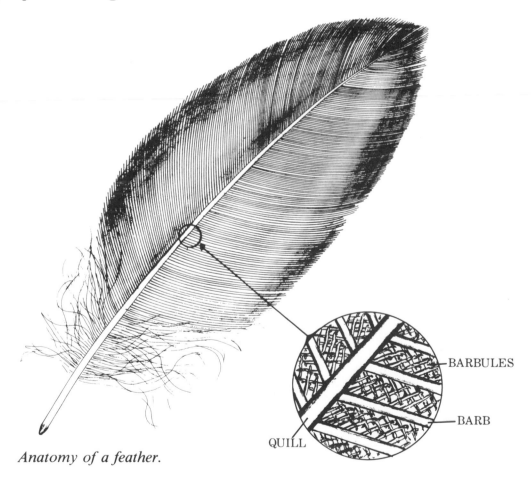

BARBULES

BARB

QUILL

Anatomy of a feather.

Feather structure. All feathers, regardless of size, are convex except the flight feather.

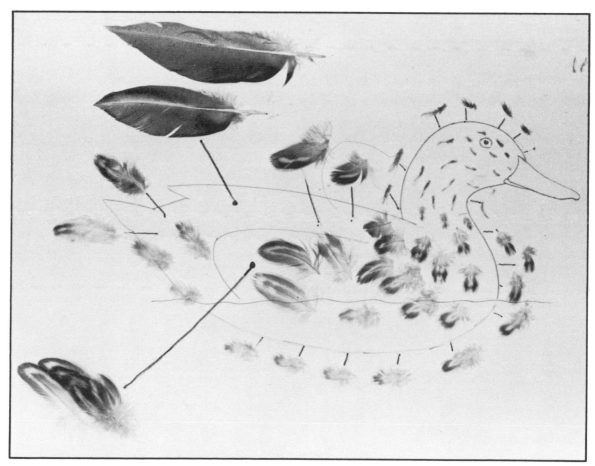

Mallard hen feathers. Actual feathers show the many shapes, sizes, and locations on a duck. The large feather at the top is a drake tertial for comparison.

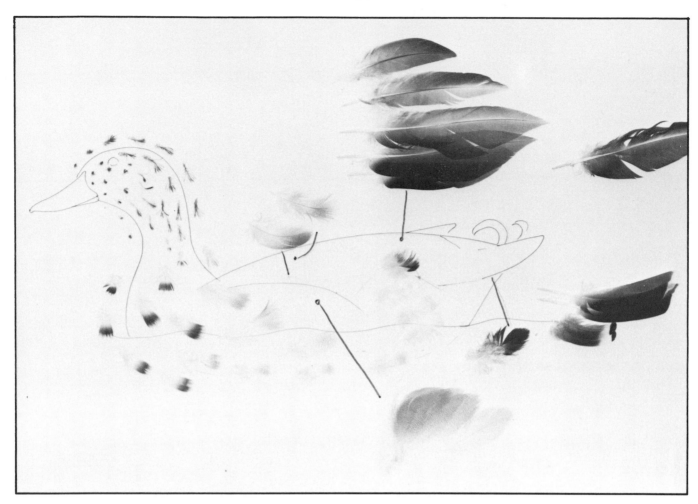

Mallard drake feathers. Actual feathers of the drake and their locations. The top five feathers are the tertials. A hen tertial is at right. The feathers at the lower right are from the speculum and greater coverts of the wing.

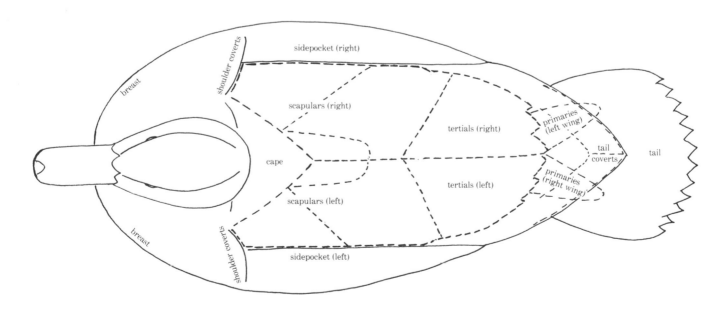

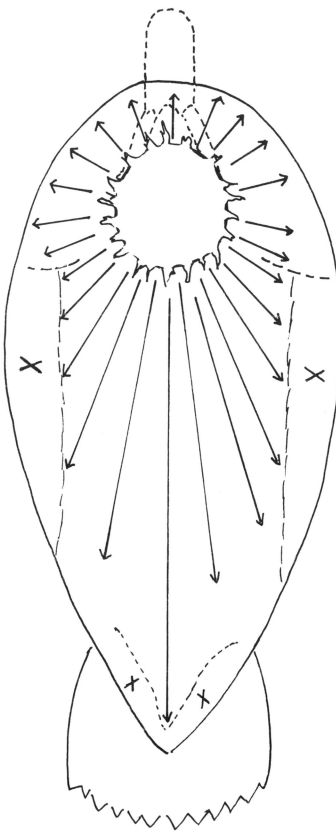

The sunburst. The feathers of the back and breast will be in a direction radiating from the center of the neck. Tertials and primaries are wing feathers and do not fall into this pattern.

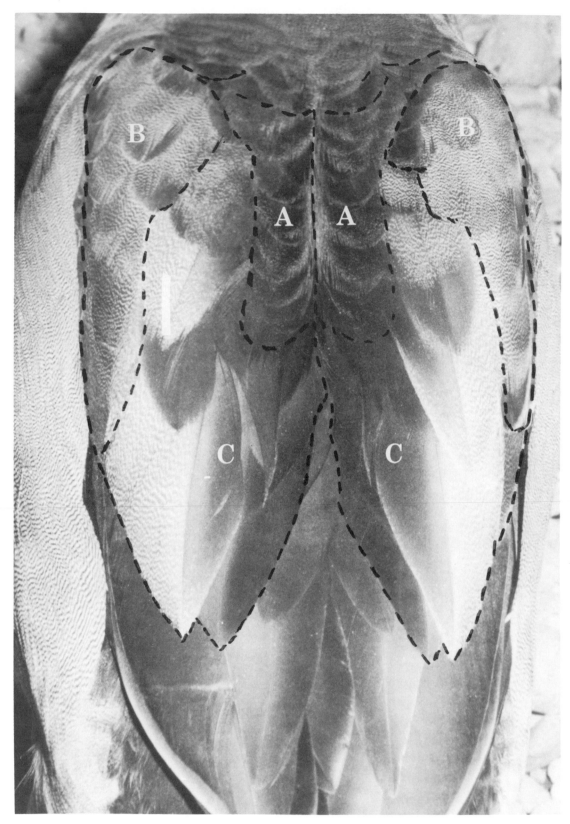

*The scapulars of a mallard drake divided into left and right sets. A—inner.
B—outer. C—middle.*

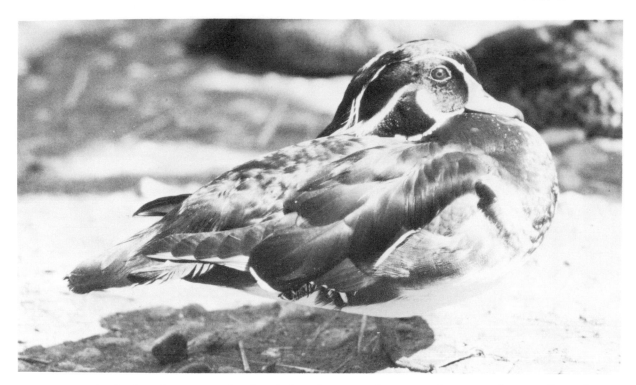

Wood Duck drake. To warm his back by the sun, the scapulars are dropped to the sides. All birds can do this. Can you pick out the sets? The large feathers and white tips are tertials.

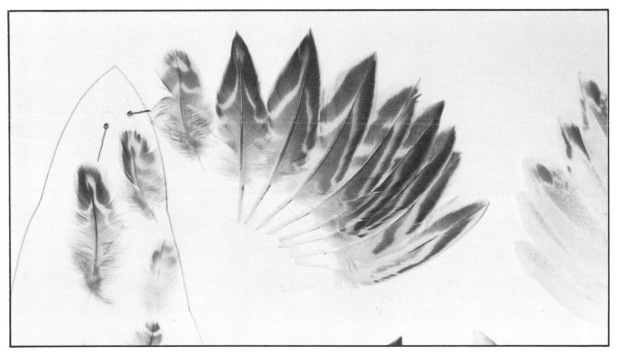

Mallard hen, tail and covert feathers with drake tail feathers on the right for comparison. Two feathers were missing from this side of the hen's tail and were just growing out of the follicles.

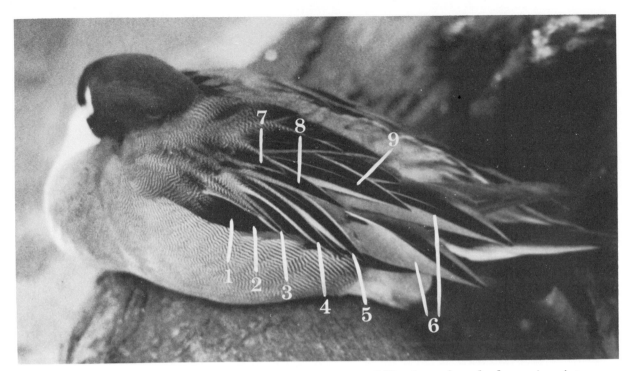

Pintail drake. This is the reason that feathers are difficult to break down in pictures. Some are oddly shaped and colored to make isolation of the whole feather almost impossible. The numbers show the corresponding scapular feathers and the two tertials (6).

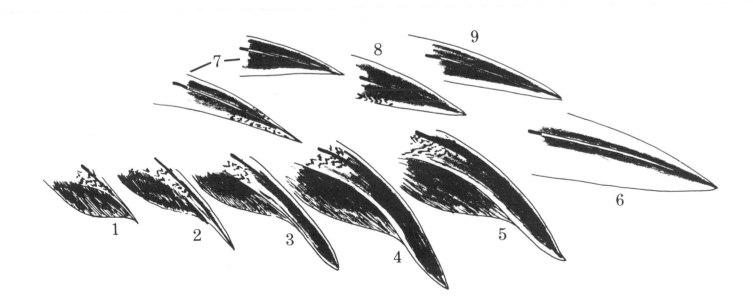

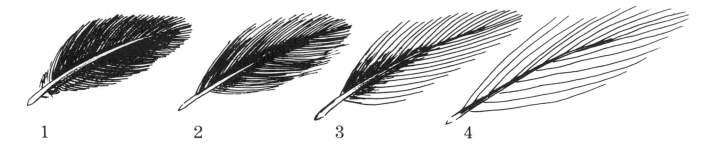

1 2 3 4

The structure of feathers vary for the purpose and use.

1 *A tight-knit feather with many barbules to hold it together is a strong structure and will be the type found on the scapulars, tertials, wing, and tail.*

2 *Many barbules knit the center and base together, but the outer barbs have less barbules and will have "soft" edges. This structure will be found on most of the body feather.*

3 *With a lesser amount of barbules near the base on the wide-spaced barbs, the ends will splay and be hairlike. This structure will be found on the feathers of the head.*

4 *Barbs have a greater space between them and fewer barbules to cling together on the feathers of crests of the head. This structure will also be found on the rump area of the Wood Duck drake.*

ANATOMY AND FEATHER DETAIL

HEAD AND NECK

The Eye

Eye contact is the first unconscious thought/behavior whenever an animal or human view each other. The eye, its surroundings with the head, and the head itself, receive the first glances of observation. We look to see if there is an eye, because if not, chances are that what we are looking at is not alive and presents no threat.

The entire anatomy may be visually searched and yet we keep going back to the head to seek the eye contact. With this most primitive of thought/behaviors, the head assumes one of the most vital roles in identification. Once eye contact is made, we are subconsciously released to scrutinize the rest of the anatomy, although there will be quick glances back to the eye now and then. (You might check this reaction yourself by using a picture where the eye cannot be clarified and another where it is super clear.)

Eye contact will play a big role for artists, for without the eye there is no life. With this statement it becomes critical that the eye and its proper location on the head is a must. I have included a drawing of the axioms for eye placement to clarify it.

There is also an eye-trough aspect of the head. The duck has to see down the bill much as we have to see down past our nose. It also has to

71

retain some vision to the rear for safety. The eye trough enables this to happen. It is an indentation from the bill that arches up and over the jowl area and dissipates toward the rear center of the neck. From the eye forward the area is concave and not bulging as one would believe. This permits downward vision during flight.

Ducks have both binocular and monocular vision. A duck's binocular vision (looking with both eyes) is limited; therefore it will use monocular vision most frequently. *Monocular* means looking with one eye. As they fly, ducks will move their head about, looking with one eye then the other. During this observation, the head may tilt to enable the duck to see better. It is one of the infrequent times that the head will not be in an upright position.

The part of the eyes that you see on a duck's head is a small area of the whole eye. It is not an eyeball such as humans have but is a saucer shape with a bulge in the center (the area we see surrounded by feathers). The eye opening is not round but almond shaped. The front corner contains the nictitating membrane, a clear moist membrane that swipes the eye to moisten it. It also covers the eye during inclement weather and while underwater. The eye does not have tear ducts as human eyes do. The eye is surrounded by a leatherlike ring and in some cases such as the Wood Duck drake is very fleshy. The eyelid closes from the bottom to the top. There is no upper eyelid.

The Bill

One of the classic features of a duck is the bill. Actually it is the combination of the upper and lower mandibles but shortened and nicknamed the "bill." Each species has a very distinctive bill. The design of each is suited for each specie's feeding habits. The evolution of the design has also included the reduction of competition for the same foodstuffs. You may find several species feeding in the same area, but rarely are they in strong competition for the food available.

There are five basic designs of bills (looking from the top side). Some are larger or smaller and differ in color, but all are used for gathering food. The bill is the only part of the duck that cannot change dimension or shape once it has reached maturity. The rest of the entire bird can change with attitude, action, and season. As a carver, it is mandatory to create the bill first, then make the head meet the bill. When painting waterfowl, it will be the bill-and-head attitude that dictates much of the action.

The upper mandible is an extension of the skull; therefore it cannot move. The lower mandible does all the moving and the actual hinging occurs far back on the head not at the corner of the mouth. If the waterfowl is nervous or scared, the feathers will be lower than the edge of the bill; if relaxed, the feathers bulge at this juncture.

The notch or V-shaped area at the top rear of the bill seems to be very difficult for some sculptors to form. It is not a notching of the section as from the side view but an angling back from the centerline on each side. The surface of the bill is rarely smooth. There are several species that have bills that may look smooth, but on closer examination, they are far from it.

When the duck is dead, the bill not only shrivels within hours, but starts shrinking at the base. This shrinkage after death is nominal on the length of the bill and width at the tip, but the lower edges will completely change dimensions. The higher bridge at the head juncture permits the lower edges of the hollow, upper mandible to move inward at the bottom without restriction. As the bill flattens out toward the end, the lower angle of the bridging in this area is less likely to permit the edges to curl. When working with mounted specimens, take these factors into consideration for accuracy.

The nail at the end of the bill is hard, much like a human fingernail. The nail on top curves down over the end and is recessed along its edges. There are some species that have a bulging type nail, but most of them will be even with the surrounding surface. The lower mandible has a nail at the end also but not quite as prominent. There is a long V-shaped area of the lower mandible (underneath) that is not hard like the rest of the bill but is instead very flexible and rubberlike.

Ducks do not have teeth but do have serrations on both mandibles called *lamellae*. These curved toothlike serrations permit retention of food in the mouth as the water is strained out through them. Gadwalls and Shovelers have longer, bristlelike, straining lamellae.

The nostrils of the bill are another feature of the puddle duck-diver distinction. The nostrils of the puddle ducks are much nearer to the head than on the divers. They are also teardrop shaped and angled at the front toward the center of the bill. The nostrils on the bills of the divers are more toward the center of the bill but not an exacting measurement. They have a more elongated opening with a ridge out over the top and they are close to being parallel to each other from the top view. The difference in design probably is to serve the needs better as they dive underwater to forage. If the nostrils were at an angle they might let the water force itself in.

The bill has a little curl upward at the corner of the mouth. This would be on the rear bottom of the upper mandible and curls like this on most species. The lower edge of the upper mandible also has a double roll that follows an indentation from the corner of the mouth, goes forward and eventually looks as if it goes under the edge. It does not meet the roll area of the rounded tip but goes off the bill under it. The rounded roll area of the tip of the bill dissipates above the double roll of the side.

Feathers

The feathers of the head and neck are very hairlike in appearance. Therefore, I usually refer to them as the hair of the head. Make no mistake, they are feathers, but their collective structure—at least the visible portion—resembles hair more than it does feathers. The feathers, starting at the front of the bird and going back, get progressively larger until they reach the area of the rear of the pocket on the side and the tertials covering the wing feathers on the top.

Starting at the front of the head, near the bill, the feathers are very minute and often rowlike in appearance. It is one of the few areas of a duck where the barbs of the feathers may look as if they all go the same direction. A closer look, however, will show that they splay in many directions. The feathers of the head get progressively larger as mentioned before and their directions conform to the contour of the head as if wind currents were blowing them. In a sense this is a directional design, so there is less drag when flying or swimming. The feathers go up and over the eye and then drop down behind as if they were a stream flowing around a boulder.

There is an indentation behind the eye similar to the ones humans have, but on waterfowl it is covered with feathers. Some carvers and painters prefer an upsweep to the feathers behind the eye. There are times when this may occur but it is dependent upon the attitude once again.

The jowl is an area of loose skin covered with feathers and stretches to fill the area when the neck is stretched forward. When the head is elevated, there has to be a point or hinge area that will make up the difference in the direction of the feathers.

Only the top rear of the jowl has feathers in line with the head. As the arc of the jowl curves downward at the rear, the direction of the feathers starts to conform with the feathers of the neck. There is an abrupt end of the hairlike feathers at the lower area of the neck. There also is a difference in height between the front and rear of the neck where this occurs.

The forehead area of the head is called the *crown* and has longer feathers than those on the side of the head. The crown is a direct indicator of the nervousness of the duck. The crown is raised or lowered in direct proportion to the anxiety of the duck. It will also pulse up and down as danger increases or decreases. The feathers are moved in a fashion that would be similar to a human being frowning. As an artist, the attitude you are trying to convey will directly affect the fullness of the forehead or crown area. This is true of the whole bird, naturally, but even more noticeable because of eye and head contact.

Several species of waterfowl have longer feathers on the rear of the head that are refered to as *crests*. Ducks with crests would be the males of these species: Wood Duck, Hooded Merganser, Bufflehead, and the Red-breasted Merganser. The Goldeneye drake might also fall into this classification. The only females to show a crest would be all the Merganser species and the Wood Duck.

The crest feathers are a very interesting structure, for they remain hairlike in appearance, but are feathers without a doubt. The crest of the Red-breasted Merganser male looks like single strands of hair sticking out behind the head. The crests of the Wood Duck, Bufflehead, and Hooded Merganser look more full and have flowing lines.

The feathers that appear strandlike have what I term as skiptooth barbs. Sawblades are sometimes designed with some teeth left out, creating a space between the remaining teeth. The same is true of these strand feathers. The barbs are spaced apart as if someone had plucked them and left every fourth or fifth barb in place. The remaining barbs cling together through the action of the barbules and with wide spaces between the barbs, the barbules will grip the next ones with which they come into contact. With so much space to be overcome between the barbs, the clinging action centers around the shaft itself. This creates a feather that looks very much like a coarse rope design and yet is sturdy enough to stand out from the head without drooping. The Red-breasted Merganser drakes have a crest of feathers structured in this fashion.

The design of the crest feathers of other drakes is similar, but the amount of space between the barbs is not as great. With less space to be bridged, the feathers do not wind around the central shaft, but are more in line with each other. The lack of barbules in great quantity permits these barbs to flow together without clinging to each other. The softness of the ends of these feathers permits the mass to flow with the air currents, creating minimum drag when flying.

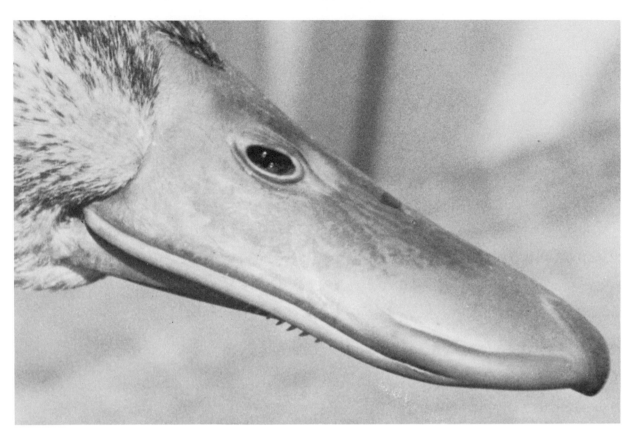

Bill of the Mallard hen. Check the details of this bill in the same manner as analyzing the whole bird.

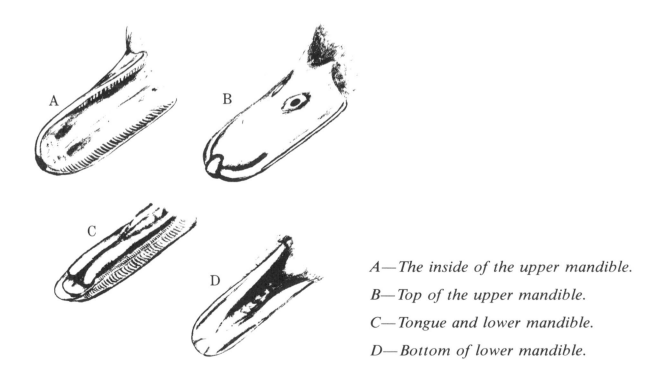

A—*The inside of the upper mandible.*

B—*Top of the upper mandible.*

C—*Tongue and lower mandible.*

D—*Bottom of lower mandible.*

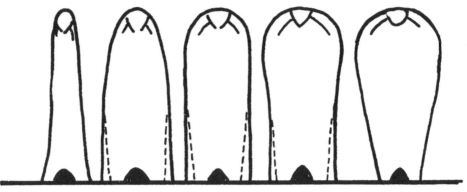

The five basic shapes of duck bills, the dotted lines at the base represent the shrinkage that occurs on a mount.

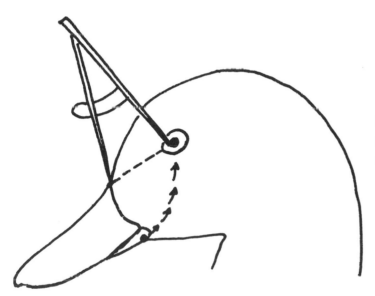

The eye is located on a line from the top lobe or corner of the bill. It will be the same distance from that corner as the bill is high.

The eye trough of the head. The eye sets on the top edge of this indentation, not in the middle.

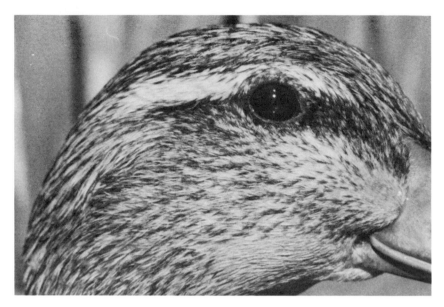

Mallard hen. The directions of the feathers on this head are indicative of most ducks, except for those with crests.

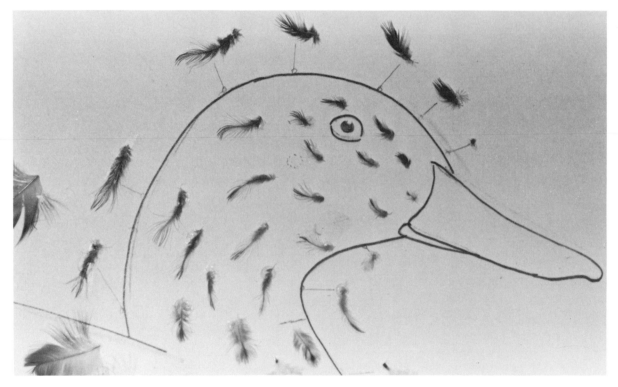

Mallard hen. The shape and size of the head feathers and their location on the head.

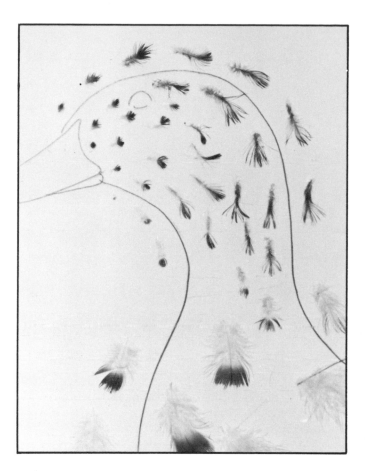

Mallard drake. The shape and size of the head feathers on a drake show up in the picture because of their color. They are much the same as the hen.

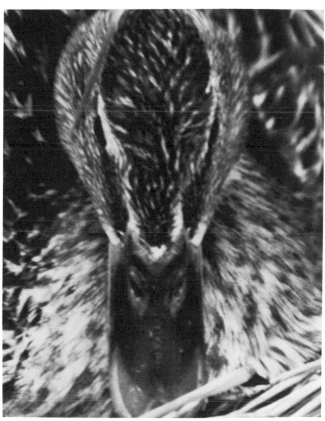

Mallard hen. This top view, taken while the duck was nesting, shows that the jowl is the widest area of the head and from that point, the sides of the head are almost straight to the bill.

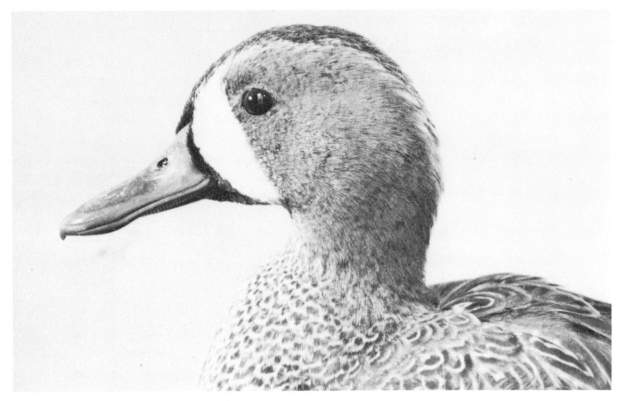

Blue-winged Teal drake. The black-and-white photograph permits us to ignore color and notice the details. Remember, color is a surface covering to make it look good.

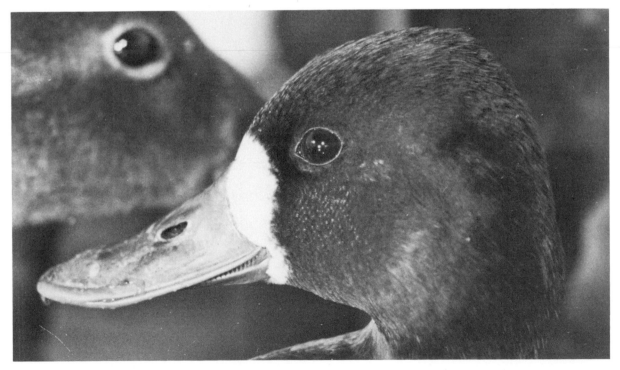

Lesser Scaup hen.

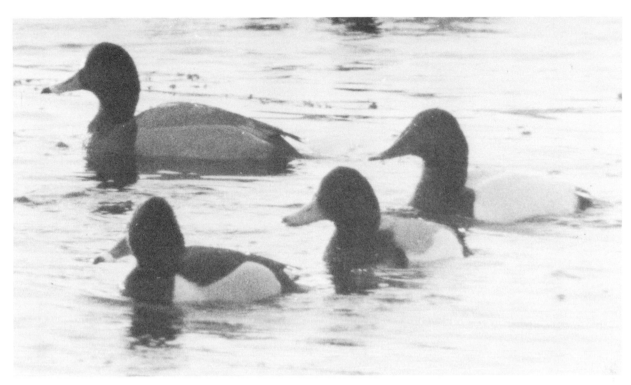

The Big Four. An early morning sun silouettes the diver drakes and shows their distinctive head shapes. The Redhead is top left, Canvasback on the right, Ringnecked front left, and Lesser Scaup in the center.

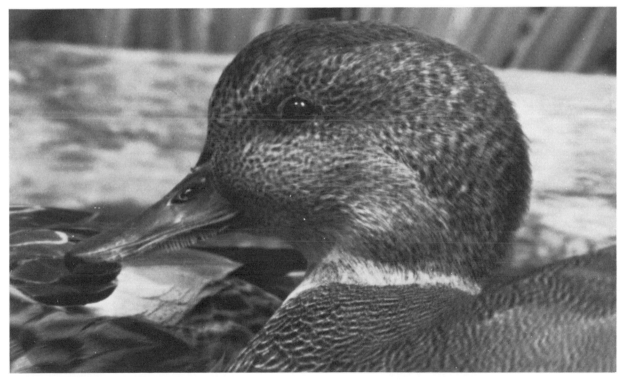

Gadwall drake.

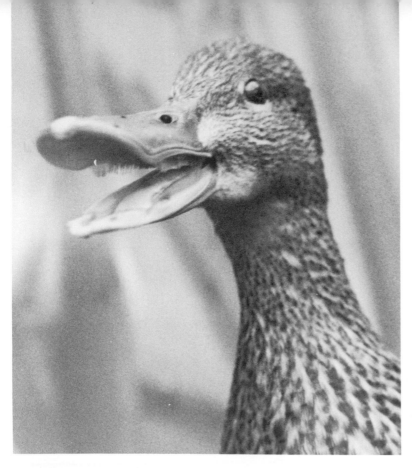

Shoveler hen. She is really mad at me, making a hissing sound and warning me away. It gave the opportunity to show the shape of the bill and mouth. This angle also shows the eye above centerline of the eye trough.

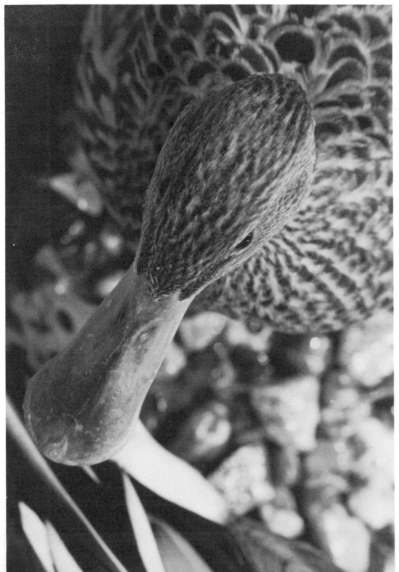

Shoveler hen. Although the mouth is closed in this shot from above, the head shape would not be much different than what was shown in the previous picture.

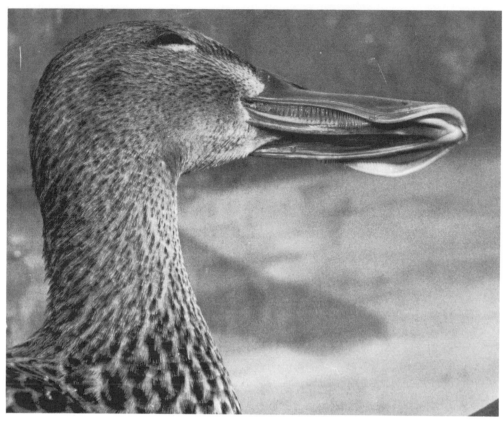

Shoveler hen. She is tilting her head to look at something above her. The lamellae or strainers of the bill are the largest on the Shovelers.

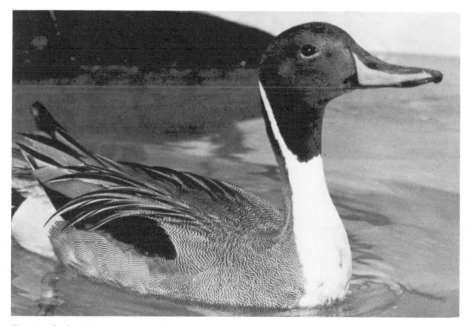

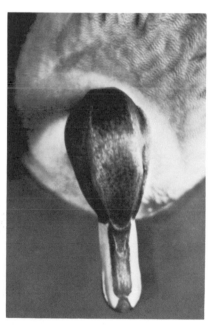

Pintail drake.

Pintail drake.

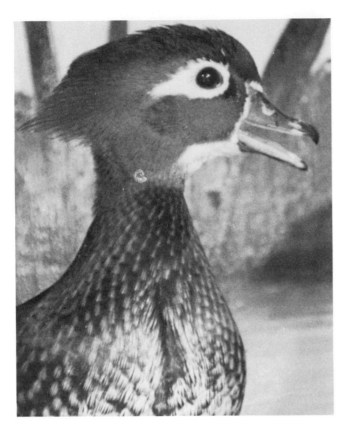

Wood Duck hen. This picture shows an indentation around the lower part of the jowl at the rear and a slight crease to the feathers above the point of the white throat saddle. These areas are the location of the white markings on the drake head. The sharp contrast of the white and extreme darks make it difficult to see on the drake.

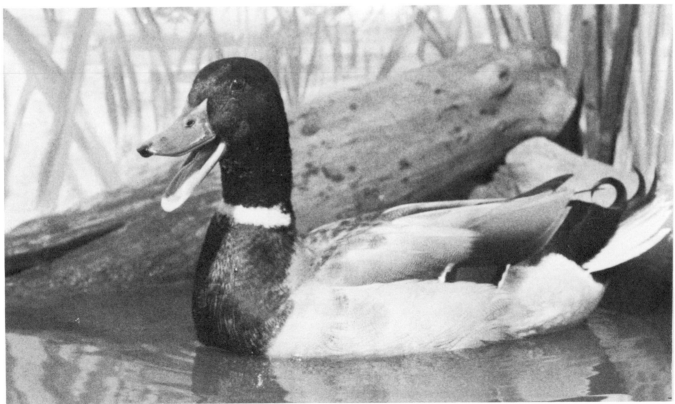

Mallard drake.

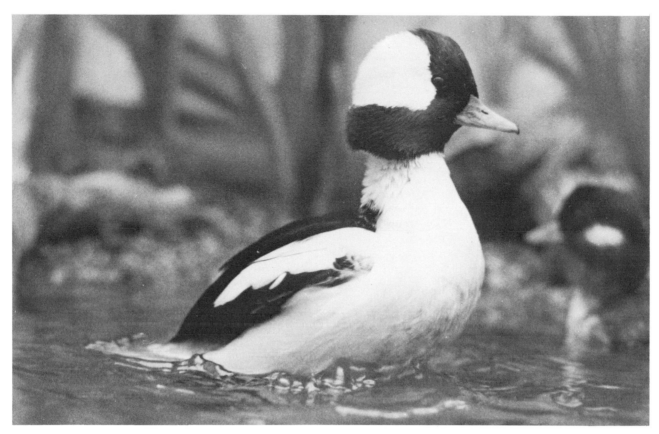

Bufflehead drake. He is treading water, getting ready to exercise his wings and readjust the body feathers. The longer feathers of the head create a bulbous look next to the shorter feathers on the neck.

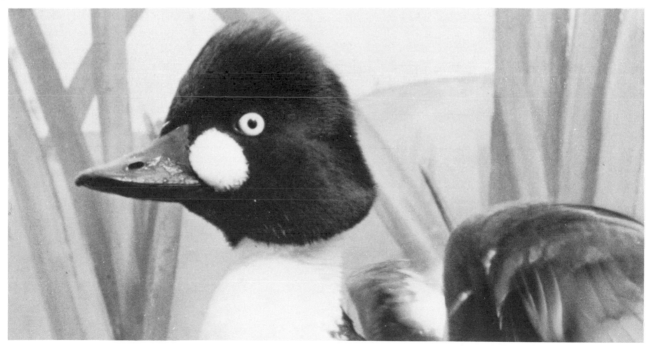

Goldeneye drake. He has the same type head feathers as the Bufflehead but are different lengths, creating an entirely different shape.

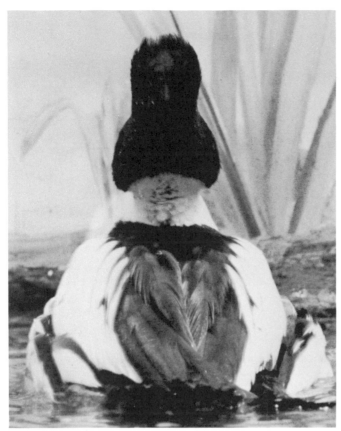

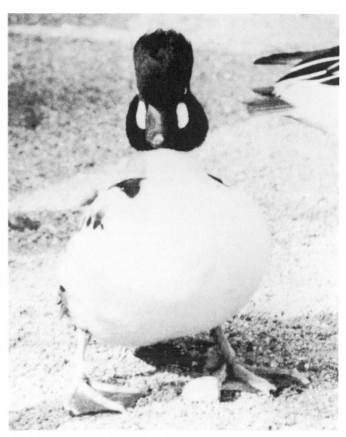

Goldeneye drake from the back.

Goldeneye drake. The head shape of the Goldeneye drake is very distinctive. Compare it and the Bufflehead drake head shape to the ducks in the picture titled The Big Four.

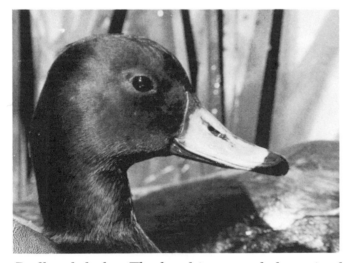

Redhead drake. The head is normal shape in the first picture, but the second shows what happens in a courtship call.

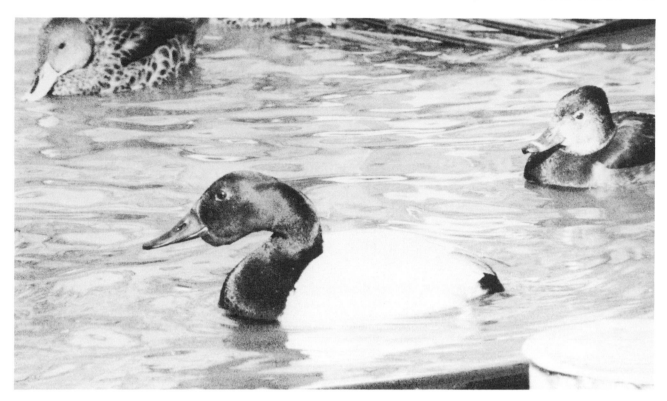

Canvasback drake. He is giving a courtship call and display. Divers also throw their head over their back to the rear in courting. In spring courtship, the Canvasback drakes eventually stretch this expandable area under the chin until it sags like a double chin.

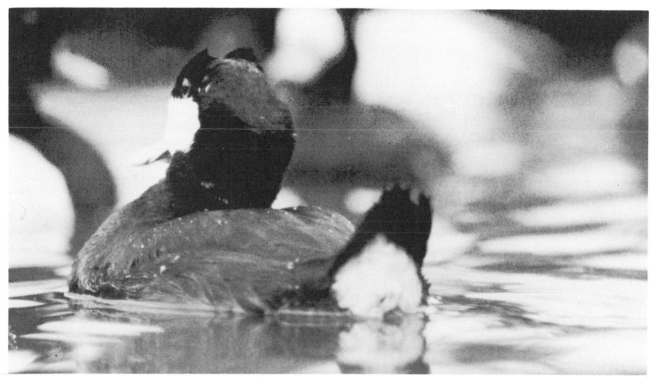

Ruddy Duck in the courtship display. His "horns" are showing: the protruding feathers of the ends of the crown.

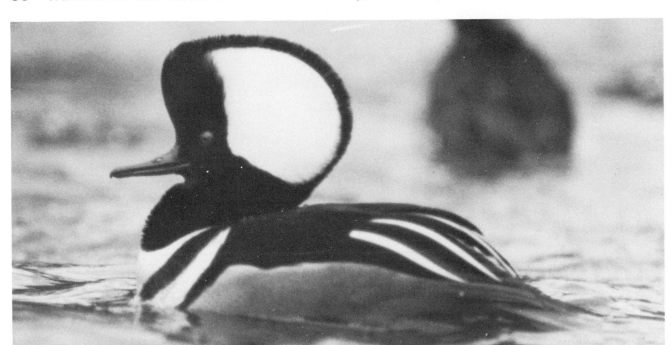

Hooded Merganser male in courtship.

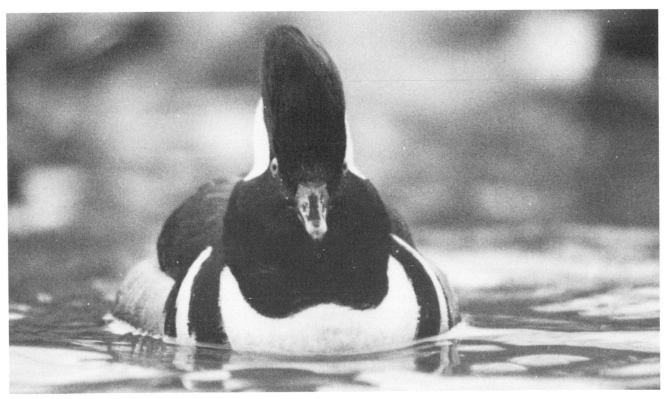

Hooded Merganser in courtship display. Hooded Merganser males have the largest air sacs creating dramatic vocal courtship displays.

Mallard drake. The hairlike feathers of the head stop at this point on the neck and the rounded breast feathers start. The white throat ring of the Mallard drake does not go all the way around. Females that show the white throat ring are usually crossed with the tame Mallard.

BREAST AND BODY

Breast

Above and below the throat a dramatic transition of feathers and anatomy takes place. The hairlike feathers of the head and neck stop abruptly and the round-tipped breast feathers emerge. The sides of the head taper from the wide jowl area to the throat transition area. From that point, the anatomy widens back out to the breast. I call this the hourglass shape. Most ducks, geese, and even swans have this taper to the throat from the head and from the breast. No matter how high the head and neck are raised or extended, the taper will still exist although the angles may increase in degrees.

The feathers of the breast, although ending in a rounded shape (exposed portion only), will have the barbs in a parallel design. The barbs do not fan out from the central shaft, or quill, but follow the shaft on the ends. Only a small area of the tip of each feather is visible. This increases or decreases with the movement of the duck and its attitude.

If the breast feathers are dark, the base of the feathers is light. If the breast feathers are light, the base will be dark. This reverse of the base coloration is on most light and dark feathers regardless of their location on the duck. Even the dark, iridescent feathers of a "Greenhead" Mallard drake have light base coloration.

The colors of the breast feathers frequently make them indistinguishable as individual feathers. Once again, color is just a covering to make it look good. The pattern of the breast feathers is very similar on most ducks with one variation. A Gadwall drake has breast feathers that are individually tipped and very easy to distinguish. Most puddle ducks will have a similar design to this feather layout. The variation is when they are more rowlike. Most divers have this trait, but the Wigeon drake (a puddle duck) also exhibits this feather structure.

The feathers of the breast increase in size as they go back toward the belly and sides.

Shoulder Coverts

Behind the breast is a set of feathers I call the shoulder coverts. They are a half-moon shape with the rounded area to the rear. The feathers of the shoulder coverts, cover the front of the shoulder area and angle down over the front part of the sidepocket. They are also one of the sets that have to act as a transitional, or hinging, area.

In a rest position with the head back, the shoulder coverts angle down to the rear. As the head and neck move forward, the feathers move in relation to the action. When the head and neck are at full extension, such as flying, the shoulder covert feathers will be in line with the body. To understand and isolate this set of feathers, the Wood Duck drake can be used as an example. The shoulder coverts of this species have the distinctive black and white markings on them. Most birds have shoulder coverts in this area but they vary in design and purpose.

The Pocket

The sidepocket set of feathers is misunderstood by many beginners and professionals alike. Under normal conditions, the wing is folded and under the larger feathers of the side. I have called it the pocket because of the association.

The feathers of the sidepocket are progressively longer and larger as they go to the rear. They angle up immediately behind the shoulder

coverts, but the lower feathers will be more in line with the lower feathers of the shoulder coverts.

To accomplish the covering of the folded wing, the long feathers emerge from the skin and are in an S shape. Their direction is up and then to the rear. I have many pictures of various species that show some of these pocket feathers at right angles to the water though. Their mass, construction, and design allow them to be opened, the wing inserted, and then closed again. When the wing is out of the pocket, the pocket feathers return to hugging the body contour. They frequently contour to the shape of the folded wing near the speculum area.

The feathers of the sidepocket on the divers appear to be more in rows than on the puddle ducks. The individual quills rarely show on any of the sidepocket feathers except for some of the female divers. The top edge of the sidepocket on puddle ducks usually arches some in the center. Divers have sidepockets that are much higher at the rear before they arc downward. The Blue-winged Teal drake, the Cinnamon Teal, and the Shovelers are exceptions to puddle ducks and their sidepockets will be higher than the others. The Mergansers are exceptions to the divers and the pocket will be lower and similar to the puddle ducks.

Belly

The feathers on the belly are very numerous and thick. They do *not* get progressively larger as the other sets of feathers do. By retaining the sameness in size, they are more capable of matting and creating the waterproofing needed for that region that is underwater most of the time. The colors are usually light or appear to be washed out on the belly feathers.

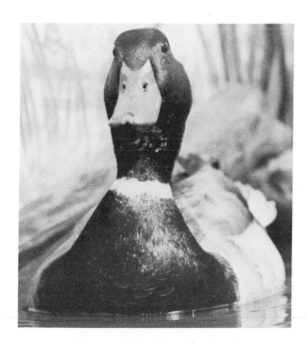

Mallard drake. This picture from the front, shows the hourglass shape. The jowl, being the widest spot of the head, narrows down to the neck below and then back out again to the width of the breast.

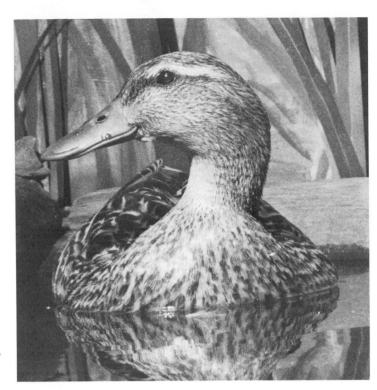

Mallard hen. The hourglass shape is distorted some as she turns her head but it still remains apparent.

Canvasback drake. The feathers of the breast appear in rows during certain attitudes.

Mallard drake. The rounded feathers of the breast start just below the white throat ring. It is the same for all ducks. The darker feathers at the top start diminishing in value and become lighter and tipped more markedly as they near the feathers of the belly and side.

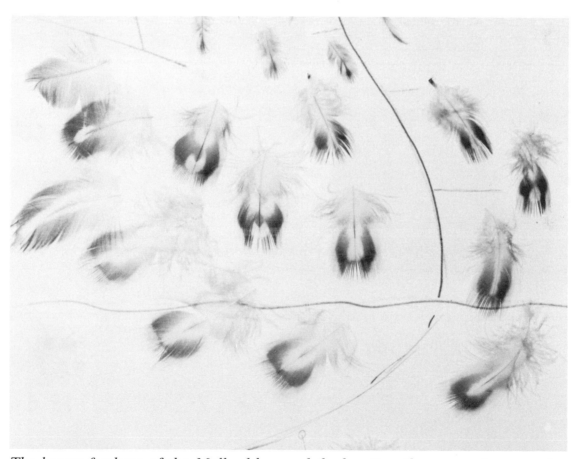

The breast feathers of the Mallard hen and the location they come from on the breast. The feathers of most ducks will be very similar to these but will vary in color.

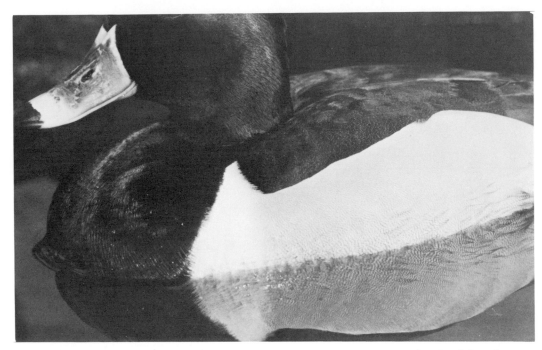

Ring-necked drake. The black feathers of the breast are flanked by the white feathers of the shoulder coverts. The sidepocket feathers are vermiculated and show stronger in the reflection than above. The feathers on the back of the Ring-necked drake are vermiculated with light brown dots (sand color).

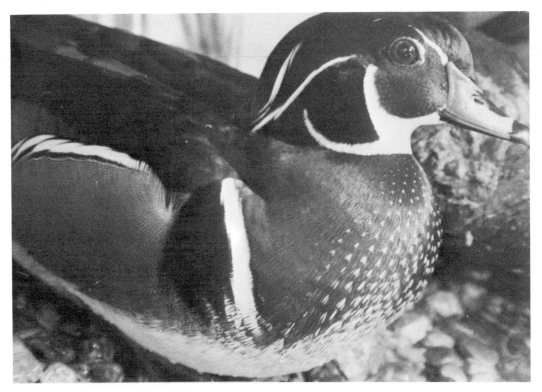

Wood Duck drake. The shoulder coverts are very distinctive in this picture. They are the set in the center with the white bar followed by the rounded black feathers. Most ducks have this set of feathers but are not as clearly marked.

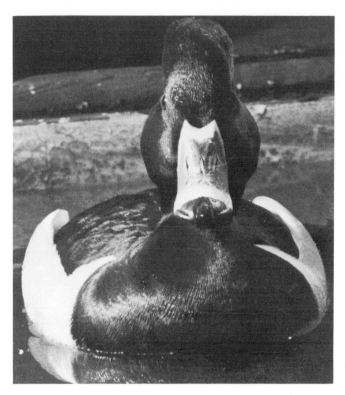

Ring-necked drake. The sidepocket feathers have been opened on each side as the drake becomes excited.

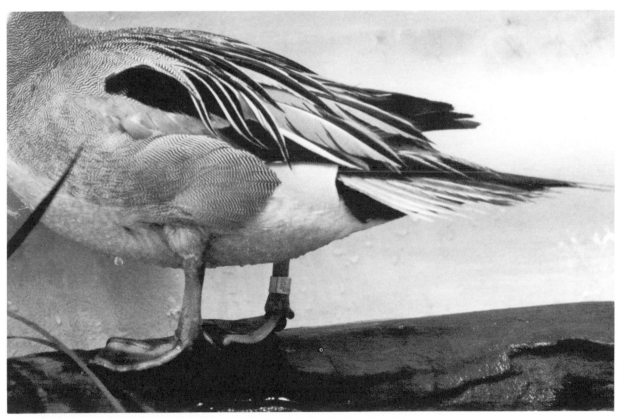

Pintail drake. The sidepocket is wet and pushed up some at the bottom rear by the leg. The upper area of the leg showing in this picture does not usually show on a standing duck. Visualize where these feathers must originate in the skin to protrude far enough to cover the wing and leg.

Canvasback drake. The shape of the sidepocket on most divers.

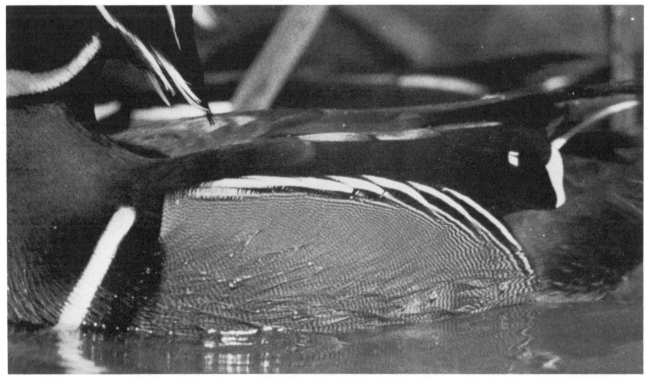

Wood Duck drake. The shape of the sidepocket of puddle ducks—the black and white edged feathers will bunch at the rear when wet or on a mounted specimen.

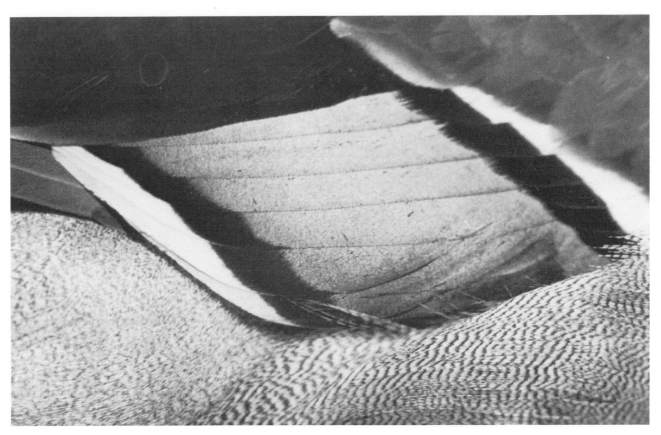

Mallard drake speculum. The speculum showing here, as the bird stands, is part of the secondary feathers of the wing. They do not have the same angle as the primaries emerging upward to the left. The sidepocket vermiculation is different than the vermiculation of the area behind it. The black and white feathers at the front of the speculum are the ends of the greater wing coverts.

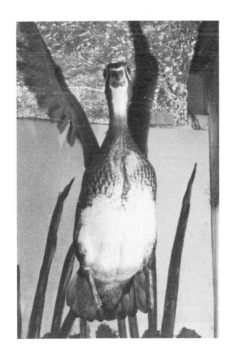

Wood Duck hen. As she takes off, the body flattens and is wider.

Ruddy Duck male. Ruddy Ducks have little neck extension even as he exercises his wings.

Pintail hen. In this position the legs appear to come out of the body but still have to exit through the rear bottom of the sidepocket. Notice how the darker feathers integrate with the lighter feathers of the belly.

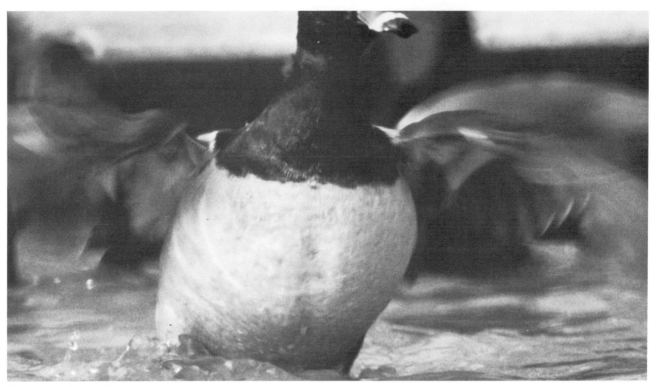

Ring-necked drake. As he exercises his wings, his rounded belly shows.

REAR

The rear or aft section of the duck is simple in design. It is rounded at the bottom and flattened on the top. It is not perfectly flat, but arched on the upper surface. Omitting the roundness on top allows room for the wings to fold over. When all is folded and in place, then it may have the appearance of being round.

Flank

The feathers immediately behind the sidepocket, the flank feathers, are in an upward direction. This is the area between the speculum and the tail. There is a definite stop to these feathers as they overlap those following the top of the body to the rear. This area allows the opening or fanning of the tail feathers to pass between the two sets.

Tail Coverts

The under-tail coverts are larger than those of the flank and belly and are a much stronger feather. Their purpose is to aerodynamically con-

tour the body to a point under the tail. The upper-tail coverts start on each side above the outside tail feathers and are rowlike to the rear center. The oil-gland coverts are in a triangular area formed by the upper-tail coverts. They are much larger, longer, and stronger feathers than those on the back of the duck. They have the capability of being lifted as a set so the bird can use the preen gland.

Tail

Divers have short tail feathers; puddle ducks have long tail feathers. Wood Ducks have squared-off tails; Ruddy Ducks have stiff tail feathers. Duck tails come in all kinds, shapes, sizes, and even different numbers, but they all have one thing in common: they work and are efficient for that particular specie's needs.

The tail is actually a combination of the left and right tail feathers. Each side can move up or down independently; however, one side cannot be spread without the other spreading also. The tail feathers are, as you might guess, much stiffer than the other feathers of a duck except the primaries of the wings. The quill placement is near the leading edge of the outer feathers and is almost to the center of each feather in the middle of the tail. The quills curve toward the inside or rear. The outside tail feathers are the lowest seen emerging from the body. Each feather is stacked on top of the next as they go toward the center. The center feather of the left and right overlap and appear as one except when the tail is opened or fanned out. When fully open all feathers can be individually counted, but when closed there may be odd numbers on each side that are visible. There are always even numbers of total tail feathers because of the two sides. If there are seven on one side, there will be seven on the other (open position). There are 20 tail feathers on Mallards. The drakes will show 8 on each side with the other 4 forming the curls. The females will have all 20 tail feathers showing when the tail is fanned.

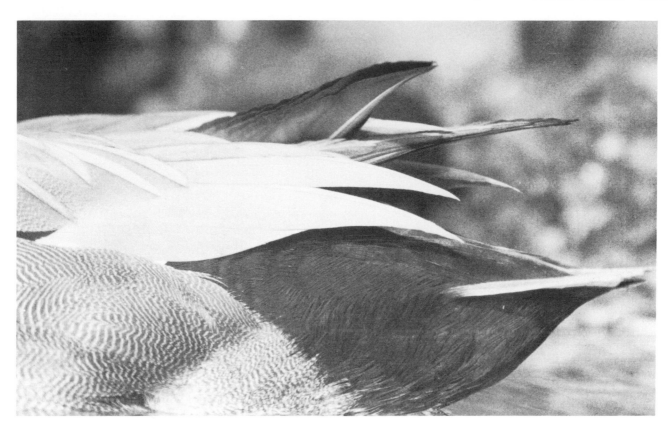

Gadwall drake. The top of the body in front of the tail is much flatter than the round area under it. The feathers can be separated in this picture by the directions. The scapulars are the ones that are angling at upper left. The longer, light-colored feathers are the tertials and crossing above them are the primaries of both sides. The feathers angling up in front of the tail are the flank feathers. The feathers above this set are pointed to the rear and are the oil-gland coverts and the upper-tail coverts. The vermiculation on the sidepocket feathers are much stronger than those behind them.

Gadwall drake. Although the longer tertial feathers (light colored in center) appear to arc from the side view, this angle shows them to be straight. The compound curves distort the actual shape from other angles.

Gadwall hen. The tail when expanded pushes out between the flank feathers and the upper-tail coverts. The distinct separation is apparent with the difference in color and markings. The flank feathers are below and the upper-tail coverts above.

Redhead hen. The feathers noted in the preceding picture are not as apparent in this picture but are similar. The tail of the divers is not as long and looks stubby in comparison. The tail is usually partially in or near the water except in this relaxed attitude.

Blue-winged Teal hen. The top view of the tail fanned out shows the upper-tail coverts being pulled with the tail feathers.

Blue-winged Teal hen. The picture from below shows the same thing happens to the under-tail coverts.

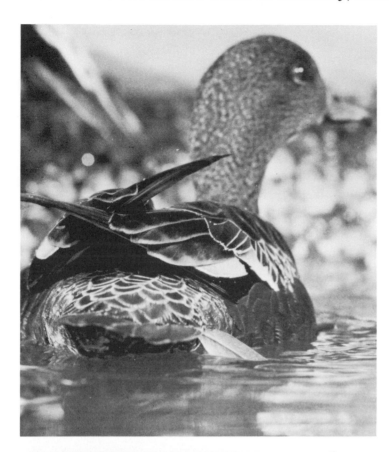

Wigeon hen. The flat area of the back shows dramatically in this picture. Without the back being flat, the wings could not fold efficiently over it.

Mallard hen. The upper-tail coverts.

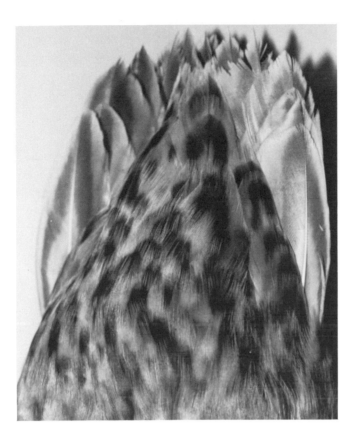

Mallard hen . The view from under the tail shows the tail stacking. It will be similar for all ducks except the shape, size, and color will vary. They also all do not have the same number of tail feathers.

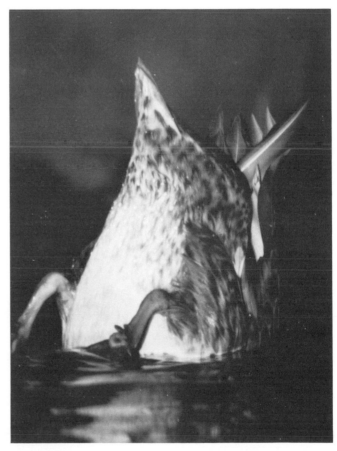

Gadwall hen. Tips to feed on the bottom.

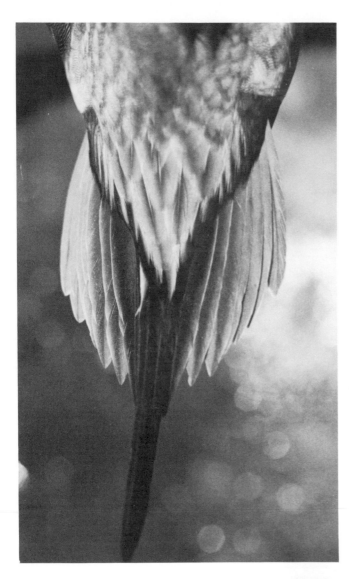

Pintail drake. The elongated feathers in the center that give the name to the Pintail are the central feathers of the tail. The upper-tail coverts are edged on the top of each one. The oil-gland coverts are the larger, light-colored feathers in a triangle at the base of the tail.

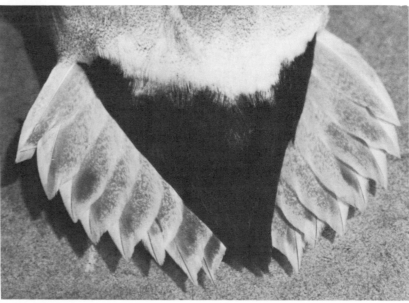

Mallard drake. The underside of the drake tail.

Mallard drake. Four central feathers of the Mallard drake meet and overlap to form two curls. One of the characteristics of the Mallard drake, these curls stay in place when the tail is fanned, leaving a notch in the center. There are 20 feathers on a Mallard tail—eight on each side of these central four curls.

VIEWED FROM ABOVE

The shape of a puddle duck on the water resembles a long teardrop form when seen from above. The divers look like chunky teardrops. The widest spot of the anatomy will be the pocket area pushed out by the folded wing. The breast is rounded if the head is back and at rest, but the whole front breast area will change as the head and neck are moved forward.

There is a triangular-shaped set of feathers behind the neck. I call these the *cape set*. They are, in reality, the feathers of the hind neck being bunched by the back position of the neck and head. As the head moves forward, they overlap less and fill the area when the head and neck are completely extended forward for flight. Another transition area of feathers.

The scapulars seem to be the most confusing sets of the feathers. They have been grouped together as the scapulars of the left or right, but I prefer to break them down even further. In my estimation, there are three individual sets of scapulars on each side. I have labeled them the *inner*, the *mid*, and the *outer scapulars*. The inner scapulars are a row of feathers on each side of the center. The outer scapulars are a triangular-shaped set that angle outward. The mid scapulars are a diamond-shaped group and are the largest of the scapular feathers. All of these observations are of the visible portion only. Each of these sets performs a different role in the many attitudes the duck assumes.

To study these feathers, or any feathers, I place a sheet of clear acetate over a picture and outline the feathers with a permanent marker. When I lift it away from the picture, I can check for the details and I need not be influenced by shape or color.

The tertials are the largest visible feathers on the body. They are not body feathers, however, but are part of the innermost feathers of the wing. Actually the tertials, or tertiaries, are a continuance of the secondaries. When the primaries fold, they are covered by the secondaries or speculum feathers. When both of these are folded back over the body, they are covered by the tertials. I have included a drawing in the next chapter, "Wings," that will help you understand the transition.

The easiest way to understand the feathers from the top view is to be able to disregard the tertials and primaries—they are feathers of the wing and not the body. Break it down from there. The feather patterns of the back are very similar on both the male and female of each species, but the male's feathers will be longer and more pointed. Wood Ducks are the exceptions to this rule, though; the male's feathers are more squarish in design.

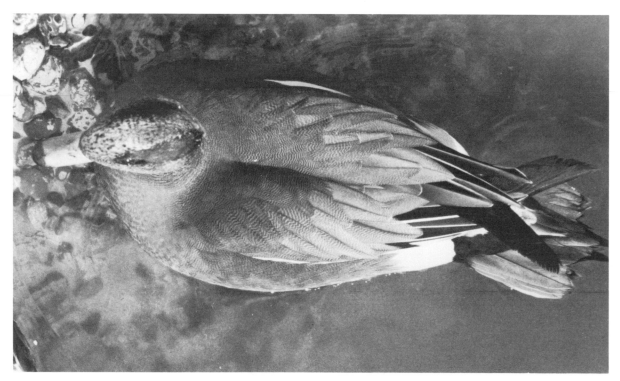

Wigeon drake.

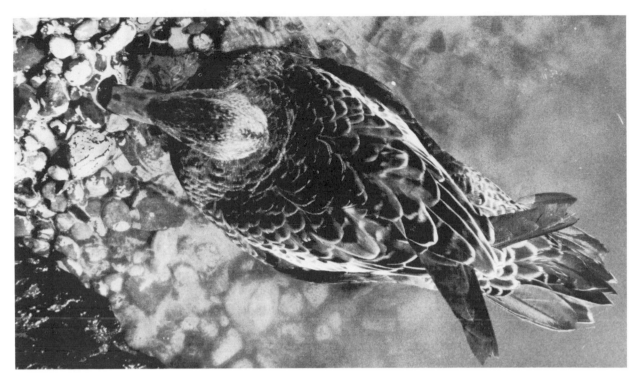

Wigeon hen.

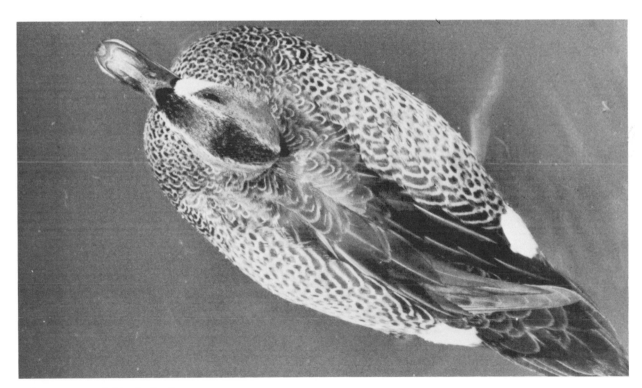

Blue-winged Teal drake.

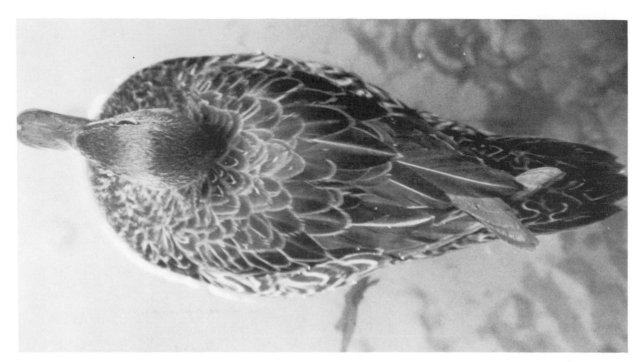

Blue-winged Teal hen.

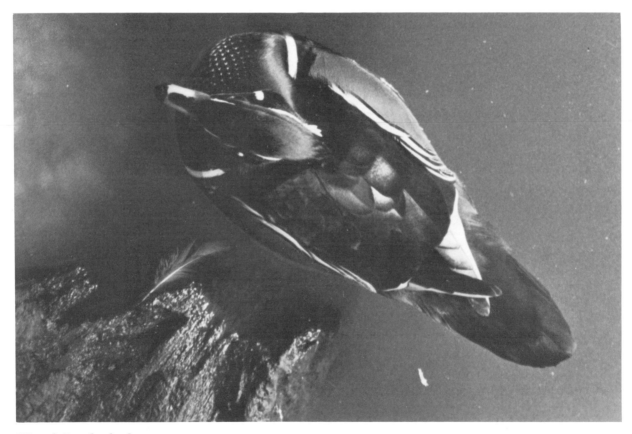

Wood Duck drake.

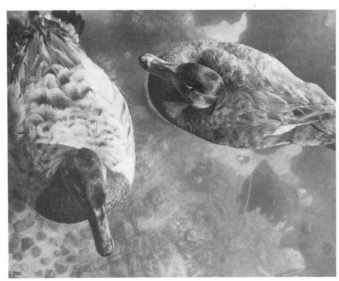

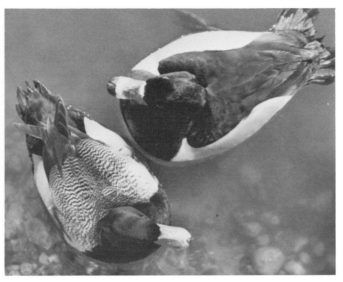

Diver hens: Canvasback on the left, Redhead on the right. The shape is the same on the males.

Diver drakes: Lesser Scaup below and the Ring-necked above. Both are small birds but the Ring-necked is usually chunkier.

Redhead drake. The primaries of the divers curve and contour with the body more than on the puddle ducks. The tertials are pulled in from each side with the crossing of the primaries. This will happen on both divers and puddle ducks.

WINGS

The wing movements are often labeled as defying description. Whoever thought that one up was trying to pass the buck. The problem is the same as it is with most things people misunderstand—it's too simple! The wing of a bird corresponds to the arm and hand of a human. Pivoting from the shoulder joint, it can move in any direction. The wing has an elbow, wrist, and hand also. Even the alula corresponds to the thumb.

The actions of the wing are basic. The feathers of the wing are moved up or down and in or out by muscles, but the forces of the currents of air do the twisting or bending of the feathers. The design of each feather of the wing is for purpose. The primaries are the long feathers at the end of the wing. They are the propelling force of flight. The simple movement of the leading edge going up and down creates a fanning of air forced backward, moving the wing forward. The inner part of the wing remains the airfoil as the outer primaries scull through the air.

The popular belief is that the primaries open on the upstroke to permit air to pass through them and then close on the downstroke so the air cannot pass through. This may happen at the outer tips but not with all the primaries.

The ten primaries of the wing are attached to the "hand," the area that would correspond to the back side of the human wrist and hand. Artist's

find the directions of the primary feathers will always have to go into that area and will be evenly spaced. For strength, the quills are located near the leading edge of the outer primaries and nearer to the center by the tenth. The quills also curve toward the tip.

The primaries have large, strong quills at their base. At the point where they emerge from the skin until the first barb of the feather, there is a gap or open space. Another feather must cover this gap in the wing, one above and one below. Those feathers covering these openings will have gaps at their base sections also. Smaller feathers will cover those gaps and smaller feathers have to cover the bases of those. And so it goes, getting smaller toward the leading edge, each feather covering a space left by the larger one under it.

The ten secondaries are also called the *speculum*. Their natural curve is toward the inside and the quills are near to center on each. (Perhaps you have noticed that, so far, I have given the number of feathers of each set. One of the qualifications of self-styled critics is to know the number of feathers on the wing. Don't laugh; recently I observed a sculpture that was superb in every respect. It was a crowd pleaser to say the least, but the sculptor had managed to put 9 primaries on one wing, eleven on another and even twelve on the wing on another piece. I still do not know whether he ever found out what the giggles were for or what caused them.)

The secondaries are attached to the area that would correspond to the region between the human elbow and the wrist. They are evenly spaced in that area and as the wing is moved, the angle of the secondaries changes with the angle of that area.

The tertials are usually five in number and are longer than the secondaries. They would be attached to the elbow region of the arm. The movement of this area dictates the direction and location of the tertials in relation to the rest of the duck. The shape and size of the tertials vary by species, so each has to be checked to ensure accuracy.

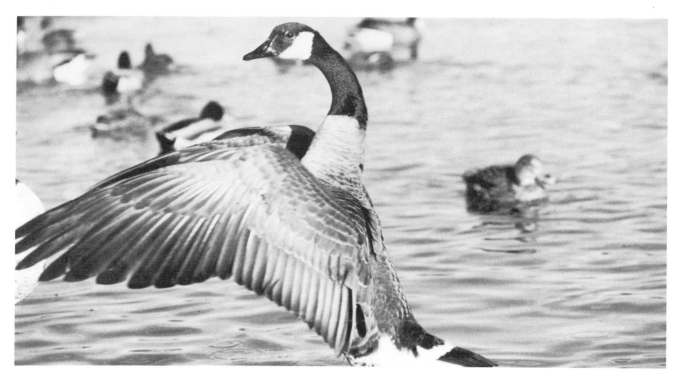

Canada goose. As the goose exercises its wings, the extended neck shows the hourglass, or tapered, shape also. There are ten primaries on each wing—the same as ducks—but there are more secondaries.

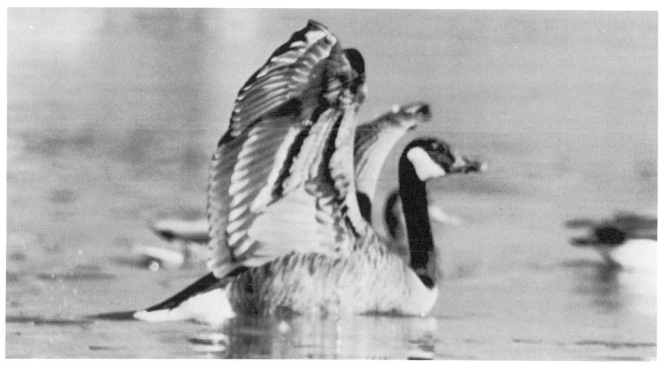

Canada goose. Just folding the wings before putting them in the pocket, the various sets of the underwing lining can be seen.

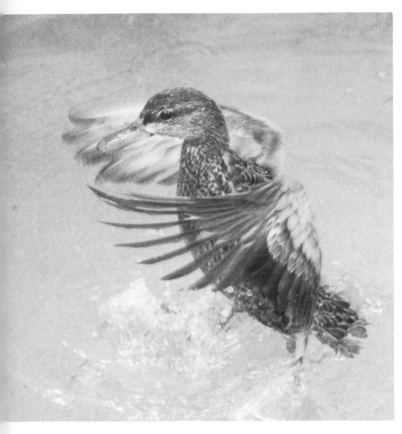

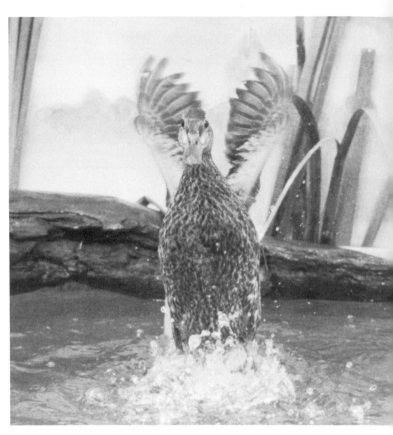

Blue-winged Teal. Almost standing on the water, she expels the water from her wings after a bath.

Blue-winged Teal hen. The hourglass taper shows in this front view as she exercises. Even with the neck stretched, it remains tapered on the sides.

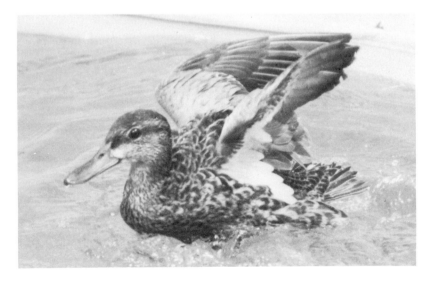

Blue-winged Teal hen. The bath over, she starts the folding of the wings and opens the sidepockets to accept them. The long, white feathers under the wing are the axillars and are on all ducks and geese but vary in color and markings.

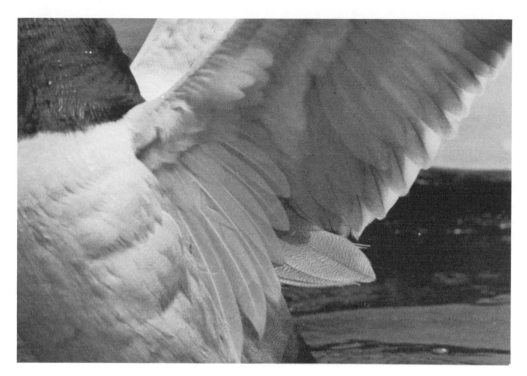

Canvasback drake. As he stretches his wings, the axillars show their position on the underside of the wing. The feathers of the sidepocket are wet and bunched, creating a rowlike look.

Mallard wing. The underside of the primaries show how they are stacked and shaped out toward the end. The quills are near the leading edge of the first primary but are more toward center by the tenth feather. The quills of the primaries curve toward the tip. The quills of the secondaries curve in toward the body.

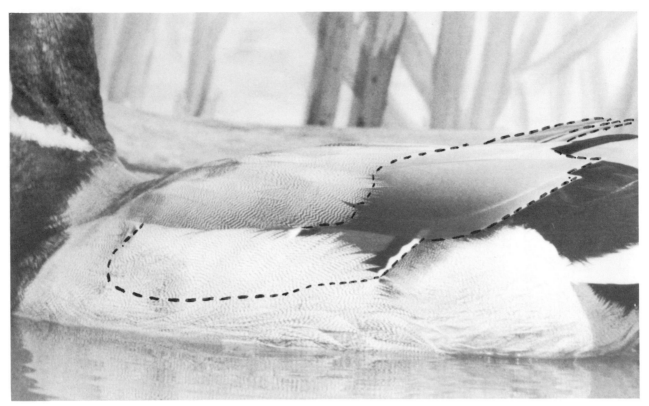

Mallard drake. The dotted line shows the location of the wing under the feathers.

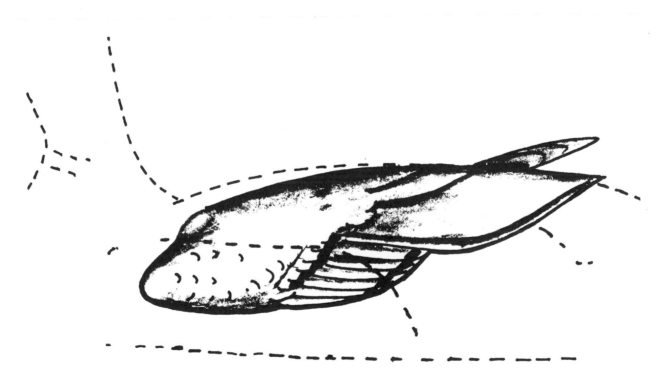

The basics of the wing without being covered by body feathers.

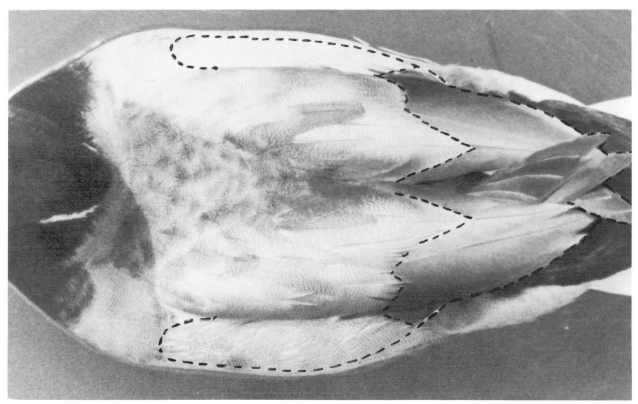

Mallard drake. The dotted line shows the location of the wings under the feathers from the top side.

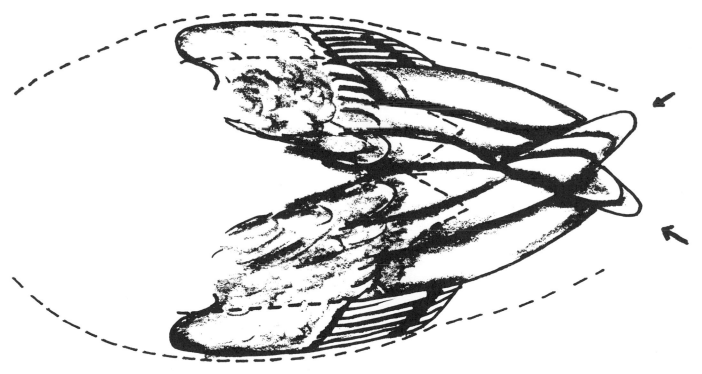

The basics of the wings folded over the body. Dotted line shows location and the arrows point at primaries and the side they come from.

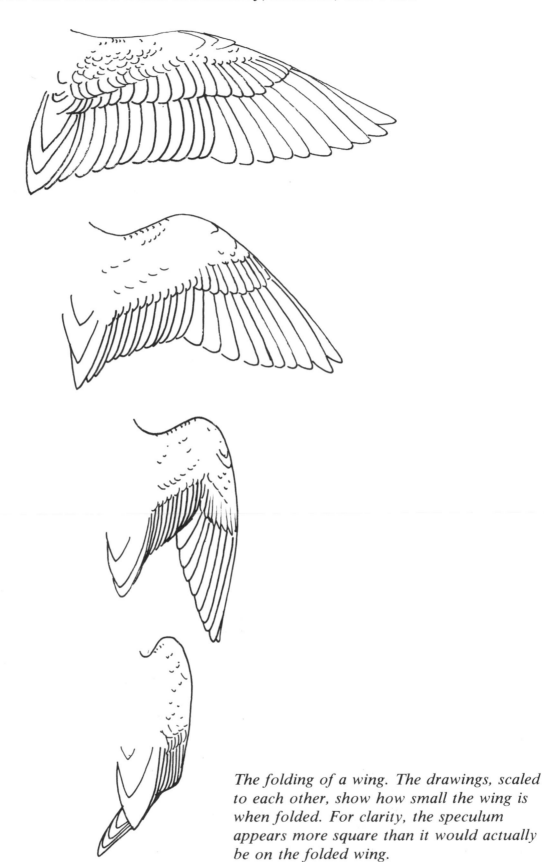

The folding of a wing. The drawings, scaled to each other, show how small the wing is when folded. For clarity, the speculum appears more square than it would actually be on the folded wing.

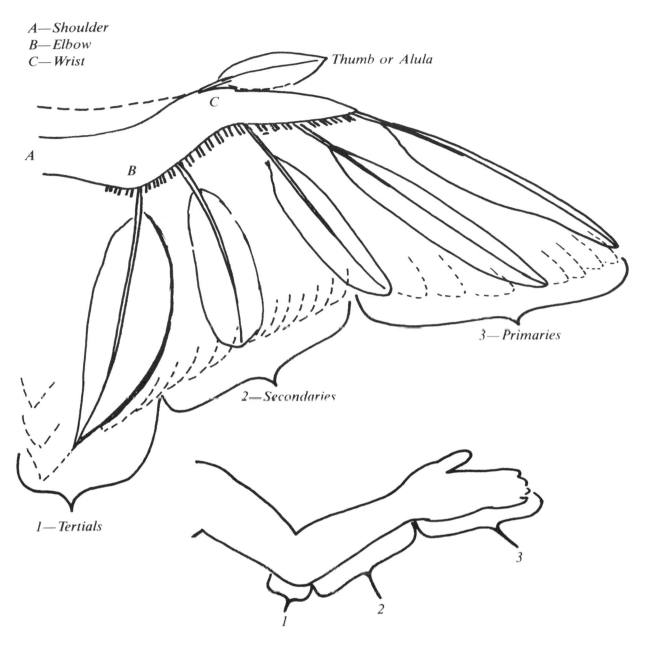

A—Shoulder
B—Elbow
C—Wrist

Thumb or Alula

A

B

C

1—Tertials

2—Secondaries

3—Primaries

1

2

3

The wing in relation to the human arm and hand.

STRUCTURE PAINTING WITH ACRYLICS
Mallard Drake

1. _____

The entire feather area of the head is painted with a base coat of Burnt Umber. The bill is painted with Cadmium Yellow Medium with some Brown left in the brush and mixed. I prefer to get life into the painting as soon as possible so the next step for me is to paint the detail of the eye, but it can be done anytime you prefer.

2. _____

Small hairlike marks are applied over entire surface to stimulate the splaying ends of the small feathers. The color used for this is a mixture of Yellow and White. Some of the lines may need a second or third coat depending on the thickness of paint. You do not have to be overly meticulous with these subcoats. The bill is coated with Cad Yellow again, this time using a clean brush before applying the Yellow.

3. _____

Thin Hookers Green is brushed over entire feather area. If the paint is too thick, it will cover all your marks. The Green should be applied in very thin coats that will allow the under colors to show through. The secret is in the thin coats and building up to the darkness you wish. The bill is highlighted and shaded using White or Ivory Black added to the Yellow.

4. _____

Definition is achieved by adding small strokes in areas you wish to highlight. The mixture is more Yellow than Green, but both are used to control the painting. If you get an area too light or dark, you can go back and re-structure that area with small lines using light and dark colors again. The bill is finished using the same colors as in the previous steps.

STRUCTURE PAINTING OF FEATHERS

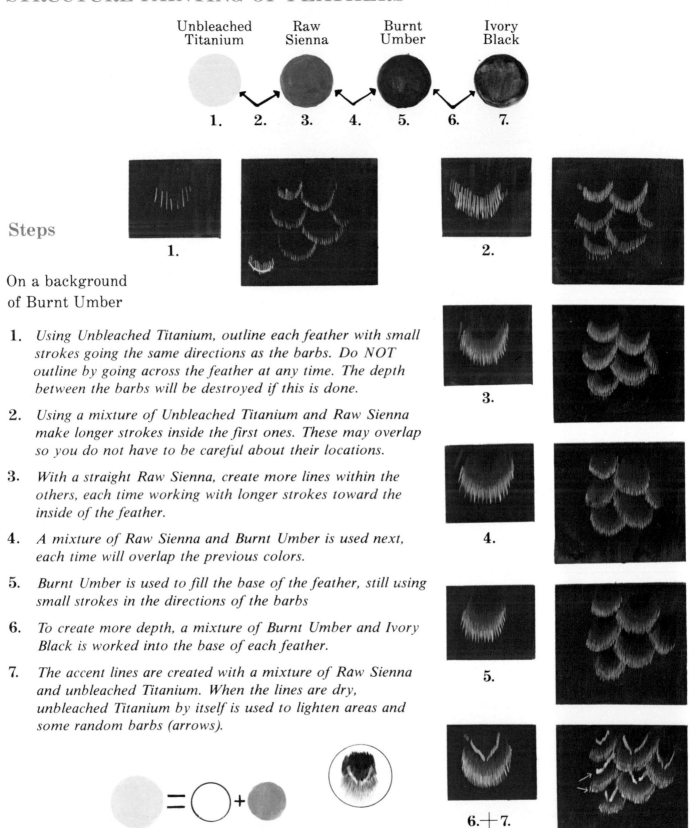

Unbleached Titanium Raw Sienna Burnt Umber Ivory Black

1. 2. 3. 4. 5. 6. 7.

Steps

On a background of Burnt Umber

1. *Using Unbleached Titanium, outline each feather with small strokes going the same directions as the barbs. Do NOT outline by going across the feather at any time. The depth between the barbs will be destroyed if this is done.*

2. *Using a mixture of Unbleached Titanium and Raw Sienna make longer strokes inside the first ones. These may overlap so you do not have to be careful about their locations.*

3. *With a straight Raw Sienna, create more lines within the others, each time working with longer strokes toward the inside of the feather.*

4. *A mixture of Raw Sienna and Burnt Umber is used next, each time will overlap the previous colors.*

5. *Burnt Umber is used to fill the base of the feather, still using small strokes in the directions of the barbs*

6. *To create more depth, a mixture of Burnt Umber and Ivory Black is worked into the base of each feather.*

7. *The accent lines are created with a mixture of Raw Sienna and unbleached Titanium. When the lines are dry, unbleached Titanium by itself is used to lighten areas and some random barbs (arrows).*

Unbleached Titanium = White + Yellow Ochre Same colors on White background.

FEATHER ACCENTS—Female Puddle Ducks

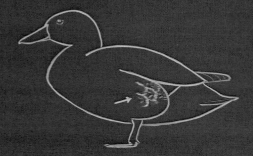

Area of detail

Mallard

Black Duck

Pintail

Gadwall

Shoveler

Wigeon

Wood Duck

Blue-winged Teal

Green-winged Teal

Markings and color will vary with age and season.

COLOR REFERENCE CHART
Puddle Ducks

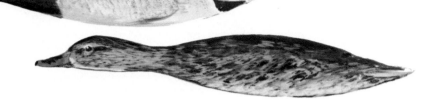

Mallard drake.

Mallard hen.

Black Duck drake.

Black Duck hen — body color similar to drake.

Gadwall drake.

Gadwall hen.

Wigeon drake.

Wigeon hen.

Pintail drake.

Pintail hen.

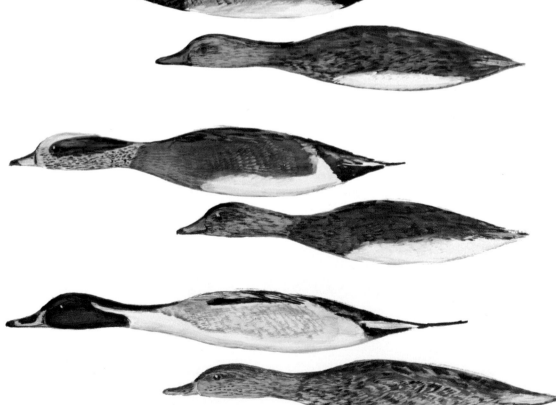

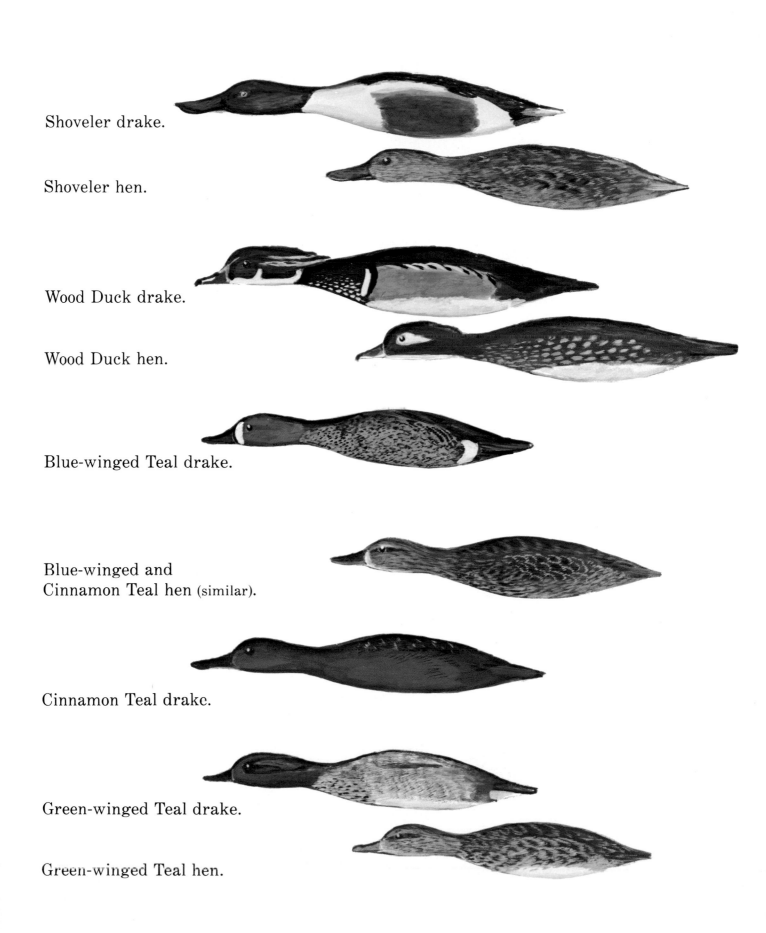

Shoveler drake.

Shoveler hen.

Wood Duck drake.

Wood Duck hen.

Blue-winged Teal drake.

Blue-winged and
Cinnamon Teal hen (similar).

Cinnamon Teal drake.

Green-winged Teal drake.

Green-winged Teal hen.

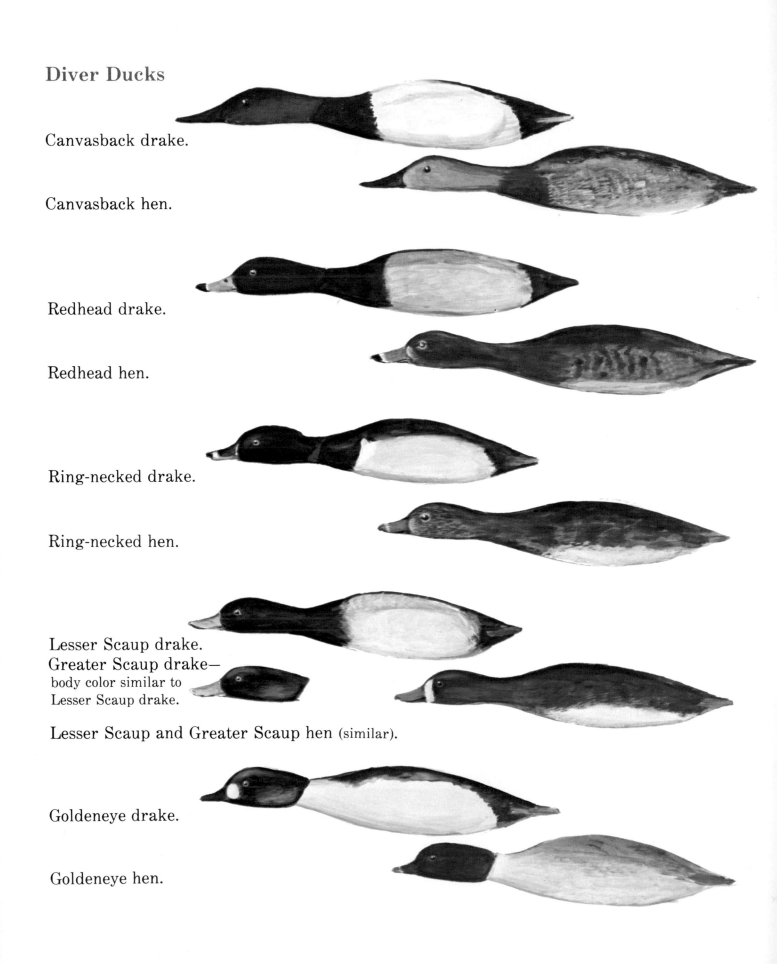

Diver Ducks

Canvasback drake.

Canvasback hen.

Redhead drake.

Redhead hen.

Ring-necked drake.

Ring-necked hen.

Lesser Scaup drake.
Greater Scaup drake—
body color similar to
Lesser Scaup drake.

Lesser Scaup and Greater Scaup hen (similar).

Goldeneye drake.

Goldeneye hen.

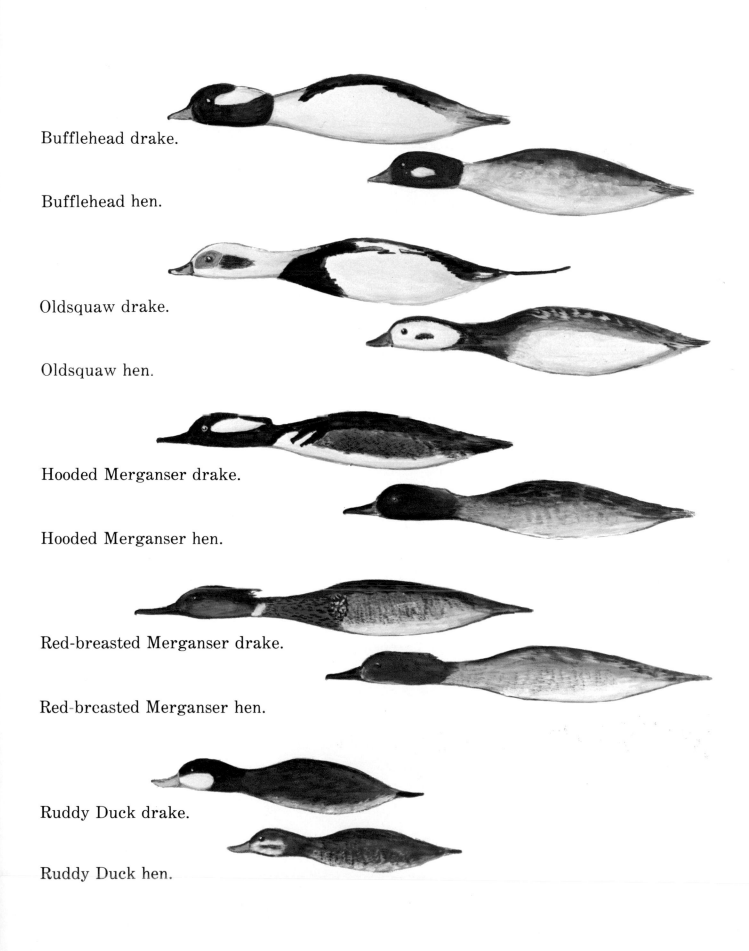

Bufflehead drake.

Bufflehead hen.

Oldsquaw drake.

Oldsquaw hen.

Hooded Merganser drake.

Hooded Merganser hen.

Red-breasted Merganser drake.

Red-brcasted Merganser hen.

Ruddy Duck drake.

Ruddy Duck hen.

WINGS
Puddle Ducks

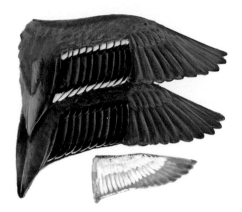

Mallard, both sexes, *top;* Black Duck, both sexes, *bottom;* and underside of both species, *below.*

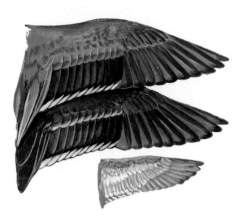

Pintail drake, *top;* hen, *bottom;* and undersides, *below.*

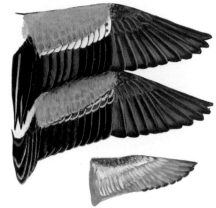

Blue-winged and Cinnamon Teal drakes, *top;* hens, *bottom;* and undersides, *below.*

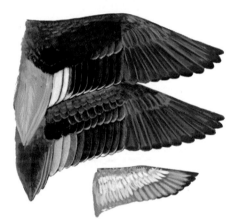

Gadwall drake, *top;* hen, *bottom;* and undersides, *below.*

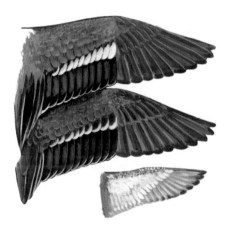

Shoveler drake, *top;* hen, *bottom;* and undersides, *below.*

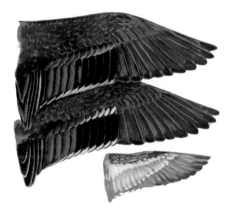

Green-winged Teal, drake, *top;* hen, *bottom;* and undersides, *below.*

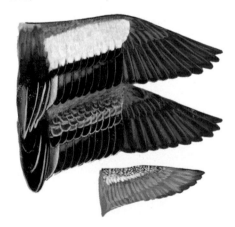

Wigeon drake, *top;* hen, *bottom;* and undersides, *below.*

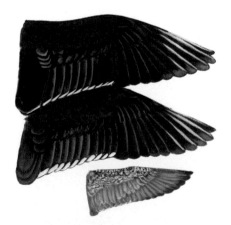

Wood Duck, drake, *top;* hen, *bottom;* and undersides, *below.*

Note: Drawings are not meant to be proportional but are for color reference only.

Diver Ducks

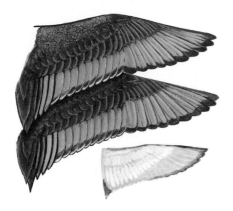

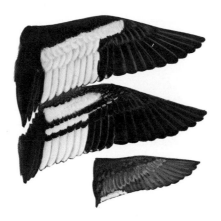

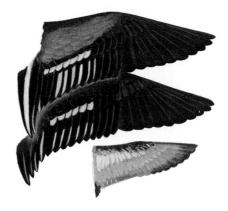

Redhead drake, *top;* hen, *bottom;* and undersides, *below.*

Goldeneye drake, *top;* hen, *bottom;* and undersides, *below.*

Hooded Merganser drake, *top;* hen, *bottom;* and undersides, *below.*

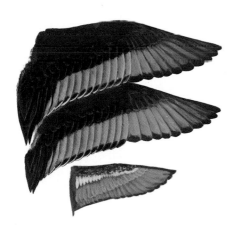

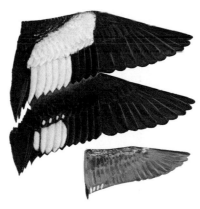

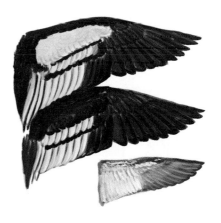

Ring-necked drake, *top;* hen, *bottom;* and undersides, *below.*

Bufflehead drake, *top;* hen, *bottom;* and undersides, *below.*

Red-breasted Merganser drake, *top;* hen, *bottom;* and undersides, *below.*

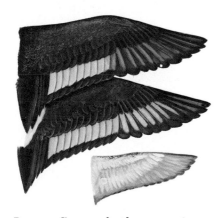

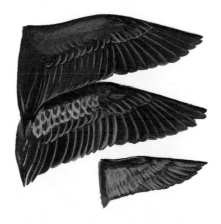

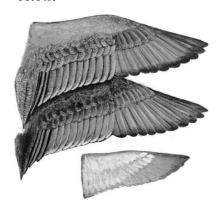

Lesser Scaup, both sexes, *top;* Greater Scaup, both sexes, *bottom;* and undersides, *below.*

Oldsquaw drake, *top;* hen, *bottom;* and undersides, *below.*

Canvasback drake, *top;* hen, *bottom;* and undersides, *below.*

Ruddy Duck drake wings—dark brown, no distinct markings.

Note: Drawings are not meant to be proportional but are for color reference only.

DUCK BILLS

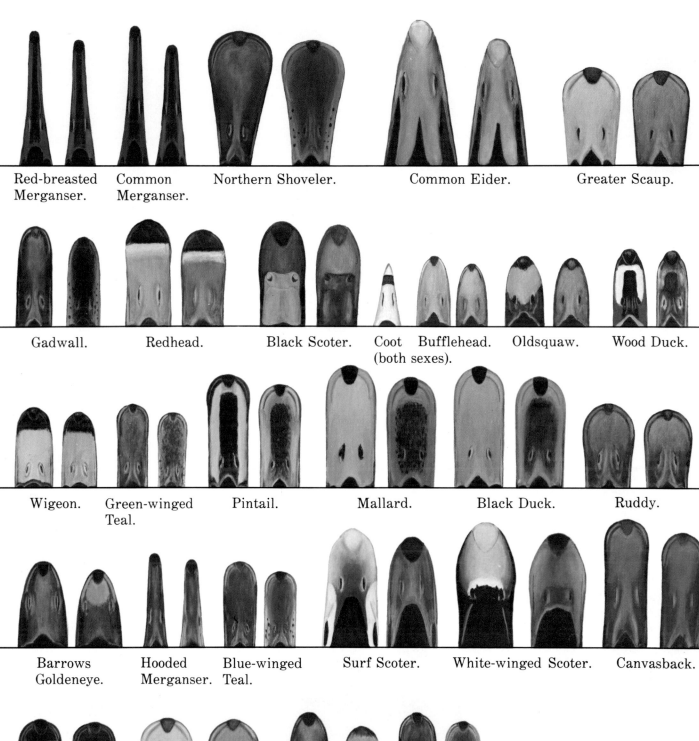

Red-breasted Merganser. Common Merganser. Northern Shoveler. Common Eider. Greater Scaup.

Gadwall. Redhead. Black Scoter. Coot (both sexes). Bufflehead. Oldsquaw. Wood Duck.

Wigeon. Green-winged Teal. Pintail. Mallard. Black Duck. Ruddy.

Barrows Goldeneye. Hooded Merganser. Blue-winged Teal. Surf Scoter. White-winged Scoter. Canvasback.

Ring-necked. Lesser Scaup. Goldeneye. Cinnamon Teal.

Note: Male bill on left, female bill on right.

DUCK FEET
Puddle Ducks

Three color variations of Mallard feet.

Black Duck.

Blue-winged and
Cinnamon Teals.

Gadwall.

Wood Duck.

Shoveler.

Green-winged Teal.

Pintail.

Wigeon.

Diver Ducks

Red-breasted and
Common Mergansers
(male).

Red-breasted and
Common Mergansers
(female).

White-winged
Scoter (male).

White-winged
Scoter (female).

Surf Scoter (male).

Surf Scoter (female).

Goldeneye.

Ring-necked (male).

Bufflehead (male).

Ring-necked and
Bufflehead (female).*

Black Scoter.

Hooded Merganser.

Canvasback and Redhead.

*Also Lesser and Greater Scaup, Oldsquaw, and Ruddy (both sexes).

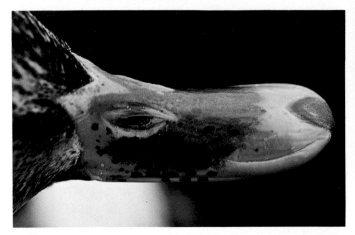

Mallard hen bill.

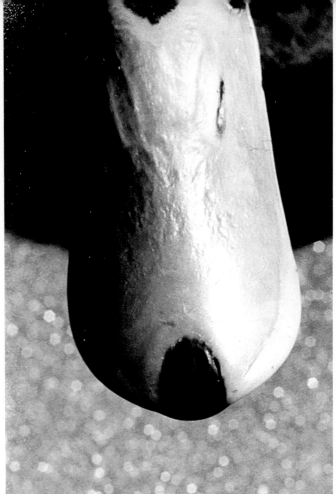

The bill of the Lesser Scaup "Bluebill" drake.

Ring-necked drake, often referred to as Ringbill. The white area is slightly raised.

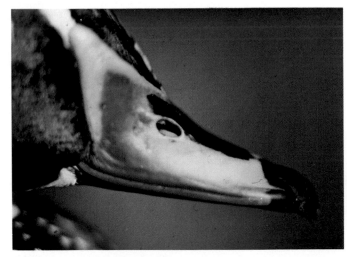

Wood Duck drake bill. The yellow area is softer and bulbous. The black on the top of the bill is recessed slightly.

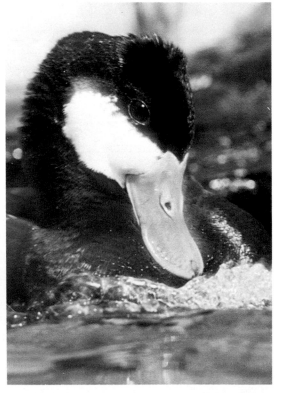

Ruddy Duck drake in courtship display.

Bill of Pintail drake shows the pearlescent qualities when wet.

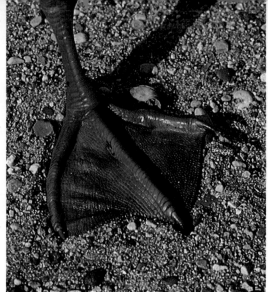

The Mallard drake—Redleg.

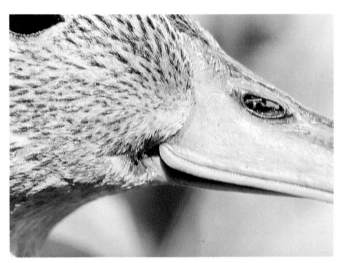

Pintail hen—the upper mandible curls upward at the corner of the mouth. You can see through the nostril openings.

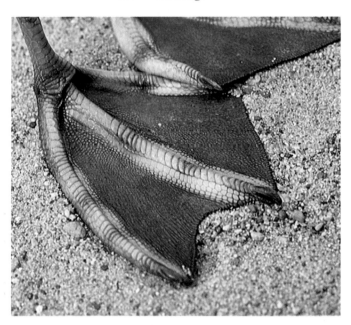

Canvasback drake feet.

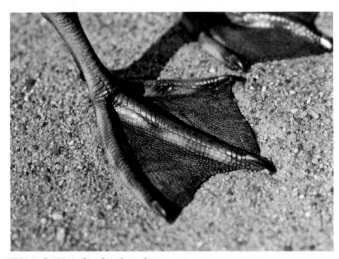

Wood Duck drake feet.

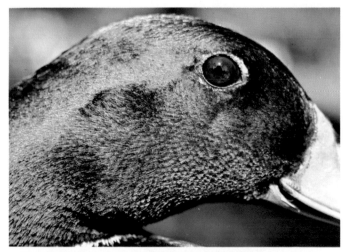

Iridescent green head of the Mallard drake.

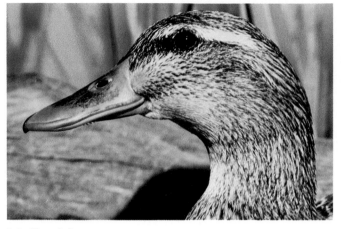

Mallard hen.

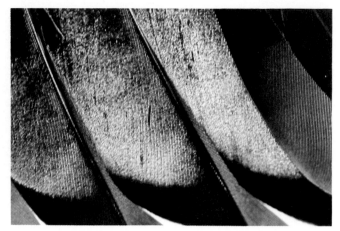

Multicolor iridescence of the Mallard wing speculum. The bright colors are on the outer half of each secondary feather.

Mallard drake, top view.

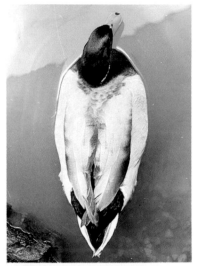

Canvasback hen, top view.

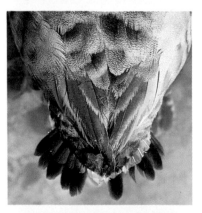

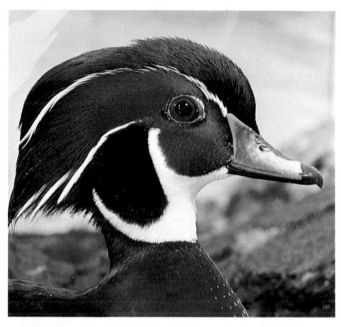

Wood Duck drake. (Photo by Dick Etter.)

Canvasback drake, top view.

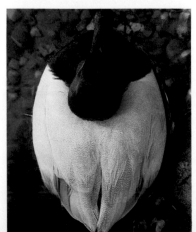

Under tail area of the Mallard hen.

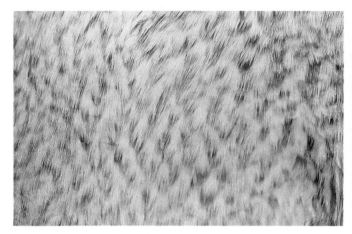

Belly feathers of the Mallard hen.

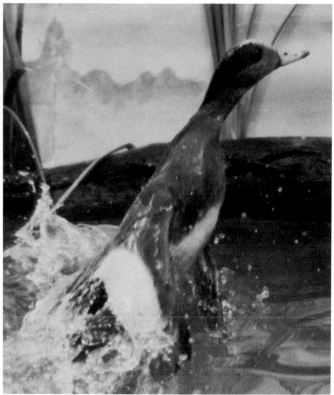

A startled Wigeon drake launches into the air.

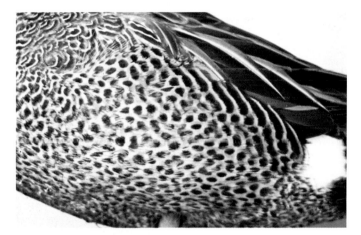

The side of the Blue-winged Teal drake.

Gadwall drake, top view.

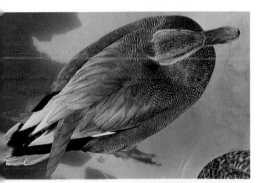

Gadwall hen, top view.

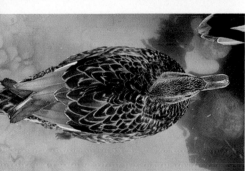

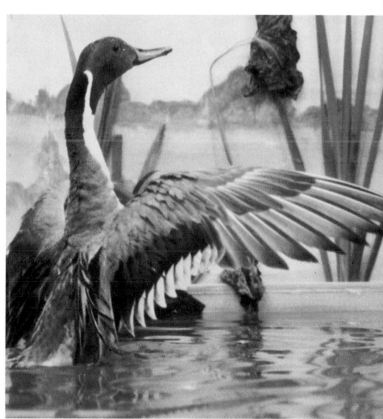

A Pintail drake flaps his wings after a bath.

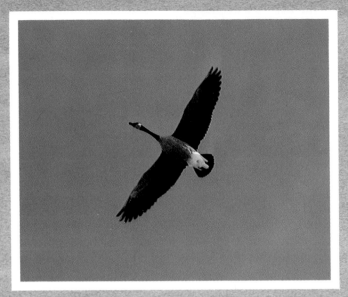

CANADA GOOSE

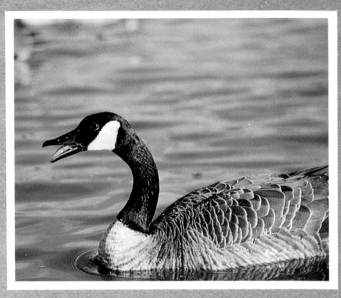

Color of inner mouth and tongue is similar on most waterfowl.

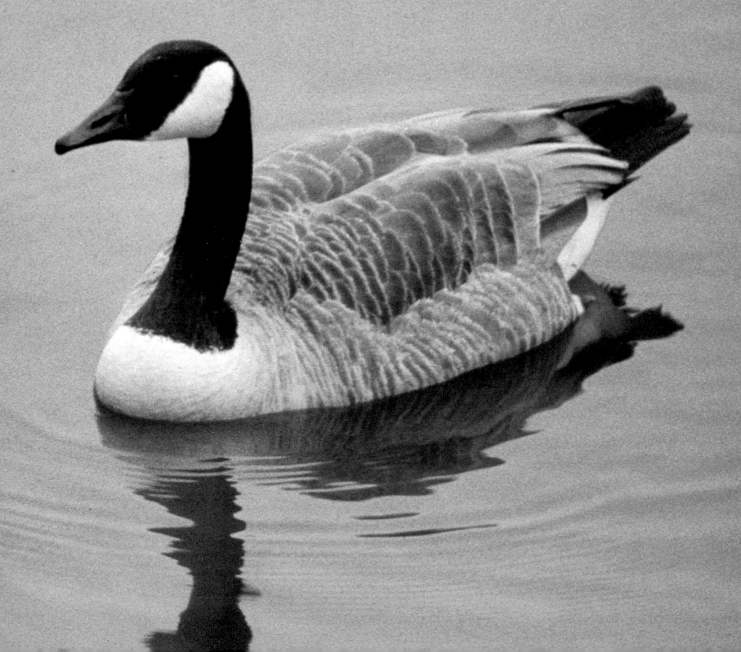

FEET

The feet on ducks are known for the web between their toes. Other waterfowl have webbed feet also, but ducks are the most recognized for this attribute. The leg and foot of the duck, as we view it, correspond to the foot only of a human. The heel would be the upper joint. The human foot to the knee would correspond to the "drumstick" of the fowl. This area is under the sidepocket feathers and only the lower regions of it are visible at times. The thigh will not be seen unless you wish to skin the bird.

Ducks walk on a pad at the base of the so-called leg portion of the foot. The toes are used for balance as they walk or stand. One of my enjoyable experiences was watching the ducks swim in a plastic box. The box allowed me to observe what they were doing with their feet under the water. To turn, one foot goes back, the other forward; then they spin around. To stop quickly, they paddle backward just like putting on the brakes. While observing some of the ducks' actions, I was able to see what they do when they dive underwater. They use their wings for the fastest locomotion to escape danger and as they slow down, they start using their feet. The feet were not used until the wings started tiring. Even ducklings tried to use their wings first, but to no avail because of their size.

Underwater, the divers use their feet above the body most of the time. Puddle ducks do not have this trait, so they will have the feet to the sides or under the body when in action.

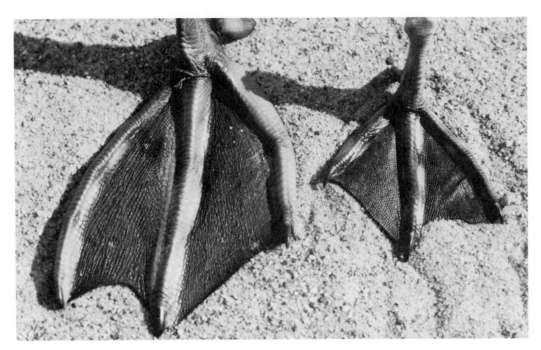

Scoter and Wood Duck feet. The size difference between the divers and the puddle ducks is dramatic in this comparison, but it mostly depends on the species as all sizes vary.

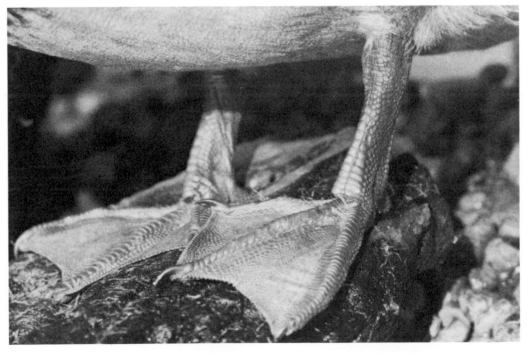

Mallard drake. The feet are able to contour to most surfaces because of their flexibility. To aid this, there is one joint on the inner toes, two on the center toes, and three on the outer toes. That is not counting the joint on each nail. The joints can move up or down to some degree. In this picture, the sidepocket is pushing the belly feathers out behind it.

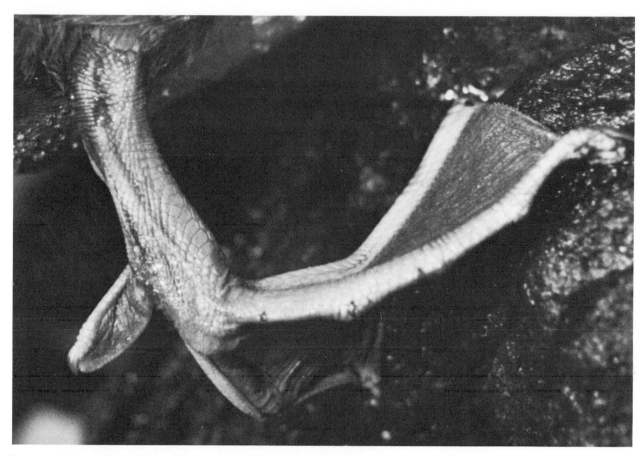

Lesser Scaup hen. The lobe of the hind toe is a diver distinction.

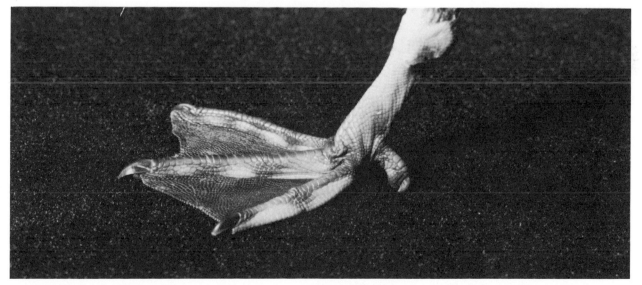

Right foot of a Green-winged Teal. A view from the innerside looking to the outside. There is an extra flap of skin on the outside of the inner toe. The hind toe does not have the lobe.

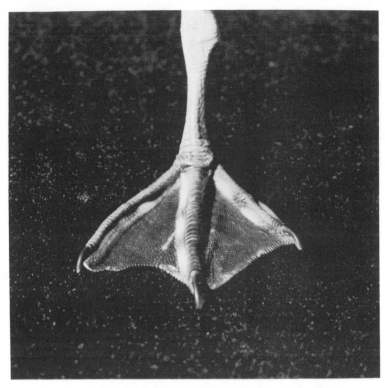

Green-winged Teal. Front view of the right foot.

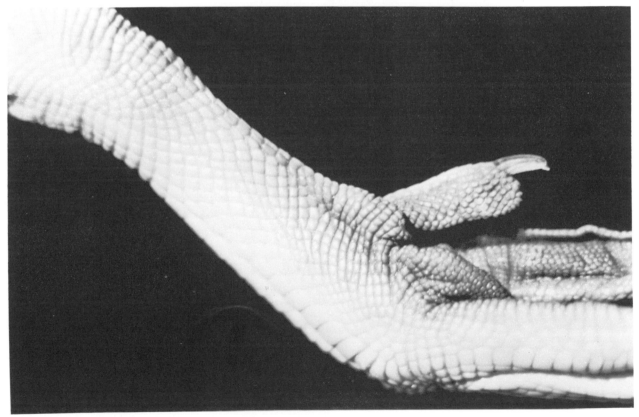

Foot of the Mallard drake.

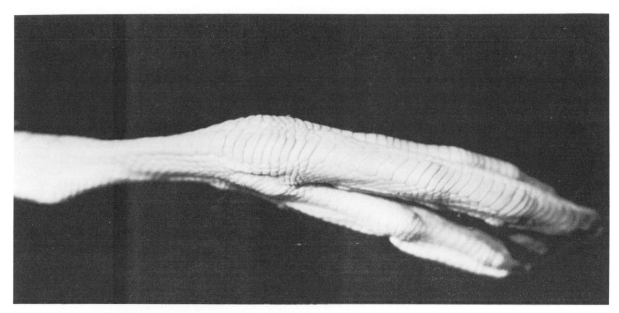

Partially folded foot of the Mallard (left foot).

Wood Duck hen with feet at rest underwater.

Wood Duck hen. This rear view shows the body contours of ducks created by prevailing forces. She is starting to move the foot on the right and the web between the toes is reacting.

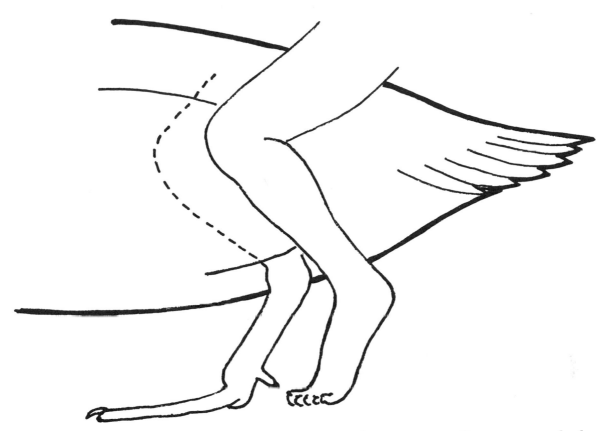

The human leg and foot compared to those of ducks. The part normally seen on a duck would compare to the human foot only, the leg is under the feathers. The direction and movements correspond also. The drumstick of a fowl, as we refer to it, would compare to the area between the knee and the heel of the human leg.

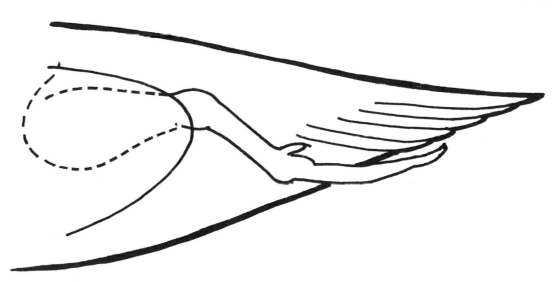

Approximate position of folded leg and foot for flying attitude. This varies with species and size of foot.

THE MOLT

Due to their continued exposure to the elements, feathers actually wear out each year and have to be replaced. New feathers will grow as birds shed the old feathers; this process is known as the molt. *Most* birds go through the molt once a year, a slow process that enables the bird to retain its flying capabilities. If they lose a feather on one wing, it will be balanced by the loss of a closely corresponding feather on the opposite wing. They can always fly to forage for food and safety.

This is not true—waterfowl are an exception to the rule. *Ducks lose their flight feathers completely* in a simultaneous molt that restrains their flying capabilities. They go through this flightless period once a year and are incapable of flying for approximately six to eight weeks while the new wing feathers grow to maturity. Ducks are very distinctive in this respect, for they not only become flightless but go through a complete molt of the body feathers, twice each year. (The wing and tail feathers are shed once a year but the body feathers change twice each year.)

Geese and some other waterbirds molt their flight feathers simultaneously also, but they only have a single annual change of body feathers.

A newly hatched duckling emerges from the shell fully covered with down. A few days later, feathers start their growth and within a few short weeks the duck is entirely covered with feathers (although the larger feathers and some areas require a longer growth time). This process varies somewhat with the individual species.

131

The plumage of a male duck starts with the covering of down as a duckling, then to the first feathers which are called the juvenile plumage. The coloration of the juvenile plumage of the males is very similar to the females. Juvenile plumage lasts throughout the summer on most species but each species may vary. The Blue-winged Teal and Shoveler drakes retain their juvenile plumage until early winter. The first signs of change on many species take place in early fall when the adult plumage starts to take place. This transition may take several months before the young drake has his first adult plumage. All of these transitions vary greatly for individual species.

The bright adult color is also called the nuptial plumage and is retained throughout the courtship and mating season in the spring. The nuptial and courtship plumage lasts throughout the spring migration back north to where they were born. After migrating and the mating season, it loses its nuptial plumage and is considered a full adult drake. The drake then starts an eclipse plumage which will resemble the female plumage. When this first eclipse has taken place, the drake will then lose the flight feathers and become flightless during the midsummer months. As they emerge from this eclipse plumage they are very similar to the coloration of the new young males entering their first fall plumage.

The colors of the female darken and are more drab during the mating and nesting period. This helps her escape detection while on the nest. The female does not lose the wing and tail feathers until nesting is over and the brooding of the young is complete.

During the early fall migration, young males are often misidentified as females. To compound this, there are males of several species of ducks that do not achieve a full nuptial or breeding coloration until their second or third year. Within these species, a young male may reach adulthood and still not attain the bright nuptial plumage. These males normally have to reach maturity before they achieve the coloration and are capable of reproducing. In most instances, a trained person can identify the young males and distinguish the difference between them and the females. Biologists and gamebreeders identify the sex of ducks by examining the vent and checking for, or the absence of, a penis.

The common method used for determining whether a bird is in its first year or an adult is to look at the tips of the tail feathers. If the duck is a first-year bird, the tail feathers will be notched on the ends. This notch will show on the young ducks that are on their first migration south. After the first year molt and regrowth, the ends of the tail feathers will be pointed. You might be asking, what has this to do with carving or painting? I think that one of my experiences might serve as an answer or at least as an insight to problems that may arise:

I was viewing some of the entries to the federal duck stamp competition a few years ago, when an artist friend walked up beside me and beamed happily. After all, he had just been accepted as one of the top 20 entries. He had reason to be proud and I saw no reason to deflate his ego at that time. Had he only realized that he had painted a Blue-winged Teal drake in the nuptial plumage alongside an immature drake, he might have wanted to hide instead. A drake in spring plumage and another in the fall plumage would never appear at the same time, and yet the judges still did not detect it. What kind of persecution do you think might have happened if it had been declared the winner?

The answer lies in the artist's ability to achieve positive reference. In this case the artist had thought that he was painting a pair, a male and female, but the young male looked very much like the female with minor exceptions. He had managed to show these exceptions in detail though. Study the plumage and the different transitions carefully before you set the world afire with your talents.

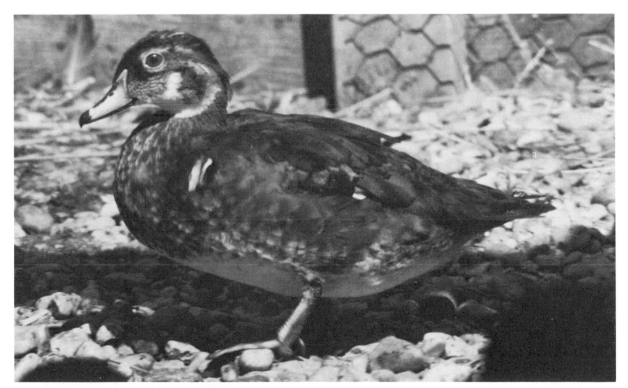

Wood Duck drake in the eclipse.

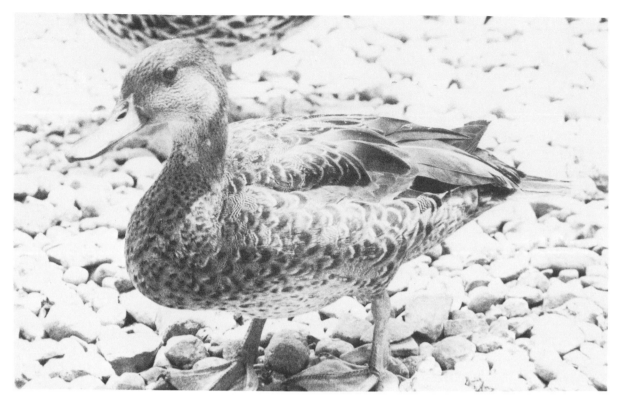

Pintail drake.

Gadwall drakes. A hen is in the background to the left.

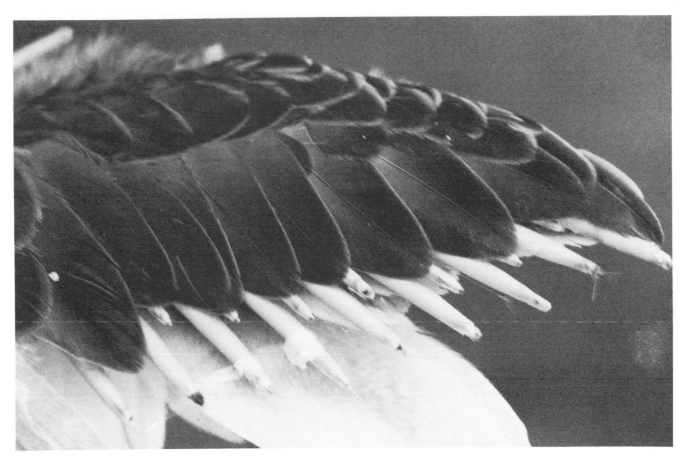

Black Duck wing in the eclipse. The primaries have fallen out and the new ones are emerging from the feather follicles.

ASSEMBLING THE KNOWLEDGE

In the first part of this book, I commented that knowledge would increase the quality. The knowledge of WHAT to do and HOW to do it comes before you CAN do it. This learning is done by compiling bits and pieces of the details that you are sure about and then filling the spaces in between as you go. The most complex things in the world are structured or assembled one bit at a time. There are no magic wands to wave so all can be completed at once. There are no magic answers that will make it easy for you—EASIER perhaps, but that is as far as it will go. There are no magic answers, *just work*. How hard you work, or have worked (learning), will be reflected in the quality of your finished art. THERE IS NO SHORTCUT TO QUALITY!

So far in this book, I have tried to build your knowledge a little bit at a time. If you are one of the majority who just look at the pictures in a book and read just the captions under them, you probably would not get to reading these comments. By detailing the captions, I hoped to trigger the learning and association for this group. If you are one who looks at the pictures, reads the captions, and continues to read the whole book, your chances of retaining the information will be much greater, and you will be the benefactor of your added efforts. Learning and teaching are all done through repetitious attention to detail.

Now that I have explained some of my methods of attacking detail and knowledge, use it to your advantage. Write your own detailed captions for any picture in any book. What would you say about that picture if you were trying to convey what you see to others? The more you think about the details, the more you will be learning, or actually teaching yourself.

Now, down to assembling the things we have learned so far. The anatomy, actions, and habits of ducks have been divided into two groups: divers and puddle ducks.

First, where would you see them? Divers normally frequent larger, open areas of water. They will be seen flying low over the water in two distinct levels. The species that fly the lowest, as an average, will be the Mergansers, Buffleheads, Ruddy Ducks, Oldsquaws, Eiders, and Scoters. At times, the tips of the wings on these species may even touch the higher waves. The remainder of the diver group fly on a level that would be just above this low-flying group.

Puddle ducks will be seen on small ponds or streams or at the edges of large bodies of water. Puddle ducks fly higher as a group than the divers. The species of Teal, Shoveler, and Wood Ducks can be found flying in an area just above the levels the divers prefer to use. I have related the level the smaller puddle ducks use as just above and below an extremely tall tree.

The problem may arise that the tree in my stomping grounds may be taller or shorter than those in your neighborhood, but experience in the field will prove my observation out.

The larger puddle ducks—Mallards, Blackducks, Wigeons, Pintails, and Gadwalls—fly at the highest level. Geese can also be seen flying in or above the same level with the larger puddle ducks. All of the observations of these various levels would be over open water and during nonmigratory seasons and average weather conditions. These levels are detailed in *The LeMaster Method—Waterfowl Identification.*

Let's further separate the two groups by their habits, shapes, and attitudes. Divers run across the water to take off. By doing so, their angle of flight will probably be low as they rise. Divers put distance between themselves and danger. Puddle ducks launch themselves from the water. Their angle as they climb will be much steeper than the divers. Puddle ducks use height to their advantage as they escape danger. Both types will take off and land into the wind. Any water depicted in your art work will have to take these factors into consideration.

In flight, divers can be distinguished by their faster wingbeats, lower flying habits, and their bulbous rear belly. The cord of the wing (from

leading edge to back edge) will be approximately one-fourth the total length of the duck in level flight. The cord of the puddle ducks will be approximately one-third of the total length of the duck in level flight. Divers land at a faster speed and a lower angle than puddle ducks. Puddle ducks "drop" into land on the water due to their higher flying habits.

During fall migration, the divers frequent large bodies of water, but may be seen on small ponds in the spring migration. Puddle ducks will be seen feeding in fields during fall migration but seem to prefer small ponds during spring migration. This is probably due to the abundance of new plant life growing at the time.

On water the divers have a chunky teardrop shape to their bodies and smaller tails than puddle ducks. The puddle ducks have bodies that are longer but still teardrop shaped. The sidepockets of the divers are much higher at the rear and wrap toward the center of the back. The sidepockets of puddle ducks are almost horizontal with the water surface. From the top view, the sidepockets of the puddle ducks bulge on the outer edges, but the inner tops of the pockets are almost parallel to each other. Some species of puddle ducks have sidepockets that will wrap over the back so you will have to check these.

The primaries are contoured to the body of the divers and do not stick out as much as on puddle ducks which have the primaries elevated highly and protruding to the rear. The tail of divers is shorter and usually on or in the water. The tails of puddle ducks are elevated and will be in the water only if the duck is scared.

The speculum of diver wings may show when they are swimming but are not noticeable due to their colors. The speculum of puddle ducks rarely show while on the water but do show when standing. Most of the speculum on divers will be white or gray but puddle ducks have vivid, iridescent colors. The exception to the puddle ducks would be the Gadwalls, which have a white patch on their speculum.

The stance of the diver is upright because the legs are located toward the rear. The puddle duck stance is more on a horizontal plane because the legs are close to the center of the body. The Shovelers and the Cinnamon Teals are noted for walking "downhill" with the breast low in front as if they were off-balance.

Both types, puddle ducks and divers, have some things in common: the angle of the bill is level or up during takeoff and is level or down when landing. Shoulders are level or above the top of the head during level flight. Their heads will be in an upright position in all aerial maneuvers except when moving them to detect something from the air. The web between the center and outside toes is notched, the inner webs curved.

The leading edge of the wing starts midway between the tip of the bill and the tip of the tail (approximately). Shoulders begin in midneck on ducks in resting position.

The feet of the divers are much larger than those of the puddle ducks and also have lobes on the rear toe. The heads of the divers are very distinctive by shape, but the heads of the puddle ducks vary less in shape and more in colors and markings. Wood Ducks are the exception to this rule in puddle ducks.

There are many individual characteristics in each of the various species but it would take volumes to describe them. This review of details should help some with your understanding of waterfowl. The extent of your knowledge can (and should) go far beyond the level described in this book if you wish to dedicate the time. It is a matter of priorities. You will be as good as you want to be, if you can honestly say to yourself, "I can do better!"

I have included some line drawings of ducks in flight for your use. These are not patterns, but tracings of a few of my photographs. You may use them without fear of plagiarism because they would be very much the same if you went out and took the pictures yourself. There are just so many things that are beyond the basics.

LAYOUT

When you are ready to compose your painting, the background should usually be someplace you are familiar with. The subject matter (ducks) should start their journey to the canvas by being very small sketches. Draw each duck or flock on a piece of tracing paper, making sure to keep each one small. Place one piece over the other and assemble the stacked images until you feel that the composition or attitude is to your personal liking. When you feel that the composition is aesthetically pleasing, trace the images underneath on the top sheet. This will give you a basic composition; although small, it will allow you a better look at the total picture-to-be. Place another sheet of tracing paper over your composition and draw a frame around the composition. Don't forget that you can make it larger or smaller at any time. When you have a balance of framed composition, sketch the background inside the frame. Identifying features for proportion are all you really need, although the more time you take to sketch it right, the less time will be lost on the canvas.

The composition and the frame around it then becomes your layout and can be gridded and enlarged onto your scene or background. It can also be projected with an opaque projector.

If you do project the image, be very cautious about enlarging or decreasing the size of the ducks within your frame. It could throw the whole perspective off if you are not careful. You may end up with the

scenic background viewed at twenty feet and the ducks in the pictures at twenty yards (hypothetical dimensions for comparison only). The picture could end with two dimensions unless you stick to the small guidelines first. It is far easier to do all of this in a small area, for the eye can detect the balance because of the proximities and ratios. If you attempt all of the layout on the full scale, it becomes more difficult to balance and may require redoing whole areas. Go after it, think it out, and then do your own thing!

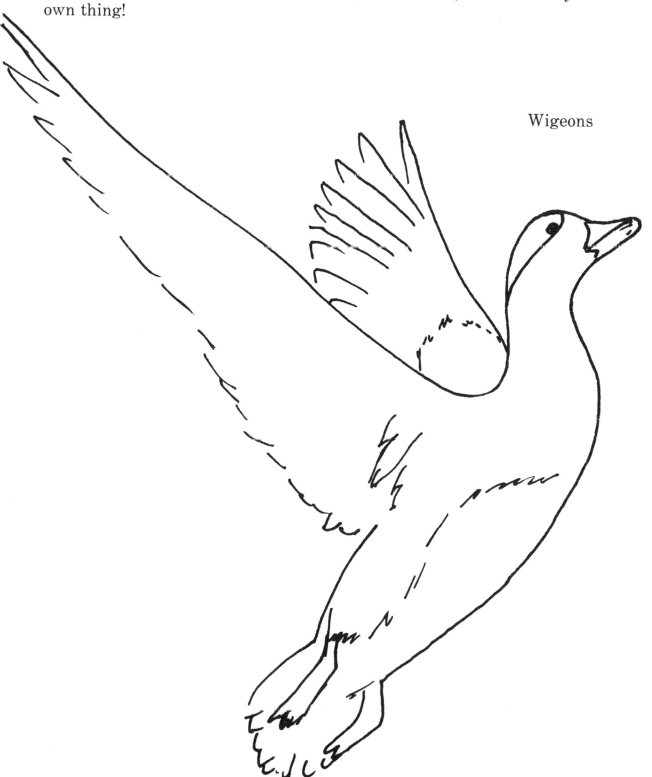

Wigeons

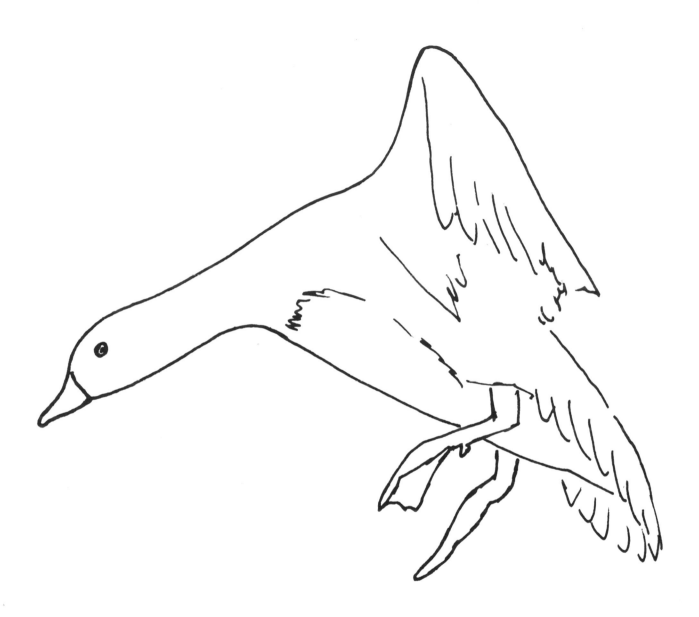

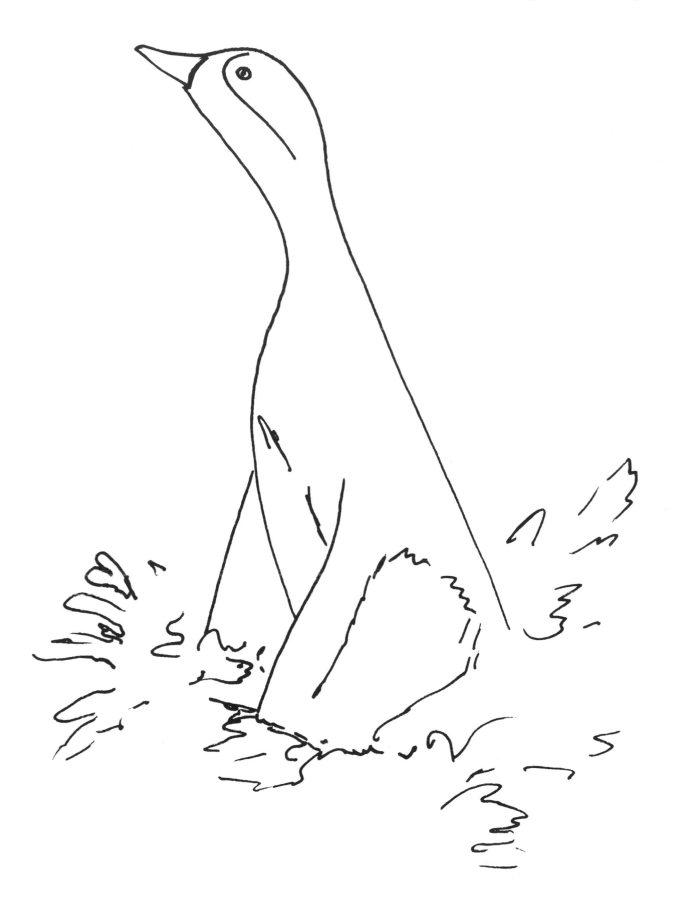

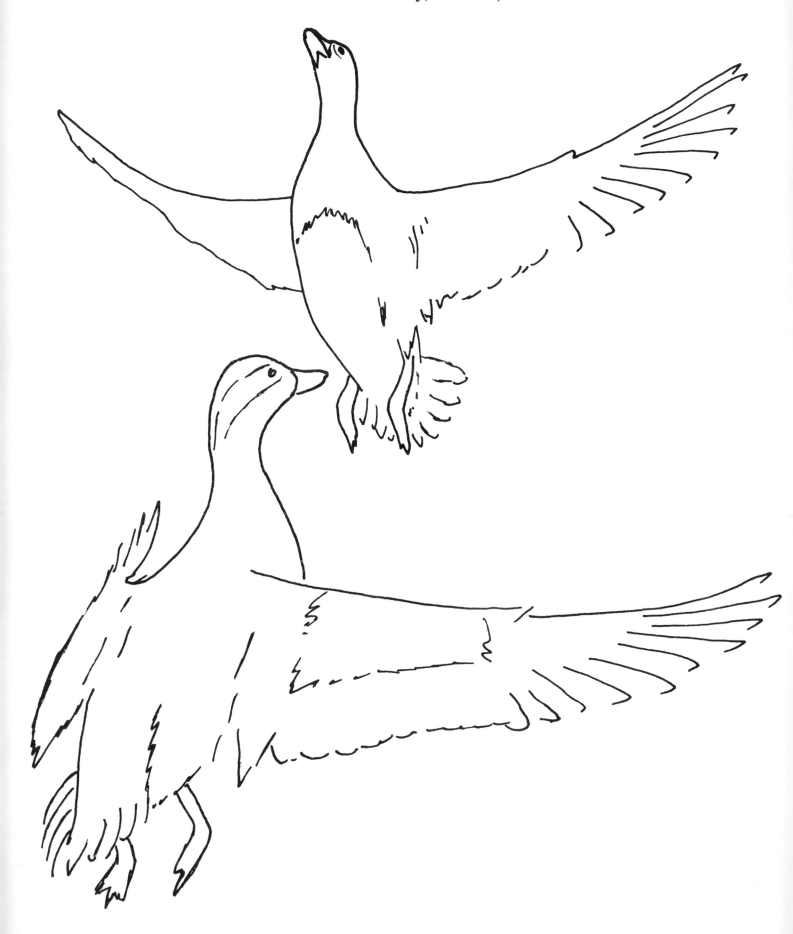

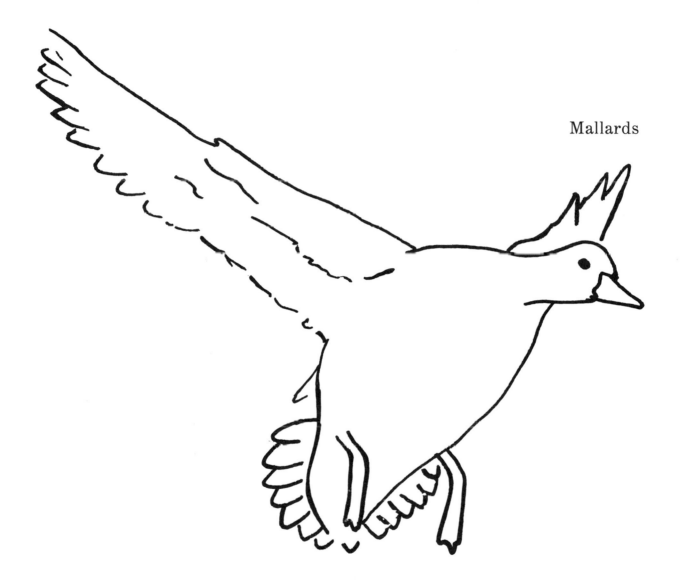

Mallards

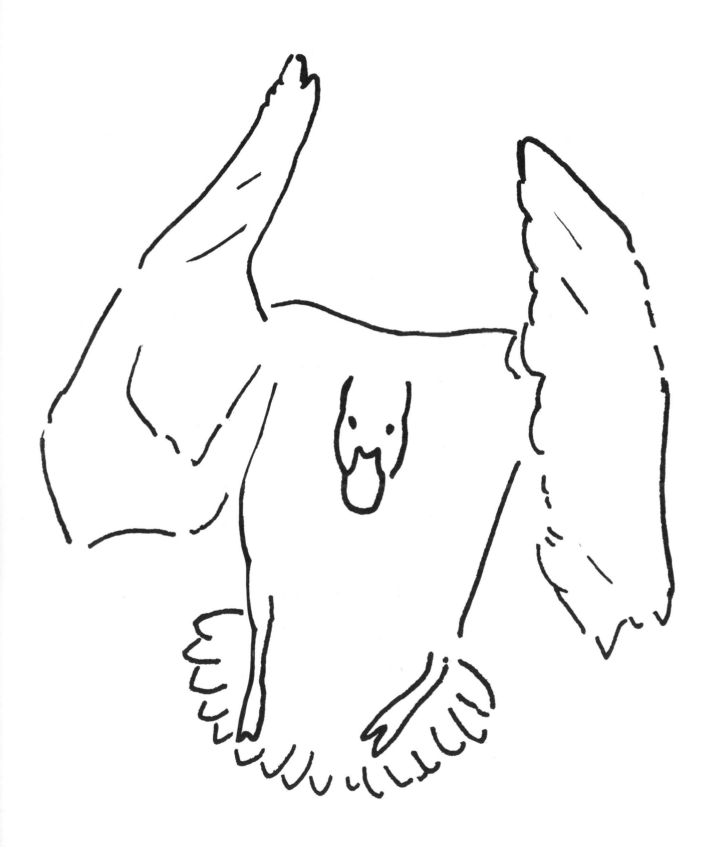

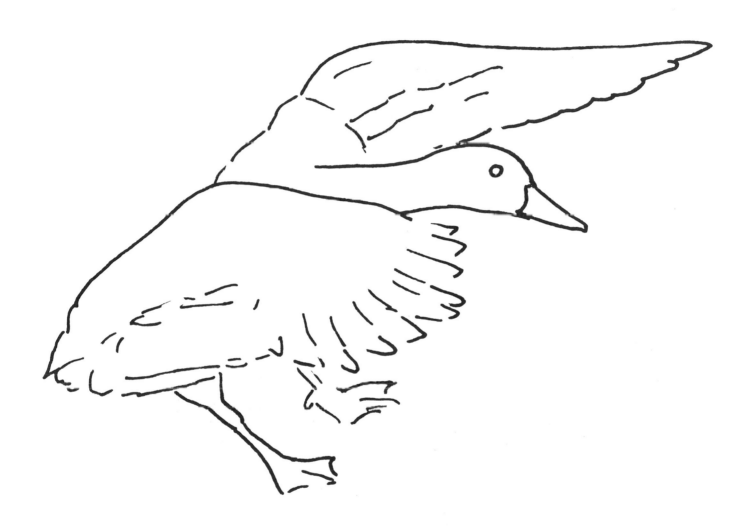

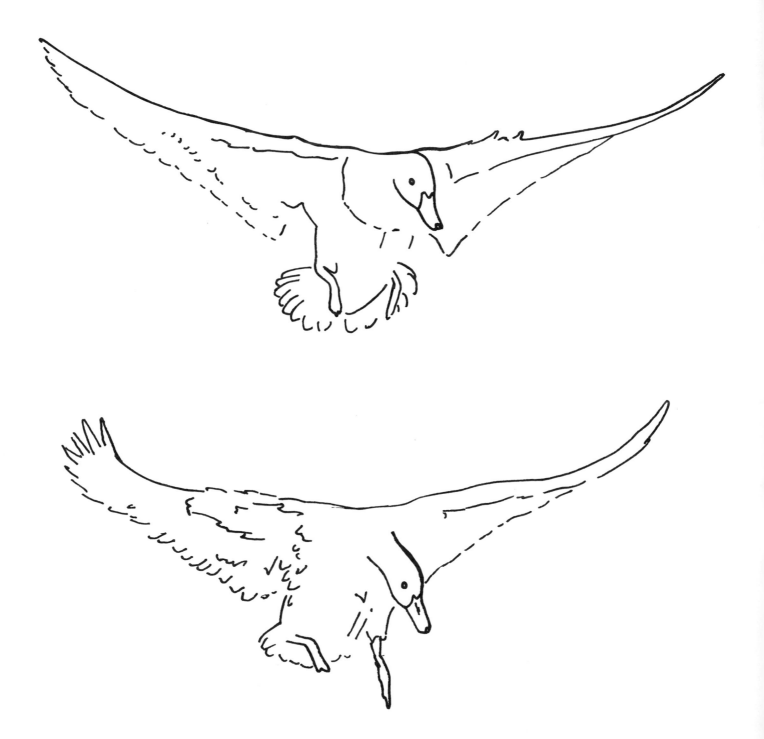

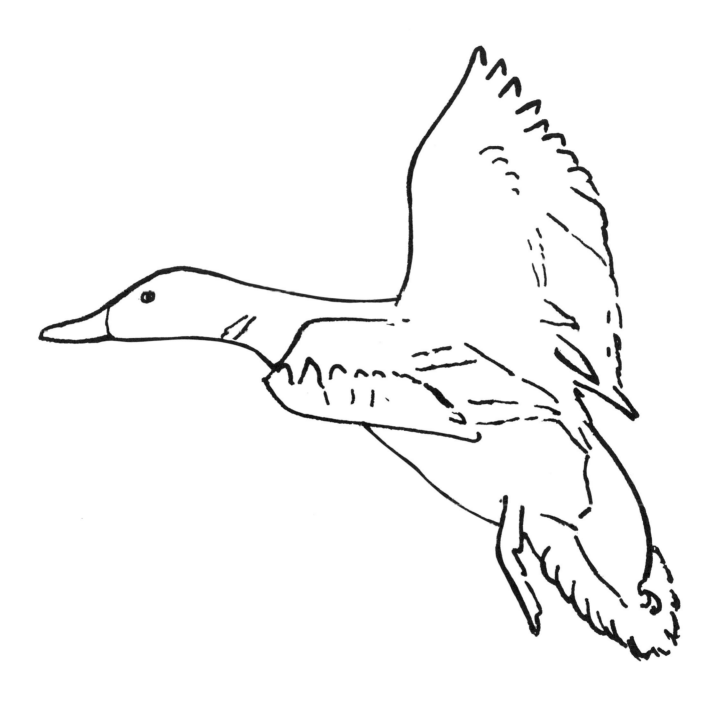

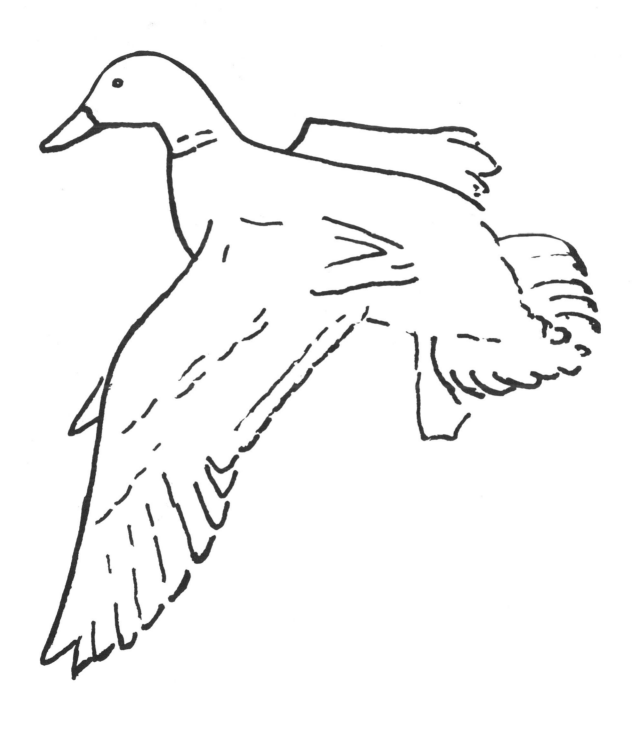

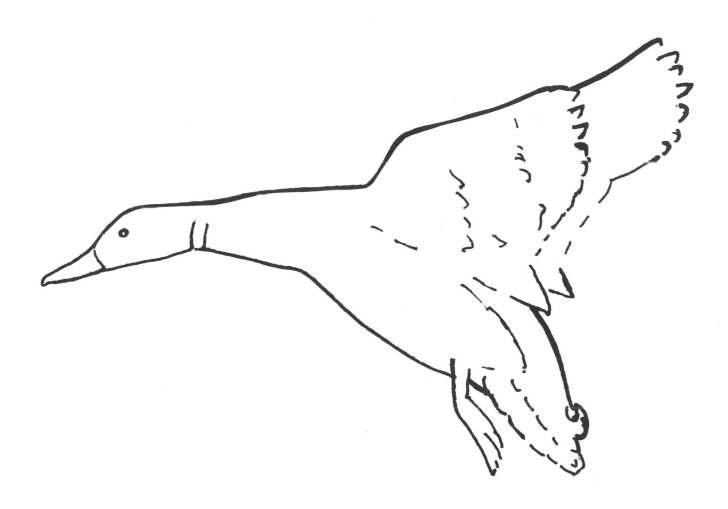

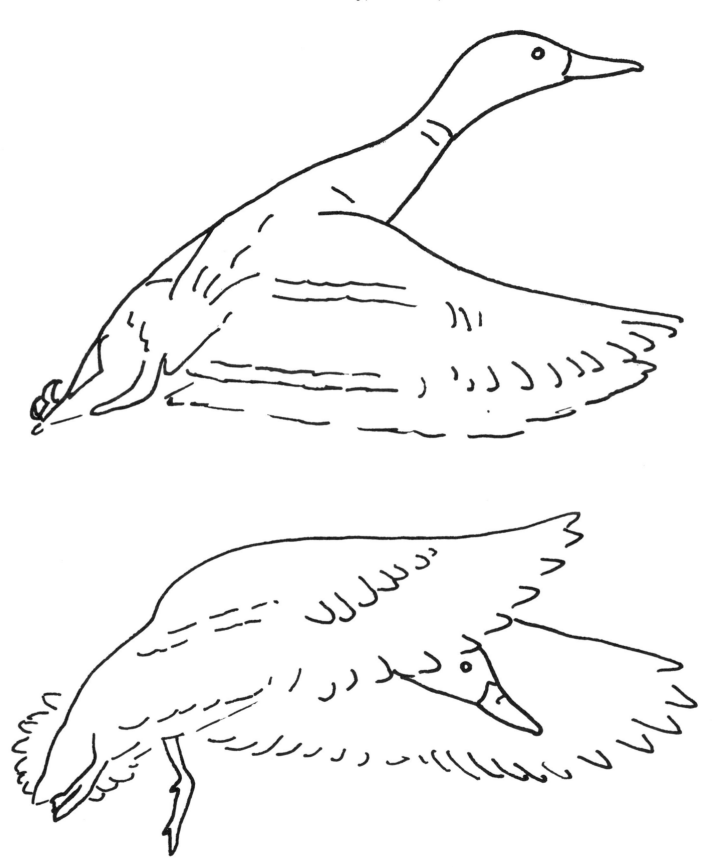

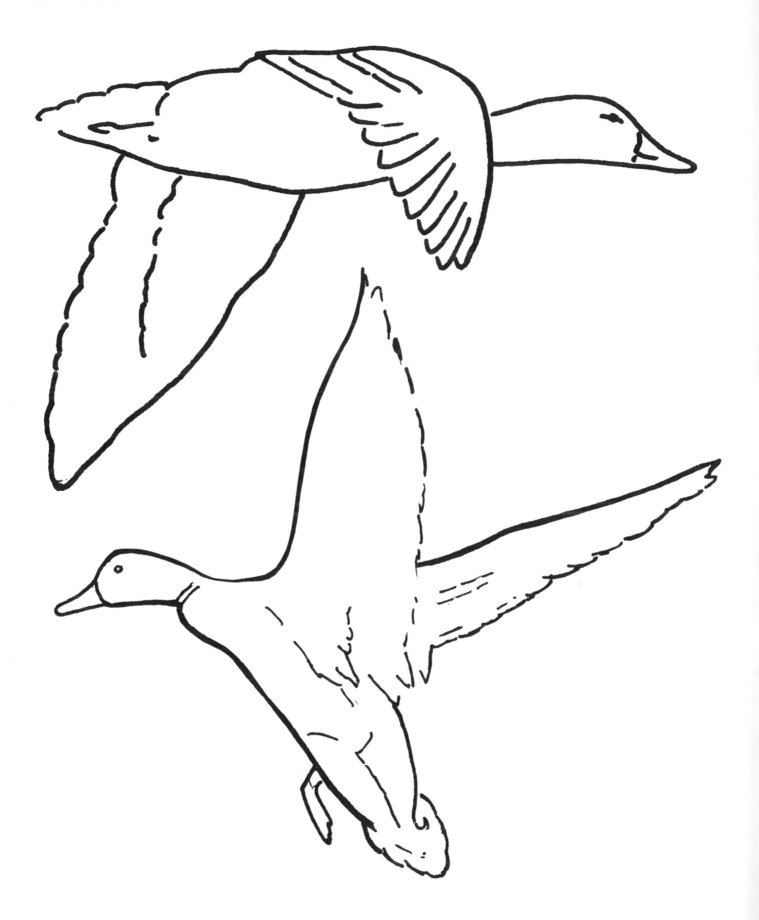

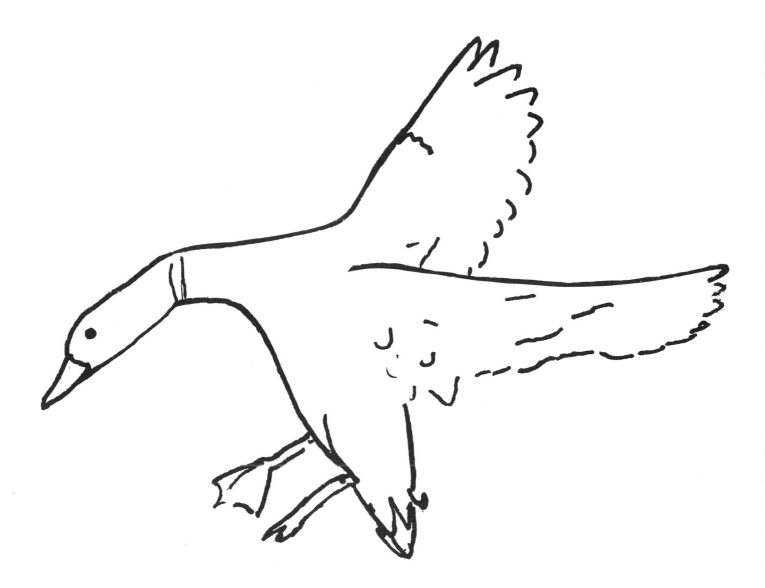

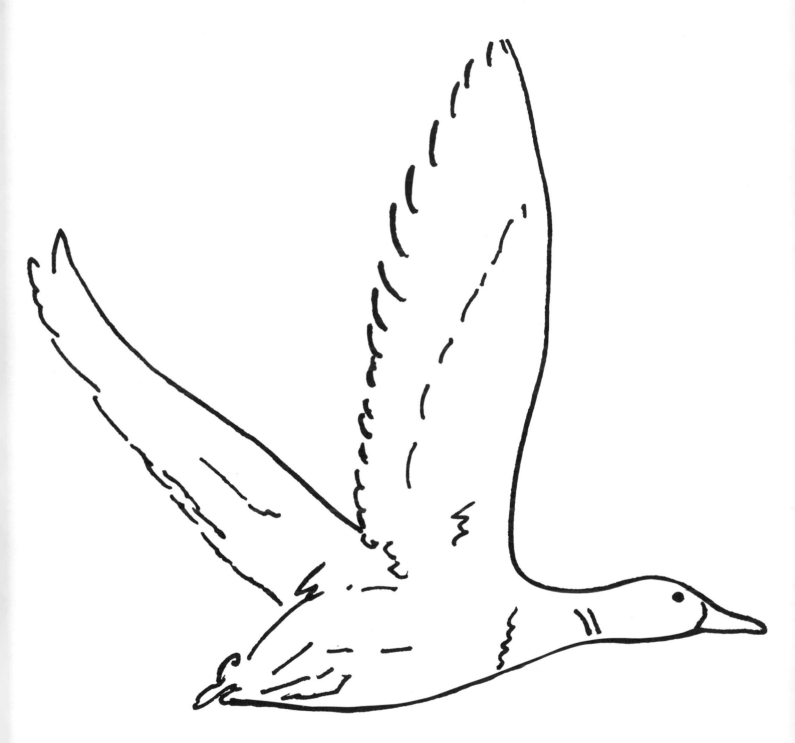

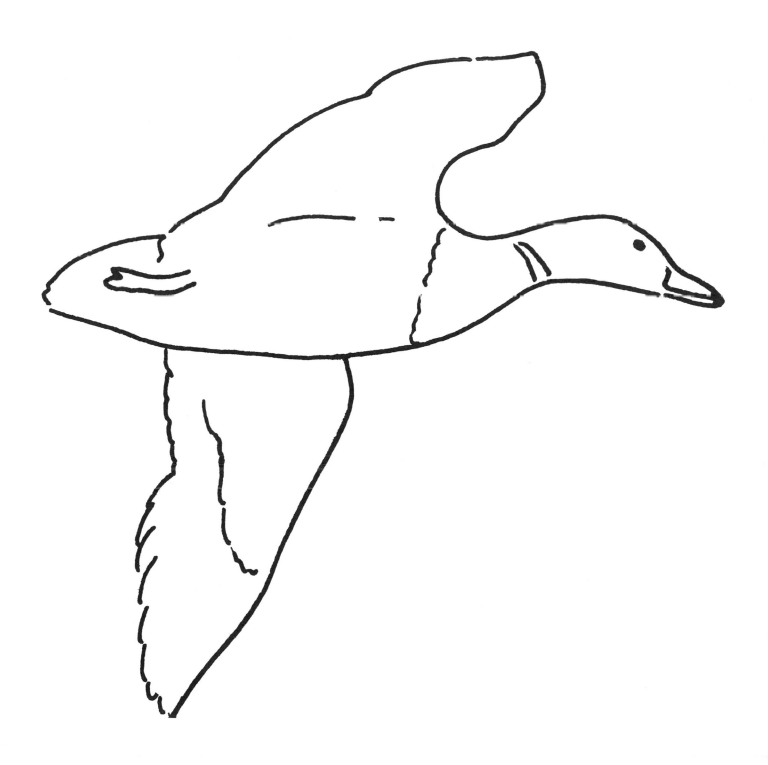

NATURE'S COLORS

Mankind has rarely duplicated the true colors of nature in any medium. Even with the finest of cameras and film, there is a loss of the actual beauty when the pictures are developed. Through the use of filters and custom processing, intense colors are frequently added to original photographs to enhance and make up the loss of color. Artists try to capture the beauty through the use of manufactured paints—paints that are mixed by and for humans. Colors of any hue, intensity, and value can be purchased by artists and yet the majority of paintings are under- or over-colored.

What is so hard about duplicating the colors of nature? Surely, with all of our technical knowhow, we should be able to duplicate the beauty that we see, and yet each time we seem to fall short or go too far with bright colors.

If we ever approach the possibility of duplicating the colors of nature it will be through knowledge—knowing what causes a color to look the way it does. Nature has a way of breaking down colors with structured hues and placed in splotches. Nature's colors do not blend as we know the integrating of paint, but are structured in hues and tones. The random coloring of multicolors are visually mixed and seem to blend together as we view them.

The simplest illustration of this would be using human hair for an example. At a distance, a person's hair appears to be almost a solid tone or color. Upon magnification, however, each hair is slightly different in color than its neighbor. The same is true with grass; each blade is slightly different from the next. Leaves are all different—weeds, bushes, and trees also.

With the knowledge that each blade of grass or leaves is different then comes the breakdown of color within each blade or leaf. The colors are an intermixture of round splotches of color that overlap each other. It would be similar to taking several shades of a paint color, thinning it greatly, and putting it on with an eyedropper. As it spreads out, each color remains in the center but intermixes with the others at the edges. This area where colors meet seems to be nature's concession to blending. Feathers also are colored in this fashion.

No two feathers on a duck are alike—no two feathers on a duck are the same color. Even each barb is colored differently from the one next to it.

The ability to break colors down to these minute differences is what distinguishes realistic painting from decorative painting. Knowledge of anatomy was first, then the attitude, and now the covering to make it look good—color.

Once again, let me emphasize that you should stick with your personal interpretation in this form of art. The breakdown in details is simply for your understanding.

Biologically, all colors are on or within the barbs of the feathers—pigmented color and structured color. With many thousands of barbs on the feathers of a duck, it is no wonder the eye blends all of it into appearing as one soft color. Visual softness comes from the *lack of contrast* between two colors. Black next to white is not a soft color contrast because of the harsh difference between the colors. As the dark color gets lighter and the light color gets darker there is less contrast and they do not seem to fight one another.

I have often stated that there are usually five or more values or hues on each feather. This is very apparent on the feathers of females and also true on the males although less noticeable. Female ducks are usually considered to be in the brown color range. This coloration helps camouflage her during the nesting season. Breaking brown down through the human mixing of colors, we find that it is a combination of red, yellow, and black according to most charts. If the brown has a reddish cast, it usually falls under the burnt umber category. If there seems to be more yellow than red, it is closer to raw umber. With this in mind, the dominating combination of colors is red and yellow. Mix these together and you will have orange, Orange, or the mixing of red and yellow, is the key to nature's colors.

Color is defined as being composed of the three primary colors: red, yellow, and blue. The mixture of any two of them in various amounts is supposed to give us most of the colors needed by artists. The manufacturers of paint also supply color wheels that will show the various colors that can be attained by the mixtures. And yet with all of this, the colors of nature are still evasive. It is simple though, for it is the addition of the third primary color that brings us to home base.

All three primary colors—red, yellow, and blue—mixed in various quantities will give us nature's colors provided that we start with the right shades of each. Frequently the amount added of the third primary is minute, but it still has to be there to achieve the range desired. These mixtures can also be darkened or lightened with the human-made "ivory black" or white.

Before you run out to the art store and pick up a carload of paint, let me caution you first. All of the primary colors are manufactured in various hues. It will take some experimenting on your part; be patient, it will work. If you run into problems, the culprit is usually the blue color.

One of my fellow decoy carvers has often said that it is impossible to achieve the real colors of the bill on a male Ruddy Duck (in the summer plumage). I agreed with him for years before I found some answers—now, I am not so sure that it can't be done. The key that opened this door happened when I was studying the different bills of the ducks for *The LeMaster Method—Waterfowl Identification*. Each day my wife and I would meet hunters as they checked in with their daily bag. I needed to get some more reference on the drake Pintail and luckily one was brought in. It had blood all over it, so I washed the bill off and got out my camera with the macro lens. I try to get ultra closeups whenever I can. As I was focusing with this high magnification, the sun came out from behind a cloud and was reflected on the wet bill. The blue on the bill was broken up in splotches of various blues and grays and all of them were pearlescent in nature. The top of the bill that always had appeared black was actually gunmetal grays and browns and they, too, appeared pearlescent. The water on the bill, given a prismatic effect by the sun rays, had opened another door for me. Pearl-like colors, structured in splotches, became an answer to problem areas I have had trouble reproducing.

The reflective, pearl-like colors are normally labeled as iridescent. My personal opinion of iridescence is a metallic looking, reflective surface. Although pearls are officially iridescent in color, they absorb some of the light as well as reflect it. Because of their structure and color, feathers do the same thing, absorb light as well as reflect it. The white of the Canvasback drakes is a highly reflective white at a distance, yet is soft appearing when viewed at close range. Examined closely, the feathers have a reflective, pearl-like quality. Most of the whites on ducks have

this same attribute but not always to the vivid extremes as the Canvasback.

If you have watched ducks in the wild, the white patches or markings are the first things you see. This is not necessarily because of their being white against another background, but the quality of the reflection as well. If you wish to check this reflective quality, make sure that you view a live duck or one within minutes after the hunter gets it. The colors of the feathers are directly affected as rigor mortis sets in. As the feathers compress they take on a darker appearance. The actual color cannot change, but the matting of feathers changes their appearance. Even after shampooing, air drying to fluff feathers, and extreme care by taxidermists, the feathers will never exhibit the quality they had when the duck was alive.

I had the opportunity to photograph a Horned Grebe at close range and found all of its feathers to have a pearlescent quality. I have never witnessed the same features after the waterfowl have been mounted.

The head of the Mallard drake is a good example of iridescent feathers. The actual iridescence is structured on the barbules of the feathers and not the barbs. As artists, it is doubtful that we will be able to go to that extreme, but we can structure the colors as per barb. Naturally this would be on extreme close-up paintings only.

Darker-colored feathers are frequently iridescent. From the range of a medium brown to a complete black, there will be a reflective green, blue, violet, or combination on the feathers. Iridescence appears as different colors from various angles. The real feather can appear so because of the many directions of the minute barbules and the varied color structure on them. The closest that an artist can come to this would be to create some texture to the surface and try to angle the colors from each direction. This is the process that the carver-painters use on their sculptures but it is far more difficult with a flat surface. Knowledge of what causes iridescence in feather coloration will enable someone to come up with the answer.

Nature's colors are beautiful, especially when viewed firsthand. The reproduction of these colors is an interpretation and spawned the first art of the cave dwellers. From then to now, and on to future generations, it will have to remain the personal interpretation guided by intimate knowledge of waterfowl.

BRUSHES

What kind of brush do you use? What brush is the best? Where can I get a good brush? These are questions that I have answered untold times—though not quite as often as "How long does it take?" The first time you enter an art store and observe the many styles and types of brushes available, you will probably throw up your hands in frustration and walk out without purchasing anything. When you have too many choices, decisions usually end with disastrous results. Many people will make a quick decision just to get something and get away from the confusion and frustration.

Selecting and buying a brush is another of the knowledge factors. You should know what a brush will or will not do before you spend your hard-earned money. A brush can make painting a real pleasure or make it miserably frustrating. Although an excellent brush is not going to ensure the quality of painting by any means, poor quality brushes are a frequent cause of poor quality paintings. I'll try to break some of the knowledge down for you so you can go to the art store with something in mind that you can use.

BRISTLE

Let's start with the part of the brush that absorbs the paint and permits you to apply it to a surface: the hair or bristle. The finest

brushes are made of *Red Sable,* which is a trade name for the hair that comes from the tail of an Asian animal, the kolinsky. The hair from the tail of the male kolinsky is considered the very best of quality. Kolinsky hair is very strong, slim bodied, and comes to a very fine point. It also has more snap or spring than other grades. Some brushes labeled as red sable may be made with hair from the tail of weasels and are not considered as fine as those from the kolinsky. All are excellent, but the kolinsky will give you more service.

Ox hair brushes are made from the hair taken from the ears of oxen. The hair is strong, light in color, and tapers to a point. *Sabeline* is a trade name for light ox hair that has been dyed. It may look like red sable and can be mixed with natural red sable. *Camel hair* is a name used by the trade for various types of soft hair. Camel hair brushes, the finer grades, may be made from badger, pony, or goat hair. Bristle brushes are made of hair from the body of hogs and boars found in the far east. The bristle hair has split ends.

Why the Different Types of Hair?

The shape, length, resiliency, and quality of the various types of hair determine the absorption into, and the flow from, the brush. These factors make it easier to use one kind of paint, with a particular brush over another kind of paint.

The Shapes

Brights are short-length brushes with square ends.

Flats have longer hair than brights but are otherwise very similar.

Round is as the name implies, round. They taper to a fine point on the better brushes but some are made with hairs all the same length.

Filberts have oval-shaped tips but may be the same length as brights or flats.

Fan blenders are fan-shaped brushes that are used to pull one color into another creating a blend of the colors. They come in a variety of hair or bristles.

What brushes are used for the various steps in painting?

Large areas or backgrounding are usually completed by using flats or brights. The brights are stiffer and will work the paint more evenly on a textured surface. The flats, having longer hair, will let the paint flow into textured areas without its being dragged out.

THE TOOLS THAT I PERSONALLY USE

Brushes

I use an inexpensive brush for backgrounding the textured surface because of the abrasiveness of the surface. Texture, or tooth, on a surface

can act like sandpaper and will eventually wear any brush down. Anyone who has ever painted a concrete block wall with a brush can attest to this.

For sealing the wood I use a lacquer-based sanding sealer, and apply it with fine grade camel hair brushes. They have a tendency to lose a few hairs now and then so you have to watch for them as you work. Camel hair distributes paint very evenly and will withstand some abuse without total destruction of the hair. It will also stand cleansing with lacquer thinner.

I use a large flat or bright to apply the gesso or undercoat to a canvas or flat surface for illustration. A better grade flat brush from the hardware store will normally do a fine job with this kind of project.

I follow a certain sequence when I paint a wood sculpture. First, I seal the wood with a lacquer-base sanding sealer and use a camel hair brush (⅝″ or ¾″). Once the sculpture is dry, I apply a dark base coat with a bright brush, being careful that there is no buildup of paint in the texture I worked so hard to create. Usually, I use a ½-inch bright for this. If I get too much lacquer in the texture grooves, it is easily removed with lacquer thinner.

The dark undercoat is applied because I feel it gives me more control over the building of the color. This is only a personal preference and you may find it to be the opposite of your likes. This is what makes painting so difficult to explain. From the colors, brushes, and surface to the techniques of best use, your answers will come from personal choice and experience. Jump in and splash the paint around; it's the only way to learn. All I can do is give my personal beliefs and likes. Your likes and dislikes may, and should, differ from others. That is what makes art what it is.

Paints

The type of paint to use is as personal as everything else is. Many people used to think that oil paints were the finest medium to use. They are easy to blend and the colors are vivid. The large selection of colors available in oils certainly helps also. The oil paints have a tendency to yellow some as they age. The colors can be blended easily because of the slow drying qualities, but *slow* is the word unless you wish to accelerate the drying time with additional mediums. The new oil-based alkyds are an answer to some of these problems because they dry more rapidly.

The problems that I have with oil paints lie in several areas. First, I hold my sculptures in my hand as I paint them—you can't do that with oils! They do not dry fast enough for my personal choice; even the alkyds don't. The real reason I do not use them, though, is the knowledge that

they cannot do what I feel must be done, at least, with my technique of painting.

I structure a painting in many built-up layers of paint. Oils would all blend chemically if not physically when applied. Acrylics are the answer to my method. They are non-yellowing, permanent, extremely adhesive, fast drying, and easily cleaned up with water. The only discouraging part for many is the fast drying qualities.

For me, acrylics are fantastic—they're just what I want. I like having the paint dry as fast as I put it on. I have no particular need to blend the paints as I know they are not structured that way on a duck anyway.

Surface

The surface on which to paint is again a personal choice. The surface will give the painting character. A lot of professionals use illustration board when painting with acrylics. There are two types: hot and cold pressed. The hot-press illustration board has a smoother surface and less tooth. ("Tooth" is the term given for granular texture. The smoother the surface is, the less "tooth" it has and the easier it will be to paint in detail. The rougher or more 'tooth" the surface has, the looser the painting should be.)

Illustration board may warp if the surface gets too wet on one side. This can be overcome if the board is soaked first and pinned down flat until it dries. Once dry, it will usually stay warp free regardless of the water content on any surface.

More and more, professionals are going to the use of pressed hardboard or masonite. They background it with gesso (acrylic base coat) and can then build up the texture desired. The advantages of the hardboard are that it will take a lot of abuse before the painting is destroyed. It also comes in large, four-foot-by-eight-foot sheets and is very economical in comparison to other surfaces.

The most common painting surface is artist canvas. It is available in many types and surface textures. A trip to the art store is the only answer and it will take some experimentation on your part before you will find the one that suits you best. Canvas has to be stretched on a frame and the frames also can be purchased at the art store.

I use disposable paper palette pads to mix paints on. There are several types available but I prefer the wax surface to the others.

All of it—paints, brushes, surfaces, and equipment will have to come from your personal experience, so jump in and splash the paint around; it's the quickest way.

PAINTING— *TECHNIQUES AND COLOR*

The art of painting has been a source of frustration for thousands of years and will continue to be as long as someone is willing to try it. Very few people ever achieve, in visual form, what they had mentally envisioned before they started. The mental aspects of painting, or the inspiration, can be compared to sitting in the car, getting the motor started, and just waiting for somewhere to go. If you get directions, you will start toward your destination. The driving will be up to you because you are the only one in the driver's seat.

If painting is to be done, it will be your driving that does it. There are certainly no others that can take your mental image and sculpt or put it on canvas. The mental pictures as you see it, can be very strong, the desire to accomplish it can be great, and yet few ever achieve the transfer and have it look exactly as they had envisioned. The more experience a person gains, the closer he will come to transferring the mental image to his artwork.

What I am trying to get around to saying is: if you have intentions of painting, jump in and splash the paint around. The sooner you start, the sooner the experience, mysteries, and problems will be met and conquered. You have to start sometime; let it be now.

There are very few mistakes in painting that cannot be corrected. If you are not satisfied, you just paint it over. If you get too much paint on, it can be taken off. There are answers for almost every problem, but only

experience will be the teacher. I mentioned in a previous chapter that I prefer acrylic paints to the other mediums. For me, it is the perfect medium but it may be different for you. Experience with each painting medium will aid you in this choice.

My method of painting is what I term *structure painting*—the building of colors, one color over another, then another, and yet another. This method dictates that the colors as they come from the tube have to be diluted with water. My painting style and the use of acrylics is close to water painting. True watercolors are thinned with water and then applied. Any moisture, even after they are dry, will reactivate them. Acrylics have pigment suspended in acrylic or liquid plastic and can be thinned with water. When they dry, they are impervious to water. By using very thin paint and a darker background, I control the buildup of color, knowing that the previous color will not lift from the moisture in the next stroke.

There comes a point, or mixture, however, when there may be too much water and not enough paint. The paint will then have difficulty sticking to a smooth surface. One of the finest features of acrylics is their excellent adhesion, but the thinner the paint, the less adhesion it has. If acrylics are applied in thick layers, they will dry without problems but the surface will look plastic in nature. I use a thicker coating for the background; this gives me excellent adhesion and a good surface with which to start. I can then use coats as thin as I like, knowing they will adhere to the first, heavier coat.

I use a disposable palette and have to admit that I probably throw away more paint than I use. I have devised means of keeping the paint in 35mm film canisters but still prefer to squeeze what I think I need out of the tube. Notice, that I said *what I think I might need*—I rarely use as much as I think it might take. When thinned, acrylics will go a long way.

To keep the paint from drying on my palette I put a couple of drops of water on each color. Acrylics are mixed and cleaned up with water. I prefer to have several drops of water or even a small puddle next to my color. Using the brush, I pull some water into the paint or vice versa. I mix it with the brush to the consistency that I want. A stroke or two on a scrap of cardstock will show if it is too thick or thin.

Using a brush for mixing is not recommended by most instructors, but I rarely do things properly anyway. I prefer to experiment until I find whatever works best for me. People who write instructions should be truthful and tell how they personally do things instead of the proper way. It would sure be different.

STRUCTURE PAINTING

Acrylics are noted for their quick-drying attributes. This is one fea-

ture that I really use to my advantage. The faster it dries, the better I like it. The secret, if there is one, could be labeled *consistency*. If you have ever watched sign painters, you might have wondered how they could get the nice even edges and curves on their letters. Having the right brush is one answer, but the flow of the paint from the brush is the secret. Furthermore, the paint has to be mixed right: if it is too thin, it will puddle; too thick, and it will not come off the brush without pressure.

If acrylics are thinned with water to a proper consistency they flow from the brush. Here are some keys to getting that consistency. If the paint is too thin, there will be a puddle or drop at the end of the stroke. If you have to press down on a brush or brush the paint out, it is too thick. This does not apply to a flat brush and backgrounding. It will happen only on a good, round sable—that is another key.

It takes a good brush, paint at the right consistency, and strokes with no pressure on the brush. If all the keys are in order, the paint will flow from the brush and painting will be an enjoyable experience.

When the acrylics are thinned to the proper consistency, they can be applied and will be translucent. Any color that you paint over the top of will still show through, but will be toned by the top color. As each stroke is applied over another, it tones or colors the ones under it. As the building, or structuring, of the paint takes place, you can see the colors blend. If the paint is applied in thick layers any color underneath will be covered. This is the next key—making sure that each coat is applied thinly enough to let the underlying strokes show also. Each of the underlying paint strokes will take on some of the aspects of the surface color. It will create the varied hues that are needed for realistic color. If this type of painting were to be attempted with oils, they would chemically puddle together and all that would be left would be muddy looking.

I suggest that you try structure painting on some waste card stock. Paint an area with burnt umber and leave the rest open. Using a variety of colors make a line or two with each on both backgrounds. When the colors are dry, turn the card and make more lines of the same colors across the previous lines. If the paint was thinned properly, there will be a mixture of the colors at every intersection. This exercise can be done with any colors and in any direction. By going across the previous lines the intersection is easily seen and more dramatic. The most dramatic conclusion will be the cannibalizing by the burnt umber background. It will literally eat the colors placed over it.

Another key to my style—by successive strokes, I can build up the color and control it as I do so. Each stroke will not cover with strength as it would on a white background. It does take longer and is more work, but I never said I was smart—just stubborn. When I get done, it's been

done my way. The personal sense of accomplishment is what painting is all about.

Let's transfer this structure painting to ducks. The feathers are composed of barbs; the colors will be painted per barb. This means that each stroke will be in the direction of the barb. As each color is applied, it will overlap the previous colors and although the intersecting colors are not at right angles, the same action will take place as they overlap each other. By using several shades of color, many colors are created on the same feather. This is exactly what we set out to accomplish. The overlapping strokes create a multitude of colors. On the real feather, no two barbs are alike; with our painted feather it will be very similar.

I think that I had better back up to one of the keys at this point. One of the most important is the brush, as I mentioned. A good red sable. I paint my entire sculptures using a #3 Kolinsky red sable brush (round). I have several brands that I prefer above the rest but admit that I have not tried every one there is. My favorite is the *Artsign Finepoint Series 9 #3*. It will do everything that I wish a brush to do. It sells in the ten- to eleven-dollar range as do the others of comparable quality. The *Strathmore Kolinsky* round red sable is another of my favorites. The others that I use are the *Windsor Newton* Series 7s and the *Delta 5000s* (marketed by Grumbacher). These brushes are not the type that the art stores have out for the public to handle so you may have to ask to see them. If they do not have them, the brushes can be ordered by the art store if you ask. They can furnish the address of the manufacturer if they cannot get the brushes for you.

I bought extremely small brushes for many years until I found what a good brush really was. I tried to get small lines using the 0s and down to the 5-0s (these numbers are for small brushes with the larger number meaning the brush is smaller and has less bristles). I thought that the smaller the brush, the smaller the line. This is true to some extent but certainly is misleading. A small brush, for instance, will give a hairline if the paint is mixed properly (true with any brush). The problem is that you have to keep going back to the palette for more paint with each stroke and sometimes half strokes. With the brushes I mentioned, I can load up the brush, make as fine a line as I will ever want, and keep going for minutes before I have to reload again.

The round red sable should be held at a low angle after loading with paint and then rolled on the palette to form a perfect flame tip. Technique is in the brush, the properly mixed paint, and then making sure that the tip merely touches the surface and the paint siphons from the brush as you make each stroke. If the tip of the brush is bending, there is too much pressure being applied. It is delicate, but it is also easy if you practice and are patient. Jump in and splash the paint around.

DETAIL— *HOW MUCH?*

There is one controversy within Bird Art that probably will never be resolved. It is a personal interpretation, and artists, being the individualists they are, are very opinionated on the subject. The dilemma: how much detail should be shown or attempted?

Some of the masters have exclaimed that good bird art shows shape, color, and lighting; others feel that it has to have infinite detail. Who is right? They all are, of course, for it is personal interpretation that widens the scope of the art.

Infinite feather detail normally cannot be detected more than a few feet away from the live bird. With this analysis, then, a painting should not have minute details of the waterfowl if it is to be shown more than an arm's length away. And if the artist chooses to do it anyway? *That* is artistic license.

What about the wood and bronze sculptures? Paintings are hung and usually viewed a few steps back to really appreciate them. Wood sculptures are frequently picked up and scrutinized. Once in hand they are usually turned over to see what the bottom looks like (decoy style). (I do not know the significance of this but it happens all the time. I even find myself doing it to others' pieces of art.) Once satisfied that there is a bottom to it, the viewer usually gets as close as possible to examine the details, rubbing the surface as if stroking feathers.

173

With people looking extremely closely at your art, it's only natural to detail the surface as much as possible. You almost have to have details, for all the admirers seem to be experts—at least that's the voiced opinion. (I have often wondered, though, when was the last time they were able to pick up a live duck in that particular attitude and examine it without the shape changing?) Minute details do not have to be shown on sculptures unless it is your personal choice.

Good art is, and always has been, viewed from a distance. It will be the viewer's decision as to the artistic merits of your style—good or bad. It will be your decision, however, to please yourself, or the viewer, in creating your art.

TIPS ON PHOTOGRAPHY

Photographs of live waterfowl are excellent sources of reference, if used in conjunction with skins and personal observation. If photos are the only source of reference available, the artist should realize the limitations and exaggerations that can occur. A good case in point for this would be an experience that happened a few years ago. A beginning carver wanted me to look at his "masterpiece." He had managed to complete a pretty good carving considering his reference was limited to a couple of pictures. I had only one criticism that was of any consequence, Why the difference in the size of the feet on the standing sculpture?

When I mentioned my observation he defended it as actually being that way and pulled out the picture he had used as reference. Sure enough, the foot in the foreground sure looked bigger than the one in the background. He had copied what he had detected in the picture without realizing the distortion of distance the camera lens shows. Most people are not that naive, but we all must start somewhere.

Taking pictures of waterfowl in the wild is fascinating, rewarding, frustrating, and frequently disheartening—not to mention physically demanding and uncomfortable at times. But it never ceases to be a thrill when the ducks are overhead, even as you crouch in the mud and shiver from the cold as water seeps into your new boots, which somehow sprang

a leak. That one exciting moment when ducks are close seems to make up for all the inconvenience and misery. It is easy to understand the feelings of a hunter as a flock comes near.

I have hunted all of my adult life, but really did not appreciate the challenge until I first tried it with a camera. In my estimation, it is far more difficult to shoot ducks on the wing with a camera than it is with a gun. Trying to focus the camera on a pair of divers whizzing by can be compared to hitting a golf ball as someone throws it past you.

When ducks are in their own element, they are very wary and elusive. If you intend to take your own pictures for reference, do not take the challenge lightly. Taking good pictures in the wild is not luck, it's patience and knowing the habits of the subject matter. If you are more venturesome and want to try it for yourself, let me give you some of my inside tips.

The best time to take pictures of ducks is usually when they are coming into, or going from, a feeding area. An area at which to take pictures can be created by throwing out corn, or bait, at a known habitat. This has to be done for some time before they may find it and get used to using your area to feed. Once they habitually start using the baited area, you may notice that the most activity occurs around sunrise and just before sunset. They feed the most before and after the long night sleeping. If the weather is colder, they require more food and the activity may go on most of the day. Naturally, if the weather is warm, then they do not feed as much. Thus, there are two main elements to overcome, poor light conditions and cold equipment. If you have selected an area that is used by the barnyard variety of semitame Mallards be aware that there is a distinct difference in their attitudes, behavior, and shape.

A blind can be constructed, keeping in mind the best lighting conditions as well as the background which you will be shooting. A lot of trees in the background may make viewing of the ducks in the photograph difficult. The ideal situation is to have two blinds, one facing west to utilize the morning sun, and one facing east for the late evening light. If pictures are taken when the sun is at a low angle, there may be a yellow glow to all of your pictures.

After building the blinds, it will take some time for the ducks to get used to them and start frequenting the area again. They will be aware of any additions to the landscape and each one will receive careful scrutiny before they feel some degree of safety. I do not recommend building the blinds until the ducks are using the baited area. If they do not frequent your enticing area, you would have built the blind for nothing. If possible, the blind should be covered with weeds or other material from the same area.

It is only human to try to make the blind as comfortable as possible and to have plenty of room to move about, but be cautious. Moving or motion is the major cause of alarm for wildlife. The faster the motion, the quicker they become alarmed. The second cause for alert is the sound of the camera clicking away. Duck wings make a lot of noise when taking off or landing so camera noise would be at a minimum if your timing is right. In addition, the more you see, the easier they can see you.

Entire books have been written about wildlife photography and if you are really sincere about taking your own reference pictures, I suggest you check at your local bookstore.

To say the least, I am determined. I wanted pictures of what I call the ice ducks—the Mergansers and the Goldeneyes. They are usually only seen in my area when there is ice on the river. I could not get close to them, however, so I decided that if they would not come to me, I would go to them. I bought a hollow plastic goose decoy and installed foam on the bottom to give it extra flotation. I then went to the hobby shop and got a radio control with servos and an electric motor used for model boats. I mounted the radio control inside the goose with the servos controlling the speed, forward and reverse, and the rudder direction. I also fitted a Nikon with a 200 mm zoom lens on it and completed the job by adding a servo for shutter release. Finally, the goose was powered with batteries. So I stood on shore and sent it out to take the pictures for me.

The only big problem I encountered was one of focusing—the goose had to be worked into a certain range before the pictures were clear. I did overlook one important thing, however; ducks are very wary of a lone goose, especially swimming directly toward them. When autofocusing telephoto lenses are available, I'll be back on shore again letting the goose do the dirty work.

EQUIPMENT

Multitudes of would-be nature photographers start with 200 mm telephoto only to be disappointed with the returned photographs not showing the detail they had hoped for. A 200 mm lens will only show action or attitude, not detail, unless you can get the subject within 50 feet or so.

In the field, I use three cameras with motor drives or winders. I purchase inexpensive automatic camera bodies with better quality lenses—80–200 mm zoom lens, 400 mm and 600 mm telephoto lenses, all prefocused on an area. I found that it is more advantageous to have a standby camera with lens on it than to change the lenses. When you are taking pictures of wildlife, the opportunities are infrequent and the action is over before you can even think of what went wrong. About the

time the ducks are in the midst of landing and the film reaches the end of the spool, you will understand why I have another camera ready to grab. It's a matter of seconds until it is all over—no time to change film or a lens.

The image of the subject should cover at least a third to half of the area in the viewfinder. Anything that appears any smaller than that will be good for attitude only because, in all probability the details will not show.

To find swift-moving ducks in the viewfinder, I use the zoom lens at the 80 mm setting to locate them. Once in the viewfinder, I slide the focus ring to the 200 mm maximum and adjust the focus if necessary. This takes some mental training (e.g., Does the focusing ring go to the left or right as they get closer?). Familiarity with your equipment before you go into the field is essential.

To find a fast-moving target with the 600 mm lens and focus it is a chore in itself. I have overcome some of this by constructing a sight (similar to a gunsight) and mounting it in the flash holder of the camera. I prefocus the camera by observing what the most frequented path of the subjects will be. To complete this setup, I attached a wide-neck strap to the camera. By using the strap behind my neck and pushing the camera out in front of me, elbows at my side, I create a mobile tripod. With the makeshift sight on the camera, I bead in on the ducks and start clicking away. Although the camera has a set focus there will be a good picture somewhere in the arc or swing.

Most of the time I use 400 ASA film although the greatest clarity comes from Kodachrome 64. It is not fast enough for my personal preference but I do use it as much as possible. I rarely use black-and-white film. Color film can be converted to black and white but not vice versa. The pictures in this book were in color before I transposed them for printing. The main problem with the faster film speeds (ASA) is the graininess when enlarged. This is permissible for personal viewing and study but tough on reproduction.

The lower the camera is to the water, the better the picture will normally be. There is a point, however, when it can be too low—experience is the only teacher in this case.

If you have an automatic, aperture-priority camera, any picture taken against the sky will make the subject appear darker because the camera reads the mass of light of the sky and not the subject. Camera equipment is very similar to the problem with brushes. You will get what you pay for and the results show as long as you are patient and can gain the experience to use it.

When you go into the field to take pictures, take along some soft wire or strapping tape. There may be times when you can bunch some weeds or brush together to conceal yourself. A quick method of holding it in place will certainly come in handy.

Of all the things to remember—camera, film, equipment bag, tape, etc.—the most important for me are munchies. It can be a long wait— good luck!

GLOSSARY

ASA-The speed of film. The higher the number ASA, the less light is required for an image.

Acetate-A clear plastic used to protect and/or illustrate artwork.

Alkyds-An oil-base paint.

Alula-Thumb of the wing.

Aperture-Setting of camera lens to amount of light.

Attitude-A condition—nervous, excited, calm, etc.

Axioms-Rules for basics.

Baiting-Putting out feed to lure waterfowl into view.

Barbs-A part of the feather attached to the quill.

Barbules-Hooklike projections from the barbs that "hold" the feather together.

Belly-Bottom of duck.

Binocular Vision-Vision with both eyes.

Breast-Front chest area.

Brights-Short-length brushes with square ends.

Bristle-Hair from the body of hogs and boars found in the Far East.

Camel Hair-Trade name for various types of soft hair.

Cape Set-Triangular shape of feathers behind the neck.

Coverts-Feathers that cover open areas at the base of larger feathers.

Crest-Longer feathers on the rear of the head.

Crown-Forehead area.

Diver-A group of species of ducks.

Drake-Male duck.

Eclipse-A change of feathers after the first year.

Elbow-A corresponding relation to the anatomy of the wing.

Eye Trough-Indentation from bill that arches up over the jowl on the head.

Fan Blenders-Fan-shaped brushes used for pulling one color into another.

Filberts-Brushes with tips that are oval shaped.

Flank Feathers-Feathers immediately behind sidepocket, between the speculum and the tail.

Flat-Long-hair brushes with square ends.

Game Breeder-Someone who raises birds in captivity.

Gesso-A white acrylic base coat.

Hair-Feathers of the head.

Hand-A corresponding comparison to the anatomy of the wing.

Hen-Female duck.

Hue-Name of a color: red, blue, yellow, orange, etc.

Inner Scapulars-Row of feathers on each side of center back.

Intensity-Brightness of color or strength.

Iridescent-Metallic-looking, reflecting colors.

Jowl-The jaw area of the head, its widest spot.

Juvenile Plumage-Feathers that emerge to replace down of the young duck.

Lamellae-Toothlike serrations on top and bottom bill.

Mid Scapulars-A diamond-shaped group of feathers, the largest on the back of a duck.

Molt-The exchanging of feathers each year.

Monocular Vision-Vision with only one eye at a time.

Nail-The hard area at the end of the bill.

Nictitating Membrane-A clear membrane that swipes the eye to keep it moist.

Nostrils-The openings of the bill for breathing.

Notch-V-shaped area at the top rear of the bill.

Nuptial Plumage-The bright spring plumage of drakes.

Oil-Gland Coverts-Feathers covering the preen gland.

Outer scapulars-Triangular-shaped set of feathers that angle outward on the back.

Ox Hair-Hair from the ears of an oxen.

Pearlescent-A reflective iridescence, usually containing a white hue.

Primaries-The ten flight feathers of the outer wing.

Primary Colors-Three basic colors: red, yellow, blue.
Puddle Duck-A group of species of duck.
Red Sable-Hair that comes from the tail of a kolinsky.
Round-Brushes that taper to a fine point.
Sabeline-Trade name for light ox hair.
Scapular-Sets of feathers on the back (three sets: inner, mid, and outer).
Secondaries-The ten feathers of the inner wing. The speculum.
Servos-Radio control relays.
Shaft-The central part or quill of a feather.
Shoulder-The wing base area of the body.
Shoulder Coverts-Half-moon shape of feathers behind the breast
 covering front of shoulders and down over the front part of sidepocket.
Sidepocket-Feathers on the side of the body housing the folded wing.
Species-A type of duck.
Speculum-The bright colored secondaries of the wing.
Tail-Rear flight appendages of the duck.
Tertials-Large feathers of the inner wing.
Throat-Upper neck.
Tooth-The roughness of a painting surface.
Transitional Sets-Feathers that serve a multidirectional purpose.
Under Tail Coverts-Feathers under the tail.
Upper Mandible-Top part of the bill.
Upper Tail Coverts-Row of feathers at base of upper tail.
Value-Shade of color (or hue) (e.g., light-dark).
"Woody"-A Wood Duck.
Wrist-An anatomy comparison of the wing.

INDEX